FADINGS

GRAFFITI TO DESIGN, ILLUSTRATION AND MORE.

24 PROFILES.

Park Library
University of Gloucestershire
Park Campus, The Park
Cheltenham
Gloucestershire
GL50 2RH

FADINGS
GRAFFITI TO DESIGN, ILLUSTRATION AND MORE.
Siggi Schlee

first published in the United States of America in 2005
first edition 08. 2005

Gingko Press Inc.
5768 Paradise Drive, Suite J
Corte Madera, CA 94925, USA
Ph: 415 924 9615
Fx: 415 924 9608
books@gingkopress.com
http://www.gingkopress.com

ISBN 1-58423-219-6 Gingko Edition/US

© Publikat
Verlags- und Handels KG
Hauptstraße 204
63814 Mainaschaff
Germany
info@stylefile.de
http://www.stylefile.de

ISBN 3-9809909-0-7 Publikat Edition/Europe

. Graffiti ist großartig! 6,1 Millionen Ergebnisse bietet Google zu dem Suchbegriff „Graffiti" an. Graffiti ist überall. In Chrom an Autobahnbrücken, in Schwarz auf Stromkästen und als Zehn-Farben-Fill-Inn an der Hall of Fame – in der 100-Seelen-Gemeinde, in Deutschland, in Europa und auch auf den anderen vier Kontinenten.

Graffiti beeinflusst! Die Szene untereinander, macht Geschädigte zu enthusiastischen Widersachern und hält den Wachschutz und die Polizei auf Trab.

Graffiti beeinflusst! Für Musiksender werden Streetart-poster zum Leben erweckt, Fast-Food-Ketten setzen in ihrer Werbung auf den Reiz von Sprühschablonen und in den Kinderabteilungen großer Warenhäuser springen einem fröhliche Tags und B-Boys entgegen.

Neben den jeweiligen inhaltlichen Anforderungen der grafischen Gestaltung unterliegt die äußere Form eben auch immer dem aktuellen Zeitgeist. Der Charme einer urbanen Kunstform als Anreiz für den Konsumenten.

Aber Graffiti vermag mehr als Lifestyle zu suggerieren, denn mit seiner individuellen Ästhetik und unkonventionel-len Wertewelt beeinflusst es seit langem viele Bereiche der visuellen Kommunikation. Grundlage dafür ist der Drang vieler Kreativer aus der Szene, neue Felder zu erschließen und ihre Erfahrungen in andere Bereiche mit einzubringen. Mittlerweile sind sie auch in der Design-szene ein fester Bestandteil mit eigener Sprache und weitreichenden Einflüssen auf ihr Umfeld.

Ein Portfolio von 24 ausgesuchten Graffiti-Grafikdesignern belegt dies eindrucksvoll. Viele von ihnen haben schon deutliche Zeichen gesetzt; die Ideen und Wege der ande-ren werden in wenigen Jahren mit Sicherheit ebenfalls zum Maßstab avancieren.

Viele Publikationen widmeten sich bereits ihrem Können und präsentierten meist den Graffitikünstler oder den Grafikdesigner. FADINGS geht den entscheidenden Schritt weiter und versteht sich nicht nur als Grafik-Werkschau, sondern zeigt, unter Betrachtung des Graffitibackgrounds auch auf, wo die individuelle Formensprache ihren Ursprung hat. Es bietet die Möglichkeit, nicht nur zu sehen, sondern auch zu verstehen, wie der Einzelne sich entwickelt hat. Dazu trägt unter anderem die Analyse ausgewählter Arbeiten entscheidend bei.

Im Kapitel FROM THE SCENE. PT1 werden Illustrations- und Designbüros unter fünf Teilaspekten betrachtet. FAKTEN und EINBLICK sorgen für das Verständnis um die künstlerische Entwicklung. KUNDENARBEITEN zeigen die Transformation der entwickelten Sprache – die Rubrik FREIE ARBEITEN und AUSBLICK, wie die Erfahrungen als Designer ihre persönlichen Arbeiten beeinflussen.

FROM THE SCENE. PT2 widmet sich Freelancern mit Graffitiwurzeln, die unter dem Oberbegriff FADINGS ihre Sicht auf den Schmelztiegel GRAFFITI TO DESIGN, ILLUSTRATION AND MORE offenbaren.

Der Tatsache, dass Kreativität nicht auf dem Papier endet, zollt die beiliegende CD-ROM, FADINGS DIGITAL, Rechnung. Filme, Animationen, Freefonts zum Download, Illustrationen und weiteres Bildmaterial runden die jeweili-gen Profile ab.

Genießen Sie auf 240 Seiten und 700MB eine Kreativreise durch die Welt von 24 Individualisten. Sehen und ver-stehen Sie die Übergänge – die FADINGS. Entdecken Sie Ihren nächsten Freelancer, Ihre nächste Kommunikations-agentur oder lassen Sie sich von den FADINGS einfach nur inspirieren.

Siggi Schlee. 2005

. Graffiti is fantastic! Google offers 6.1 million results to the search query "graffiti". Graffiti is everywhere. On motor-way bridges in chrome, on transformer boxes in black and as a ten coloured fill-in on the Hall of Fame, in the smallest village, in Germany, in Europe and on the other four continents as well.

Graffiti inspires! It inspires the scene itself, it turns victims into enthusiastic opponents and keeps watch patrols and police on the go.

Graffiti inspires! Street art posters come alive for music programs, fast-food chains exploit the appeal of graffiti stencils and funny tags and B-boys jump up at us from the children's departments of large stores.

Apart from the particular requirements of graphic design in regard to content, the outer form is always also subject to the current Zeitgeist. An urban art form has its charms as an incentive for the consumer.

But graffiti can do more than convey a lifestyle. For a long time now it has been influencing many sectors of visual communication with its individual aesthetics and unconventional code of values. The basis for this comes from many creative individuals on the scene who seek to open up new areas and introduce their experiences into other sectors. Meanwhile they have become an integral part of the design scene with their own idiom and a wide-ranging influence on their environment.

A portfolio with 24 selected graffiti-graphic designers substantiates this impressively. Many of these designers have already made their mark; the others have ideas and ways that will certainly set a benchmark in the near future.

Many publications have already been devoted to their proficiency and usually present the graffiti artist or graphic designer. With FADINGS we can go one decisive step further because it is not only a graphic showcase but considers the graffiti background and can thus reveal the origins of the individual formal vocabulary. It gives us the opportunity to see as well as to understand how the individual has developed. Among other things, this is supported by an analysis of selected works.

Illustration and design bureaux are viewed under five aspects in the chapter FROM THE SCENE. PT1. The chapters FACTS and INSIGHT help us to understand the artistic development. CLIENT WORK demonstrates how the developed idiom is transformed. Under the headings FREE WORK and OUTLOOK the contributors show how their experiences as designers have an influence on their own individual work.

FROM THE SCENE. PT2 is devoted to freelancers with graffiti roots who disclose their views on the melting pot GRAFFITI TO DESIGN, ILLUSTRATION AND MORE, under the title FADINGS.

The enclosed CD-ROM, FADINGS DIGITAL pays tribute to the fact that creativity does not end on paper. Films, ani-mations, freefonts for downloading, illustrations and other graphical material enhance the respective profile.

On 240 pages and 700MB you can enjoy a creative journey through the world of 24 individualists. See and understand the transitions – the FADINGS. Discover your next freelancer, your next communications agency or just let the FADINGS inspire you.

Siggi Schlee. 2005

02.0

. BÜRO DESTRUCT

Das international renommierte Grafikdesignerkollektiv BÜRO DESTRUCT zählt zu den „jungen Wilden" der Grafikerszene. Die wichtigsten Tätigkeitsbereiche von BÜRO DESTRUCT sind Visualisierungen im Bereich von Corporate Identity, Logos, Plakaten, Büchern, Platten- und CD-Covern. Eine Spezialität des Grafikdesigner-kollektivs aus Bern, Schweiz, ist unter anderem auch die Entwicklung neuer Schrifttypen (Fonts).

Im „Die Gestalten Verlag", Berlin, erschienen seit 1999 mehrere Bücher von BÜRO DESTRUCT und 2002 eröff-nete es in Zürich den Shop „Büro Discount", eine Platt-form für Grafikdesign und Streetart.

. BÜRO DESTRUCT

BÜRO DESTRUCT is an internationally renowned collective of graphic designers and ranks among the "Neo-Fauves" of the graphic scene. BÜRO DESTRUCT specialises in the visualisation of Corporate Identity, logos, posters, books, record and CD cover design. This group of graphic desi-gners from Berne, Switzerland, has further specialised in the developing of new fonts.

Since 1999 BÜRO DESTRUCT has published several books in "Die Gestalten Verlag", Berlin, and in 2002 a shop was opened in Zurich called "Büro Discount", which acts as a platform for graphic design and street art.

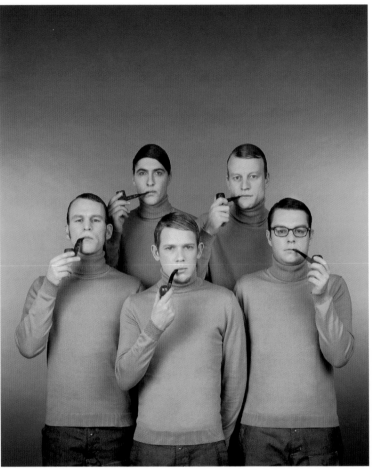

•001

```
-----------------
•001 H1/MORITZ/LOPETZ. front row.
     MB/HEIWID. back row
     Photo: Regula Roost. Berne. Switzerland
     Hair and Makeup: Anja Wiegmann. Berne. Switzerland
```

. GRAU MACHT GRAU

Draußen regnet es kübelweise und drinnen klingelt das Telefon. Grau macht grau! Man bittet mich um ein Vorwort zu einem Buch über Graffiti Art. Es ist das Buch, das Sie jetzt in Ihren Händen halten. Es ist keine leichte Aufgabe über Graffiti Art zu schreiben, schon gar nicht für einen Büromenschen wie mich. Sie glauben, ich mache Witze? Keineswegs, denn ich bin ein echter Schreibtischattentäter! Jeden Tag gehe ich in mein Büro, setze mich an meinen Tisch, zünde mir eine Zigarette an, setze Kaffee auf und starte meinen Computer (PowerMac G4). Ich hantiere mit meinem Acrobat, jongliere mit meinem Photoshop und übe mit QuarkXPress den Spagat. Draußen regnet es kübelweise, drinnen klingelt das Telefon und aus den Lautsprechern spricht ununterbrochen „De La Soul" zu mir: Grau macht grau!

Es ist also für einen Büromenschen wie mich keine leichte Aufgabe über Graffiti Art zu schreiben, aber ich sehe bei genauerem Betrachten doch so einige Berührungspunkte. Einer davon ist bestimmt: Wir fahren in derselben Straßenbahn, wir verfolgen dieselbe Schiene. Ein weiterer ist bestimmt: Wir benutzen dieselben Zeichen und sprechen deshalb auch dieselbe Sprache. Wir haben den gleichen Code. Graffiti kommt letztlich vom griechischen Verb „graphein", also ritzen, graben, eingravieren. Vor einigen tausend Jahren hat man damit begonnen, die Oberfläche mesopotamischer Tontafeln mit zugespitzten Stäben einzuritzen. Das war der Ursprung der Schrift und darum geht es auch heute noch: eine Oberfläche zu durchdringen. Der Grafikdesigner und der Graffitiwriter verfolgen so gesehen also letztlich eine ähnliche Absicht in ihrer Tätigkeit.

Während wir Grafikdesigner als Schreibtischattentäter über eine Tastatur, sozusagen noch latente oder zumindest widerrufliche, Schriftbilder auf die Mattscheibe zaubern, sprüht der Graffitiwriter mit seiner Dose, quasi als Guerillakämpfer, bereits ein offenkundiges Bild auf die graue Mauer.

Einerseits ist so gesehen – interessanterweise – der tippende Schreibtischattentäter freier als der Guerillakämpfer, der im freien urbanen Raum Farbe aufträgt, andererseits bewirkt – genauso interessant – der Graffitiwriter in seiner spezifischen Vorgehensweise die eindringlichere grafische Geste als der Grafikdesigner. Sollte es nicht umgekehrt sein? Und spielt das überhaupt eine Rolle? Und spielt überhaupt irgendetwas eine Rolle?

Ein Code ist ein System aus Symbolen. Sein Zweck ist, Kommunikation zwischen Menschen zu ermöglichen. Unsere Alphabete sind also nichts anderes als Codes, die beabsichtigen, das Sprechen sichtbar zu machen. Eines der ersten Alphabete waren die Hieroglyphen. Dabei handelt es sich für unser heutiges Verständnis eher um Bilder als um Schriftzeichen (heute würden wir vielleicht von Piktogrammen, Icons oder im weitesten Sinne von Logos sprechen). Doch auch die Buchstaben unserer heutigen Alphabete sind letztlich nichts anderes als Bilder (deshalb auch der Name: Schriftzeichen). Ihre Aufgabe ist es, die gesprochene Sprache ins Visuelle umzukodieren.

Wie ist eigentlich die Lage heute? Okay, es regnet kübelweise und das Telefon klingelt ununterbrochen. Aber das sei nur am Rande erwähnt! Ist es denn nicht so, dass wir alle schon längst zu Opfern der globalen Kommunikation geworden sind? Fette Warenketten bombardieren unser tägliches Leben mit schrillen und schreienden „Kauf mich"-Leuchtreklamen und Fernsehwerbespots. Eine Revolution, die unser Leben vermutlich weit mehr beeinflusst als wir bisher angenommen haben! In diesem Sinne sollten Sie nun dieses Buch, das Sie gerade jetzt in den Händen halten, genau durchgehen und nachdenken!

Unsere These soll sein: Wir Büro Destruct-Attentäter und Graffiti-Guerillakämpfer haben letztlich denselben Rhythmus, dieselben Harmonien, dieselbe Melodie. Wir haben den gleichen Code und wir wissen: Grau macht grau!

Draußen regnet es kübelweise und drinnen klingelt das Telefon – das soll uns ganz egal sein. Denn es ist uns nur im geringsten Maße möglich, darauf Einfluss zu nehmen: Auf die Welt!

Hgb Fideljus
Büro Destruct. 2005

. GREY MAKES GREY

Outside it's pouring with rain and inside the telephone is ringing. Grey makes grey! I've been requested to write a foreword to a book on graffiti art. This is the very book that you are now holding in your hands. It is no easy task to write about graffiti art, especially not for an office worker like myself. You think I'm joking? No way! I am a genuine armchair assassin! Every day I go into my office, sit down at my desk, light a cigarette, put the coffee on and start up my computer (PowerMac G4). I fiddle about with my Acrobat, juggle around with my Photoshop and practise balancing acts with QuarkXPress. Outside it's pouring with rain and inside the telephone is ringing and from the loudspeakers "De La Soul" is forever telling me: grey makes grey!

Although it is no easy task for an office worker like myself to write about graffiti art I can see when I look closer that there are actually some points of contact. One of them is the fact that we travel in the same tram and thus follow the same track. Another one is the fact that we use the same symbols and thus also speak the same language. We both have the same code. The word graffiti originally comes from the Greek verb "graphein" meaning to write, scratch, carve. Several thousand years ago in Mesopotamia someone began to carve the surface of a clay tablet with a pointed stick. This was the birth of writing which still serves the same purpose today: to penetrate a surface. When seen from this perspective, the activities of graphic designers and graffiti writers pursue a similar aim.

While we graphic designers quasi as armchair assassins conjure up the still latent (or at least revocable) typefaces on the screen with a keyboard, the graffiti writer quasi as guerilla fighter, sprays an immediately visible picture on a grey wall with his spraycan.

On the one hand, it is an interesting aspect that the typing armchair assassin has greater freedom than the guerrilla fighter who spreads his colour in the open urban space. On the other hand, it is equally interesting that the graphic gesture created by the activities of the graffiti writer has greater impact than that of the graphic designer. Shouldn't it be the other way around? Does it matter? Does anything matter?

A code is a system of symbols. It's purpose is to facilitate the communication between people. Our alphabets are just codes used for the purpose of making speech visible. One of the first alphabets consisted of hieroglyphs which are now considered to be more pictures than characters (today we would probably speak of pictograms, icons or in the broadest sense, logos). However even the letters of our modern alphabet are only pictures. Their function is to convert spoken language into something humanly readable.

What is the actual situation today? Okay, it's pouring with rain and the telephone keeps on ringing, but this is just marginal! Is it not true that we became the victims of global communication a long time ago? Rich chain stores barrage our day-to-day existence with shrill and lurid neon signs and TV commercials shouting "buy me"! This revolution probably has a much greater influence on our life than we have ever realised! You should study this book that you are now holding in your hands with this in mind and think about it!

Our theory should be that ultimately we Büro Destruct assassins and graffiti guerrilla fighters have the same rhythm, the same harmonies, the same melody. We share the same code and we know: grey makes grey!

Outside it's pouring with rain and inside the telephone is ringing – it's all the same to us. We only have the slightest chance of exerting any influence on all this – on the world!

Hgb Fideljus
Büro Destruct. 2005

FROM THE SCENE. PT1

04.0

Ich glaube, dass es ein echtes Privileg ist, an
dieser noch jungen und einzigartigen Kunstform
teilzuhaben, die sich in stetiger Bewegung befindet
und auf dem Weg ist, Neues zu entwickeln.

CMPONE

04.0

I really believe that it is a genuine privilege to partici-
pate in this still young and very unique art form that is
constantly on the move and on its way to developing
into something new.

CMPONE

. FACTS
CMPONE. Claus Michael Pedersen. *1970

. ARBEITSBEREICHE
. Illustration
. Artdirektion in der Zeitungs- und Werbebranche
. Comicstrips für Zeitungen
. Fachbereichsleiter und Lehrer an einer Jugendschule

. HISTORY
1984 erste Graffitierfahrungen, nachdem kurz zuvor
 CMPSPIN gebildet wurde
1990 Gründung der THESOUTHSIDECREW
1995 Layouter bei der Zeitung Sjaellands Tidende
1997 Layouter bei der Zeitung Naestved Tidende
2000 llustrator und Artdirektor bei BBDO Kopenhagen,
 Dänemark
2002 Artdirektor bei Sjaellandske Medier
2005 Fachbereichsleiter an der Jugendschule Naestved

Anfang 1984 kam ich in Kontakt mit der kreativen
Intelligenz und Energie der ursprünglichen Kultur der
HipHop-Szene. Wie die meisten Teenager habe auch ich
gezeichnet, so dass ich ganz selbstverständlich zum
Graffitiwriting kam. Im gleichen Jahr tat ich mich mit
SPIN05 zusammen und wir gründeten CMPSPIN.
Damals entschlossen wir, unsere Bilder hauptsächlich
auf Geschichten aufzubauen. Manche waren natürlich
erzählerischer als andere.

Obwohl wir jetzt in verschiedenen Ländern leben, lassen
wir Geschichten die Hauptrolle in unserer Arbeit spielen,
um nicht die Abenteuer zu vergessen, die durch Graffiti-
writing entstehen. Mit oder ohne Sprühdose. Fotoapparat.
Pinsel. Oder nur dem Stift.

. KONTAKT. CONTACT

Home. 01
Naestved City. Denmark

. JOB FOCUS
. illustration
. art director in the newspaper and advertising business
. cartoon panels for newspapers
. head of department and teacher at a youth school

. HISTORY
1984 first writing experience shortly after forming
 CMPSPIN
1990 formation of THESOUTHSIDECREW
1995 layouter for Sjaellands Tidende newspaper
1997 layouter for Naestved Tidende newspaper
2000 illustrator and art director at BBDO Copenhagen,
 Denmark
2002 art director at Sjaellandske Medier
2005 head of department at Naestved youth school

Early in 1984 I became attracted to the creative
intelligence and energy of the original HipHop culture.
Like most teenagers I was already into drawing, so it was
only natural that I should become involved with graffiti
writing. In the same year I teamed up with SPIN05 and
we formed CMPSPIN. From then on we decided to base
the composition of most of our paintings on stories.
Naturally, some of these were more story-like than others.

Although we are now living in different countries, we still
choose to let the story play a major role in our work, not
forgetting the adventures to be had with graffiti writing.
With or without the spraycan. The camera. The brush. Or
just the pen.

• 001

• 001 CMP. logo. 2004
• 002 CMP. at work. 1997
• 003 VIEW. from the office. 2004
• 004 CMP. in the office. 2004
• 005 CMP TEGNESTUDIE. CMP drawing studio. logo. 2000

• 002 ++ 003

CMP
tegnestudie

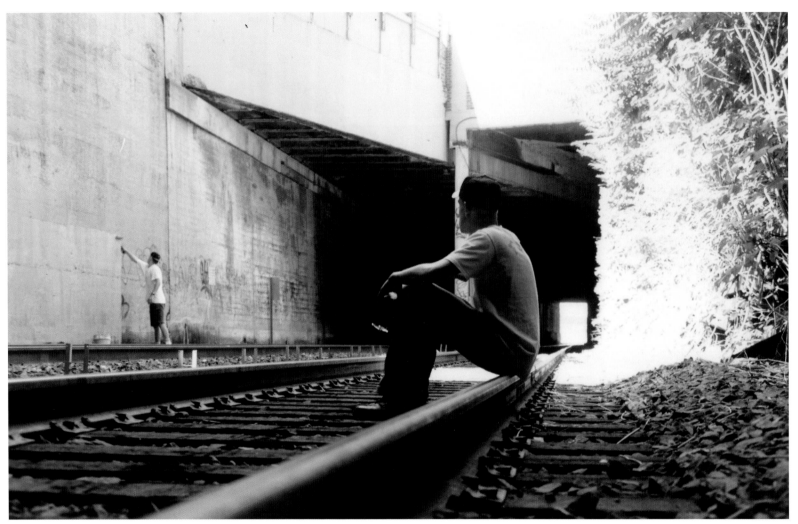

•006

•006 GETTING PREPARED. New York. 1993
Photo: SPINO5

Mitglied der THESOUTHSIDECREW zu sein, bedeutet, mit neuen Ideen konfrontiert zu werden. Es bedeutet, durch neue kreative Lösungen herausgefordert zu werden. Die THESOUTHSIDECREW ist eine multitalentierte Crew aus sieben sehr unterschiedlichen Einzelpersonen, verbunden in tiefer Freundschaft durch Graffitiwriting.

Die Crew ist ein lebendiges Beispiel dafür, dass die Akzeptanz der Unterschiede den Einzelnen stärker macht. Aus diesem Grund glaube ich wirklich, dass es ein echtes Privileg ist, an dieser noch jungen und einzigartigen Kunstform teilzuhaben, die sich in stetiger Bewegung befindet und auf dem Weg ist, Neues zu entwickeln. Das ist gut, weil rohes und unberührtes Graffiti lebendig bleibt. Es ist dauerhaft. Es wird für immer bleiben.

Bis jetzt hat sich mein Fokus also nicht wirklich verändert.

Being a member of THESOUTHSIDECREW means being confronted with new ideas. It means being challenged by new creative solutions. THESOUTHSIDECREW is a multi-talented crew consisting of seven very different individuals who have strong ties of friendship through graffiti writing.

The crew is a living example of how the acceptance of these differences can make each member stronger. This is one of the reasons why I really believe that it is a genuine privilege to participate in this still young and very unique art form that is constantly on the move and on its way to developing into something new. This is good because raw and untouched graffiti is alive. It is very enduring and will be here forever.

So far my focus has not really changed.

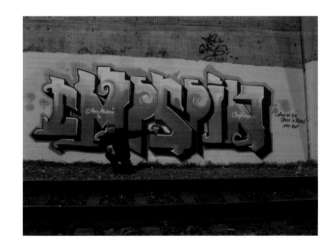

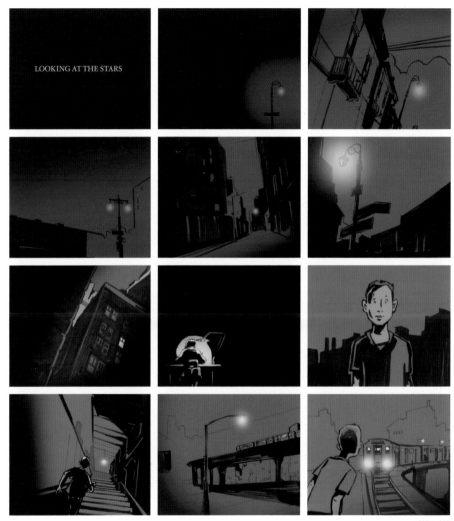

LOOKING AT THE STARS

•007

•008 ++ 019

•007 CMPSPIN. mural. at the Basle line. 2004
•008 ++ 019 LOOKING AT THE STARS. screenshots. 2004
see the film on FADINGS DIGITAL

•020

•020 LIVE THE ADVENTURE. New York. 1992
Photo: CmpOne

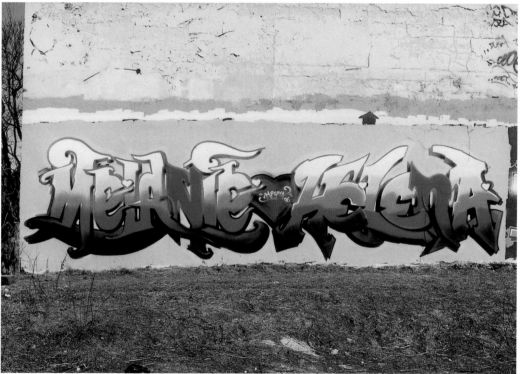

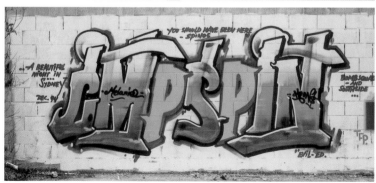

•021 CMP. mural. 1992
•022 CMPSPIN. mural. 1992
•023 CMPSPIN. mural. Sydney. Australia. 1994

•024 MELANIE. mural. 1996
•025 MELANIE/HELENA. mural. 1996

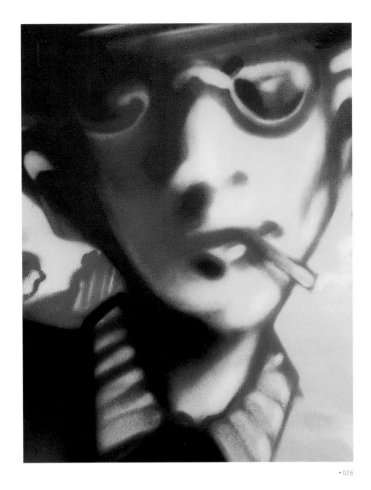

• 026

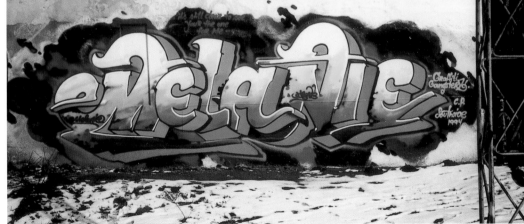

• 027 + 028

• 026 CHARACTER. canvas. detail. 2000
• 027 CMPSPIN. mural. Australia. 1994
• 028 MELANIE. mural. 1994

. PROJEKT
LIVING WALLS

. KUNDE
Montana Furniture

. BESCHREIBUNG
Die sehr weltoffene und geachtete dänische Möbelfirma
Montana lud 1997 elf Graffitiwriter aus den Vereinigten
Staaten, Frankreich und Dänemark ein, an einem Experi-
ment teilzunehmen. Insgesamt 612 Quadratmeter
Montana-Möbel wurden dekoriert und in Städten wie
Odense, Aalborg, Kopenhagen, Reykjavik, Lillehammer,
Paris, Berlin, London und Zürich als eine Quelle von
Inspiration und Provokation ausgestellt.

Das Aufeinandertreffen von „quadratischen" Designer-
möbeln und graffitibezogenen Bildern funktionierte
ganz gut.

. PROJECT
LIVING WALLS

. CLIENT
Montana Furniture

. DESCRIPTION
In 1997, Montana, a very open-minded and much
respected Danish furniture company invited eleven graffiti
writers from the United States, France and Denmark
to participate in an experiment. A total of 612 square
metres of Montana furniture was decorated and exhibited
in Odense, Aalborg, Copenhagen, Reykjavik, Lillehammer,
Paris, Berlin, London and Zurich to serve as a source
of inspiration and provocation.

The encounter between „design-square furniture" and
graffiti-related images was quite successful.

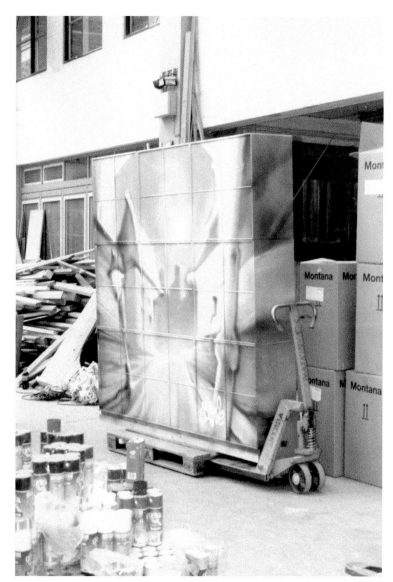

•029 ++ 030

•031

•029 ++ 031 MONTANA FURNITURE. 1997

SIGN Of The Times

. PROJEKT
SIGN OF THE TIMES

. KUNDE
PÅ GADEN TAGESZEITUNG

. BESCHREIBUNG
Der Comicstrip SIGN OF THE TIMES passt mit vielen
meiner Wand- und Leinwandbilder zusammen. Der visuelle
Ausdruck ist wohl anders, aber viele Themen stammen
aus meinem Graffitiwriting-Hintergrund.

Es ist eine permanente Herausforderung, die Werkzeuge
des grafischen Geschichtenerzählens zu beherrschen
und Geschichten an ein großes Publikum zu liefern.
Man weiß nie, wie sehr man den Leser ergriffen hat. Da
musst du dich einfach auf deinen Instinkt verlassen. Ich
konnte nie gut Witze erzählen. Deshalb erscheinen meine
Comicstrips auch nicht auf den Witz-Seiten der Zeitungen.
Sie sind eher Zeitdokumente. Aller Zeiten. Sie zeigen,
ob die Zeiten hektisch sind; oder verrückt. Und natürlich
nicht zu vergessen – sie zeigen auch, wenn die Zeiten
einfach wundervoll sind.

SIGN OF THE TIMES ist genau das, was der Name sagt.
Daher ist es für mich eine ausgezeichnete Plattform,
über jedes Thema nachzudenken, das mir gefällt. Dabei
konzentriere ich mich auf die Fragen, die man sich selber
öfter über die Umstände des ganz normalen Alltags, in
der Nachbarschaft und über die globalen Umstände stellt.
Das Ziel ist es, einfach die Wahrheit zu zeigen. Das
bedeutet, Fragen zu stellen, ohne Anweisungen zu geben,
wie nach deiner Meinung andere Menschen ihr Leben
führen sollten.

. PROJECT
SIGN OF THE TIMES

. CLIENT
PÅ GADEN NEWSPAPER

. DESCRIPTION
The cartoon panel SIGN OF THE TIMES resembles many
of my wall paintings and canvases. The visual expression
is somewhat different but a lot of the subjects come from
my background as a graffiti writer.

The ongoing challenge is to learn the tools of graphic
storytelling, and deliver stories to a large audience. You
never know how well you grip the reader. You just have
to trust your instinct. I was never good at telling jokes
so the cartoon does not appear in the "funny pages".
It is more of a documentation of the times we live in.
Any times. It depicts the times when they are turbulent
or when they are crazy and of course, when they are
wonderful.

SIGN OF THE TIMES is exactly what the name says.
Therefore, I can use it as a perfect platform to reflect
on any theme I choose. I do this by concentrating on the
questions that one often asks oneself about common
everyday situations in the local neighbourhood or situati-
ons all over the world. The goal is just to show the simple
truth. This means asking questions without giving others
instructions on how you think they should live their lives.

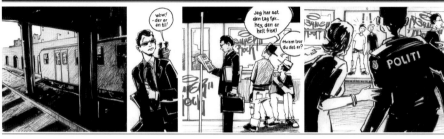

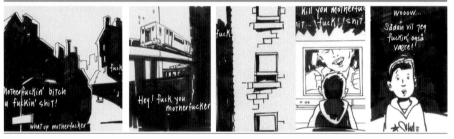

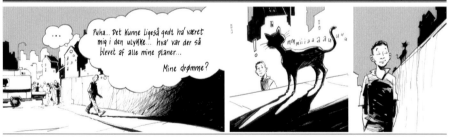

• 032 ++ 034

- - - - - - - - - - - - - - - -
• 032 KLICHÉ. 2003
• 033 FUCKIN' GENERATION. 2003
• 034 ET LIV EFTER DØDEN?. 2004

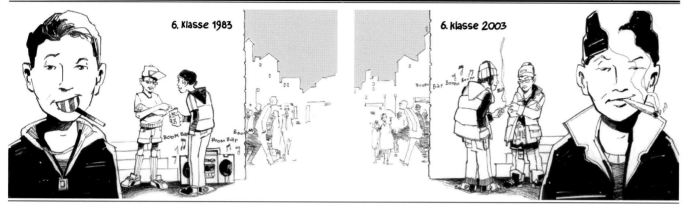

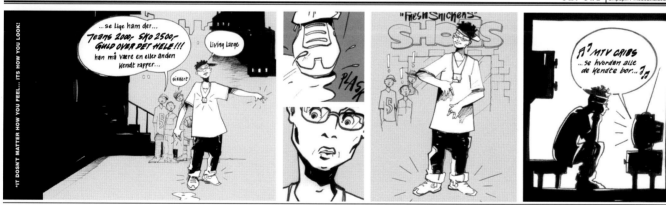

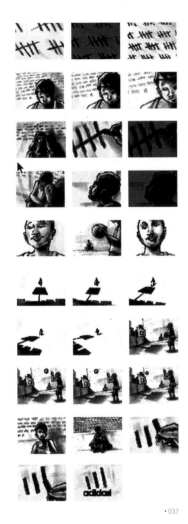

• 037

• 038

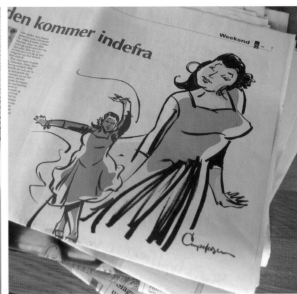

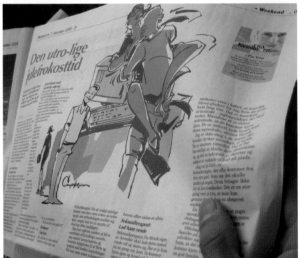

• 039 + 040

• 037 STORYBOARD. 2001
• 038 + 040 ILLUSTRATIONS. various editorial illustrations
for danish newspapers. 2004

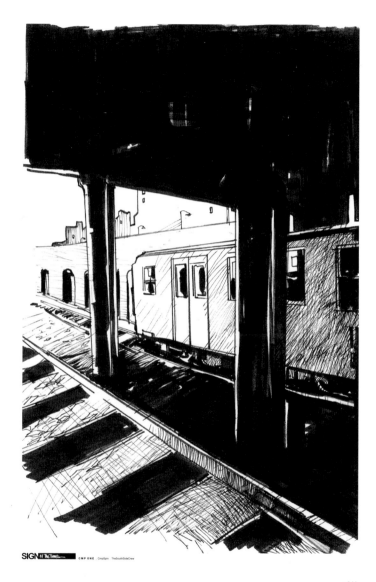

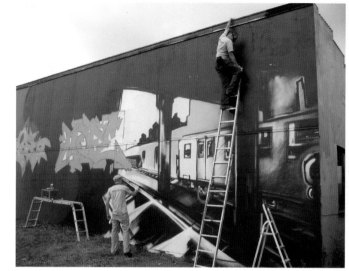

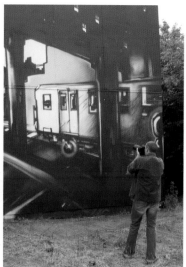

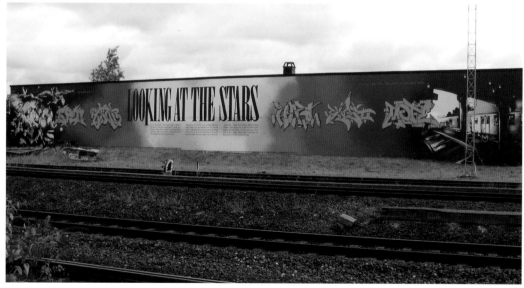

•041 SIGN OF THE TIMES. drawing. 2003
•042 + 044 LOOKING AT THE STARS. THESOUTHSIDECREW. mural. 2003

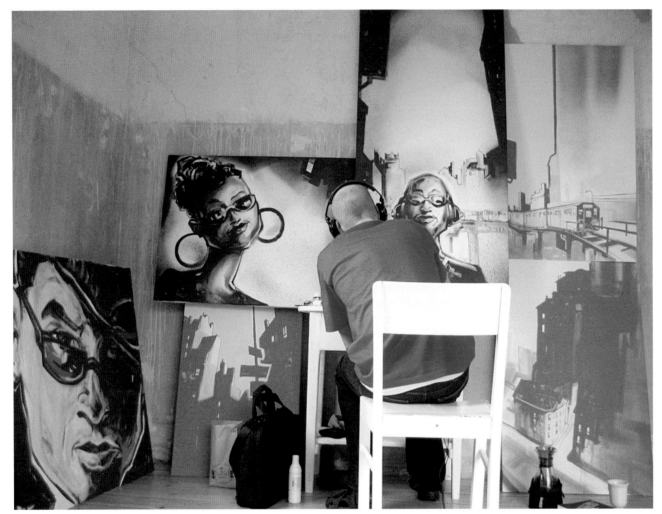

• 045

• 045 ATELIER. 2004

•046 ÷ 048

•046 IT'S ELECTRIC. canvas. 2004
•047 ROCK THE ROOFTOP. canvas. 2004
•048 CAN YOU FEEL IT?. canvas. 2004

. PROJEKT
LINES. Ausstellung in der Galerie K 31.
Lahr. 2004

. BESCHREIBUNG
ECB, MR. GREEN und ich taten uns zusammen, um mit
60 Leinwänden in der Galerie K 31 eine Ausstellung
zu gestalten, die auf sehr unterschiedlichen und sehr
emotionalen Bildern basierte. Wir mussten uns einen Titel
ausdenken, der stark genug war, diese Unterschiede
zu umfassen. Der einfache Titel LINES war genau das,
was wir suchten. Der Künstler DARE hat die Ausstellung
gut koordiniert und eine gedankenvolle Eröffnungsrede
gehalten.

Obwohl ich nie gerne an Ausstellungen teilnehme,
muss ich wirklich feststellen, dass mich der Event sehr
inspiriert hat und dass ich dort viel gelernt habe.

. PROJECT
LINES. Exhibition at the K 31 Gallery.
Lahr. Germany. 2004

. DESCRIPTION
60 canvases, ECB, MR. GREEN and I joined forces at the
K 31 Gallery to create an exhibition based on very
different and very emotional images. We had to think of
a title powerful enough to embrace these differences.
Something as simple as LINES was exactly what we
were looking for. The exhibition was well coordinated by
the artist DARE, who also held a very reflective opening
speech.

Although I never really enjoy participating in exhibitions,
I certainly believe that this show gave me a lot of inspira-
tion and that it taught me a great deal.

•049

•050

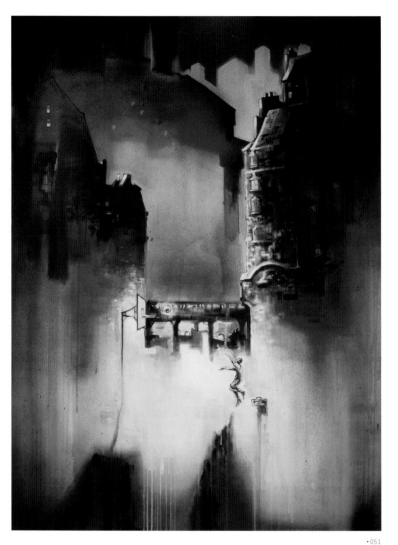

•051

•049 ELEVATED BEATS. canvas. 2004
•050 IT WAS JUST BEFORE MIDNIGHT. canvas. 2004
•051 DREAMING. 2004

. Ich werde weiter an der Gestaltung so vieler Bilder
arbeiten, dass sie dazu ausreichen, eine Stadt voll
erzählerischer Gefühle und Abenteuer zu bauen.

. I will continue to work on the creation of enough
images to build a city filled with narrative emotions
and adventures.

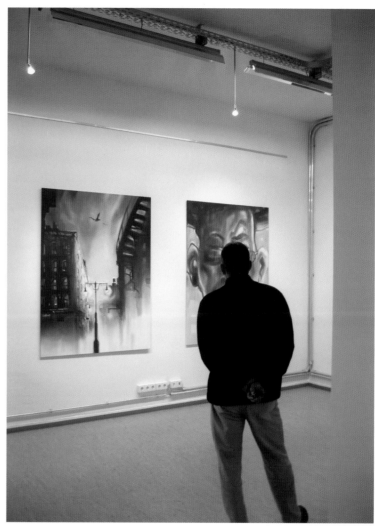

• 052

Ich bin mir sicher, dass es noch viele Dinge, Oberflächen und Ideen zu entdecken gibt; jede mit ihren eigenen Grenzen, die es von Graffiti-künstlern zu brechen gilt.

ZEDZ

I am sure that there are many things, surfaces and ideas to be explored, all with their own boundaries which are about to be torn down by graffiti artists.

ZEDZ

. FACTS
ZEDZ. *1971

. ARBEITSBEREICHE
. Grafikdesign
. Illustration
. Modedesign
. Graffitikunst
. Architektur
. Neue Medien
. Malerei
. Skulptur- und Produktdesign

. HISTORY
1985 Beginn mit Graffiti
1998 Abschluss an der Gerrit Rietveld Art Academy
in Amsterdam, Niederlande, seitdem sowohl auf
künstlerischer als auch auf kommerzieller
Basis tätig

Ich habe im Alter von 14 Jahren mit Graffiti angefangen.
Zu diesem Zeitpunkt hatte ich noch keine Ahnung, wo
mich dies einmal hinbringen würde und keine Idee davon,
wie sich die Graffitibewegung verändern würde. Mit fort-
schreitender Zeit nahm ich mein Hobby immer ernster;
ich wollte, um den Reiz nicht zu verlieren, das, was ich
machte, richtungsweisend beeinflussen.

Die Zusammenarbeit mit einer Reihe von Spezialisten aus
verschiedenen Bereichen, wie z.B. Architekten, Web-
designern und anderen, ermöglicht es dauerhaft den
kreativen Ausdruck neu zu entdecken und auszuweiten.

. KONTAKT. CONTACT

Home. 01
Amsterdam. Netherlands

Home. 02
http://www.zedz.org

. JOB FOCUS
. graphic design
. illustration
. fashion design
. graffiti art
. architecture
. new media design
. painting
. sculpture and product design

. HISTORY
1985 started writing
1998 graduated from the Gerrit Rietveld Art Academy
in Amsterdam, Netherlands, since then working
on a personal and commercial level

I started to write graffiti at the age of fourteen. At the
time I had no idea where this would lead me or where
this movement would go. In the course of time my hobby
became more serious and I wanted to give it a direction
to keep it interesting.

By collaborating with a range of professionals from diffe-
rent disciplines such as architects, artists, web designers
etc. I am constantly exploring and expanding my means
of creative expression.

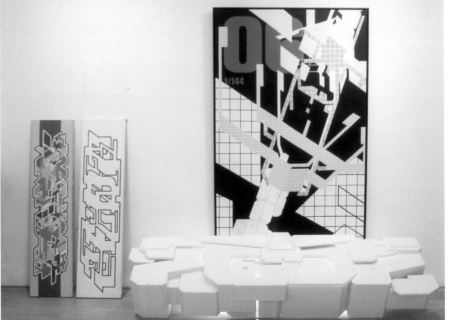

• 001 ++ 003

- - - - - - - - - - - - - - - - -
• 001 ZEDZ. 2004
• 002 ++ 003 JOLLIJST EXHIBITION. Amsterdam. Netherlands. 2004

Ich sehe Graffiti als Tattoos auf der Haut der Stadt. Natürlich gibt es einen typischen Graffitistil – der, der meiner Meinung nach am nähesten am ursprünglichen Graffiti dran ist. Daneben sehe ich aber auch eine stilistische Entwicklung, die eine weitgefächertere Auslegung der Graffitiessenz verfolgt, mit großem Freiraum für Experimente, neue Formen und Formate.

I consider graffiti to be the tattoos on the skin of the city. Of course, there is a typical graffiti style, which I perceive as being the original graffiti. Besides that I see a stylistic development which calls for a wider interpretation of the concept of graffiti and has a lot of space for experiments, new forms and formats.

· 004 ++ 009

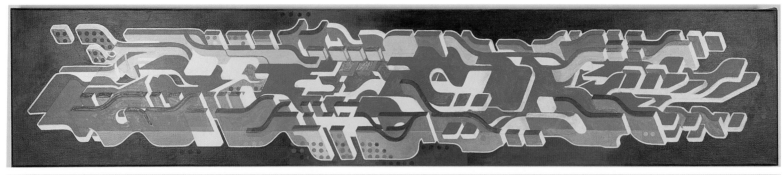

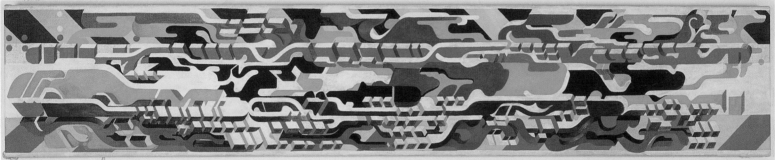

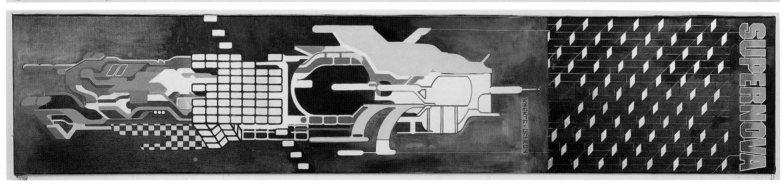

• 010 ++ 012

- 010 RONI SIZE. acrylics on canvas. 180cm x 35cm. 1998
- 011 AUTECHRE. acrylics on canvas. 175cm x 30cm. 1998
- 012 SUPERNOVA. acrylics on canvas. 200cm x 40cm. 1998

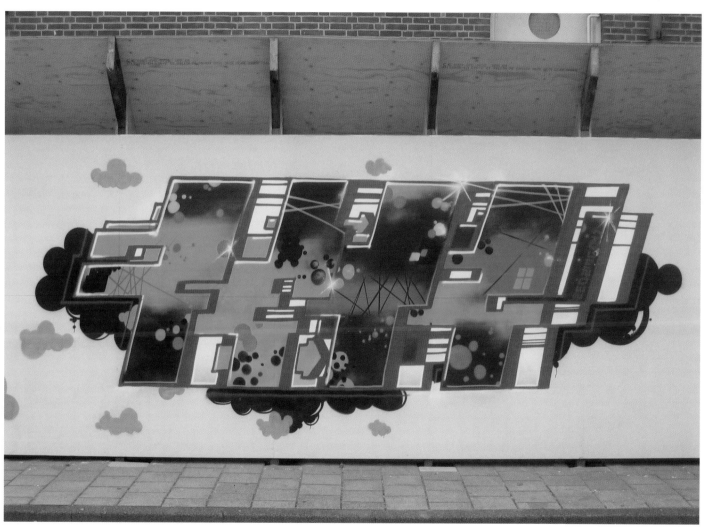

•013

- - - - - - - - - - - - - - - - - -
•013 ZEDZ. mural. 2004

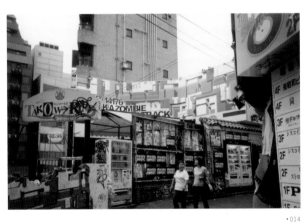

• 014

• 015 ‖ 016

• 014 SHAKKAZOMBIE. sticker (4.5m x 18m). Tokyo. Japan. 2001
• 015 ‖ 016 SHAKKAZOMBIE. logo and mirror image
 for a Japanese HipHop band. 2001

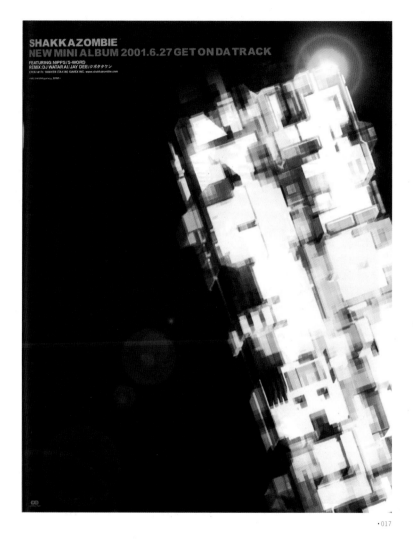

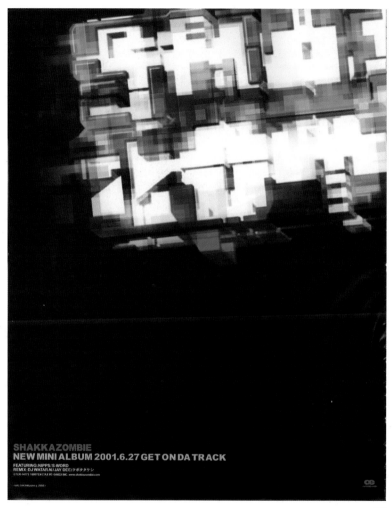

•017 + 018 SHAKKAZOMBIE. commercials. created by a Japanese agency. 2001

•019

•020

•019 + 020 TRANSFORMFONT. font that served as basis for
SHAKKAZOMBIE design. 2001

. KUNDE
SWAGGER

. BESCHREIBUNG
Dieses Buchstabenobjekt entstand für eine Kooperation
mit dem japanischen Modelabel swagger™ (Tokio). Das
Artwork basiert auf der Idee, eine Skulptur zu gestalten,
welche als Kleiderregal funktioniert, die Kleidung gleich-
zeitig aber auch zur Schau stellen soll. Das Ergebnis
dieses Ansatzes war, dass das Design auch auf eine
Kleiderserie gedruckt wurde – platziert an ungewöhnli-
chen Stellen.

. CLIENT
SWAGGER

. DESCRIPTION
This letter-object was developed for a collaboration pro-
ject with the fashion label swagger™ (Tokyo). The artwork
is based on the idea of making a sculpture that could
serve as a clothing rack and also be used to display the
clothes. As a result of this idea the design was printed in
unexpected places on a whole collection of clothes.

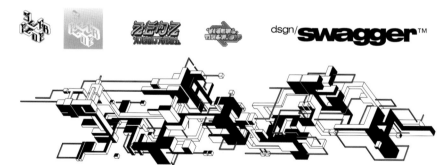

dsgn/**swagger**™

• 021

• 022 ++ 025

• 021 ++ 025 SWAGGER. assignment for an
advertising campaign. 2004

. PROJEKT
PIETER VAN ULDEN. Ausstellung in der Galerie Pieter van Ulden. Leiden. Niederlande. 2002

. BESCHREIBUNG
Die Arbeit, die ich für diese Ausstellung gestaltet habe, beschäftigt sich damit, wie das über Eck gemalte Bild in seiner Wirkung, gegenüber einer Umsetzung auf einer ebenen Oberfläche, beeinträchtigt wird. Es ist eine Studie, wie ich in einem Raum arbeiten möchte und über den Gebrauch der isometrischen Perspektive im Kontext eines dimensionalen Raumes.

. PROJECT
PIETER VAN ULDEN. exhibition at the Pieter van Ulden Gallery. Leiden. Netherlands. 2002

. DESCRIPTION
My work for this exhibition deals with the subject of how the effect of a picture is impaired when it is painted over a corner in comparison to being painted on a flat surface. It is a study on how I would like to work in a space and on the use of isometric perspective in the context of dimensional space.

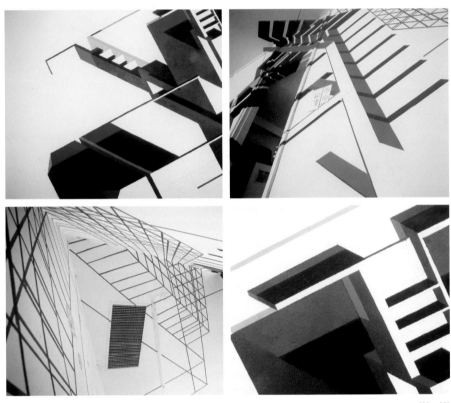

• 026 ++ 029

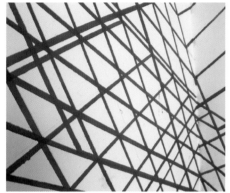

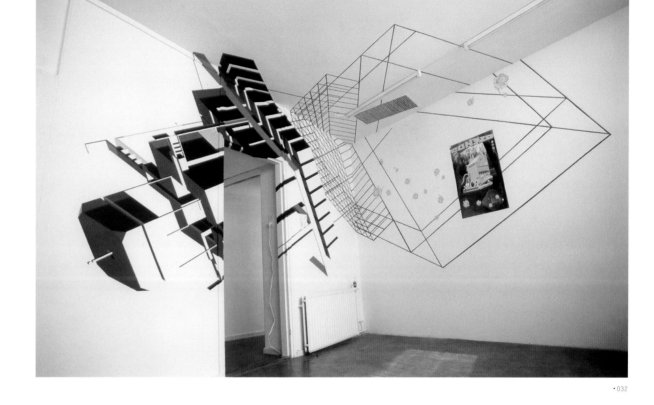

• 030 + 031

• 032

- - - - - - - - - - - - - - - - -
• 026 + 032 PAINTING. at the Pieter van Ulden Gallery.
acrylics on wall. Leiden. Netherlands. 2002

. PROJEKT
HAPPY CHAOS/STATE OF THE ART. Ausstellung bei Felix
Meritis, Zentrum für Kunst und Wissenschaft.
Amsterdam. Niederlande. 2004

. BESCHREIBUNG
Dies ist eine Arbeit, die speziell für eine zweitägige
Tagung angefertigt wurde. Die Grundlage sind auf Fenster
aufgebrachte, transparente Aufkleber. Der Gedanke ist,
diese Aufkleber als Basismaterial zu verwenden, welches
sich gut dazu eignet, jederzeit und sehr schnell neue
Kompositionen zu kreieren. Das ist wie "copy & paste"
am Rechner – nur dass es im wirklichen Raum geschieht.

Das Bild zeigt ein großes Gebilde, welches den Beobach-
ter in die Lage versetzt, es als große Struktur draußen
auf der Straße, durch das Fenster hindurch, anstatt auf
diesem aufgeklebt, wahrzunehmen.

. PROJECT
HAPPY CHAOS/STATE OF THE ART. exhibition at Felix
Meritis, Centre for Arts and Sciences. Amsterdam.
Netherlands. 2002

. DESCRIPTION
This is a project that was especially prepared for a con-
ference lasting two days. The basic material consists of
a transparent sticker applied to the surface of a window.
The idea of this sticker is to provide a basic material with
which new compositions can be rapidly created at any
time. It is similar to the computer "copy & paste" method,
except that it is in real space.

The image shows a large structure that enables the
viewer to see it through the window as if it were outside
the building and not stuck onto the inside of the window.

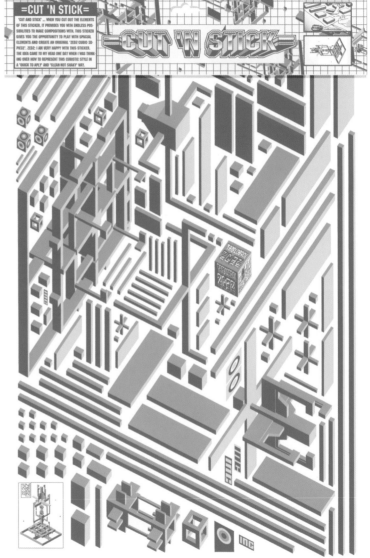

•033

•034

05.4

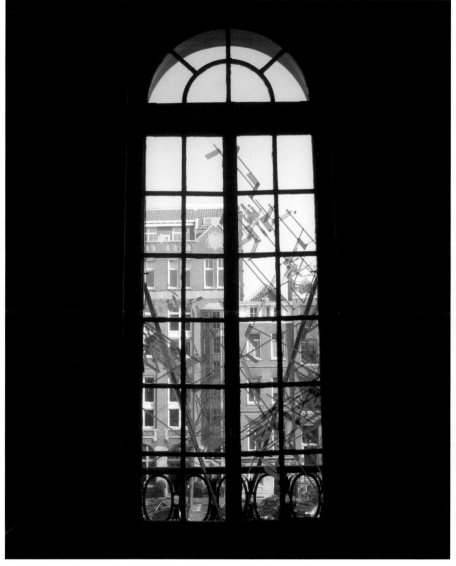

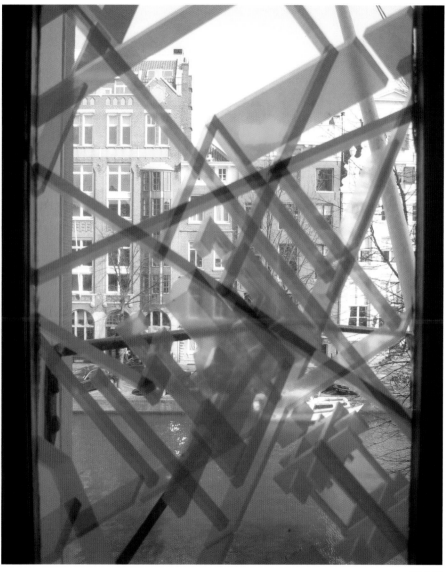

• 035 ++ 036

• 033 ++ 034 CUT 'N STICK. stickers. 2004
• 035 ++ 036 HAPPY CHAOS/STATE OF THE ART. stickers on windows at
Felix Meritis. Amsterdam. Netherlands. 2004

. PROJEKT
ZEDZBETON

. BESCHREIBUNG
Das ZEDZBETON Projekt ist das Ergebnis der Zusammenarbeit zwischen Maurer United Architects (MUA) und ZEDZ. MUA wollten zu der Zeit mit Graffitikünstlern zusammenarbeiten, als ich auf der Suche nach Architekturelementen war, die man in Graffiti einbinden konnte. ZEDZBETON 2.0 ist eine Anregung für eine Art „Stadtmöbel", das über 40 Meter lang, acht Meter breit und vier Meter hoch ist. Das Objekt ist Auszug und Modifikation aus einem meiner ersten isometrischen 3D-Designs (1996).

Der Gedanke ist ein Realraum-Graffiti, was als Objekt für alle möglichen Arten von Straßenaktivitäten, wie das Genießen eines Essens im Freien, rumhängen, Skateboard fahren und Graffiti malen, dienen soll.

. PROJECT
ZEDZBETON

. DESCRIPTION
The ZEDZBETON project is the result of a cooperation between Maurer United Architects (MUA) and ZEDZ. At the time MUA wanted to collaborate with graffiti artists while at the same time I was looking for architectural elements that could be integrated into graffiti. ZEDZBETON (2.0) is a proposal for a "piece" of "city furniture" of about 40 meters length, 8 meters width and 4 meters height. The object resulted from the extraction and modification of one of ZEDZ's first isometric 3D designs (1996).

The idea is to create a real space graffiti that can serve as an object for all kinds of urban activities such as enjoying an outside lunch, hanging around, skateboarding and writing graffiti.

•037

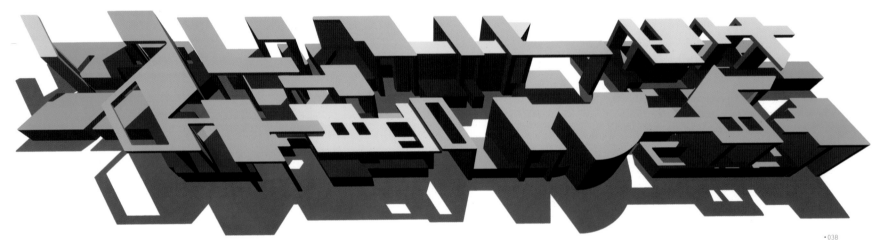

•038

•037 ZEDZBETON 3.0. proposal. 2003
•038 ZEDZBETON 2.0. proposal. 2003

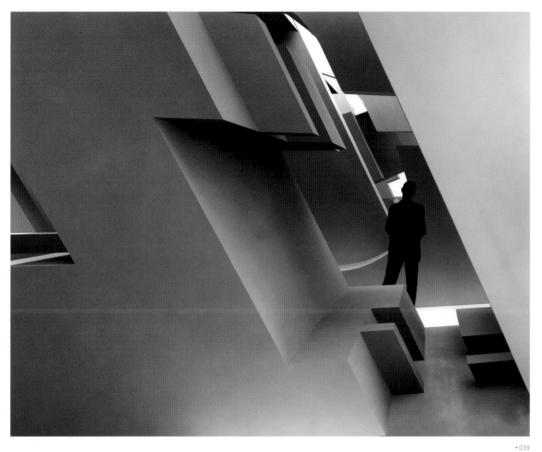

•039

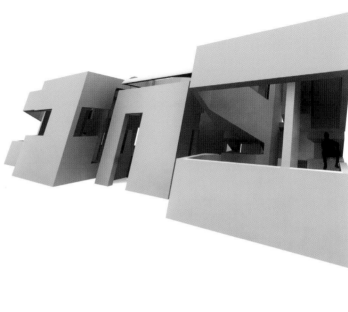

•040 ++ 041

•039 ZEDZBETON 3.0. inside. 2003
•040 ++ 041 ZEDZBETON 3.0. various views. 2003

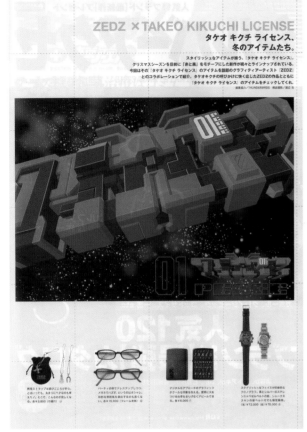

ZEDZ ×TAKEO KIKUCHI LICENSE

タケオ キクチ ライセンス、
冬のアイテムたち。

スタイリッシュなアイテムが揃う「タケオ キクチ ライセンス」。
クリスマスシーズンを目前に「赤と黒」をモチーフにした新作が続々とラインナップされている。
今回はその「タケオ キクチ ライセンス」のアイテムを話題のグラフィティアーティスト「ZEDZ」
とのコラボレーションで紹介。タケオ キクチの呼びかけに快く応じたZEDZの作品とともに
「タケオ キクチ ライセンス」のアイテムをチェックしてくれ。
編集協力/THUNDERBIRDS 構成撮影/宮江 浩

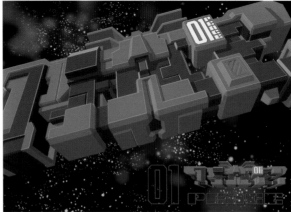

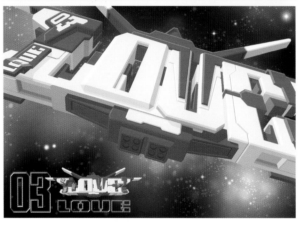

•042

•043 ┼ 044

•045 ┼ 046

•042 ZEDZxTAKEO KIKUCHI. free work used for a Takeo Kikuchi
commercial. 2004
•043 PEACESPACE. 3D letter images. 2004
•044 LOVESPACE. 3D letter images. 2004
•045 UNITYSPACE. 3D letter images. 2004
•046 HAVINGFUNSPACE. 3D letter images. 2004

Sowohl die Kombinationen von, als auch die Spannungen zwischen Graffiti und Design sind sehr interessant für mich. Ich mag es zu sehen, wie sich Dinge ändern und sich auf andere Stufen begeben. Ich mag es, von neuen und innovativen Arbeiten überrascht zu werden.

Ich bin mir sicher, dass es noch viele Dinge, Oberflächen und Ideen zu entdecken gibt; jede mit ihren eigenen Grenzen, die es von Graffitikünstlern zu brechen gilt. Ich glaube, das ist der Gedanke von Graffiti. Es gibt keine Regeln darüber, welche Untergründe ein Künstler bemalen darf und welche nicht. Es gibt keine Grenzen bezüglich Größe, Style, Position. So lange etwas hervorsticht, spricht es mich an. Die Kunstform Graffiti bietet jedem Interessierten Zugang. Graffiti gemixt mit anderen Disziplinen kann für den Designbereich sehr interessant sein, weil Graffiti auch sehr kompromisslos sein kann. Damit steht sie im Gegensatz zu vielen anderen Disziplinen.

I have always been very interested in the combination of graffiti and design and the tension there is between them. I like to see how things change and move to other levels. I like to be surprised by seeing new and innovative work.

I am sure that there are many things, surfaces and ideas to be explored, all with their own boundaries which are about to be torn down by graffiti artists.
I think the meaning of graffiti is this; there are no rules governing the types of surface which an artist can or cannot paint. There are no limitations of size, style or position. Anything that stands out attracts me. As an art form graffiti can be practised by anybody who wants to join in. Combining graffiti with other disciplines offers fascinating perspectives in the field of design because graffiti can be very uncompromising. In this it stands in contrast to many other disciplines.

• 047

• 047 JUKEPROCESS. proposal for a juke box based on letters. wood. 2004

06.0

„STYLE IS THE MESSAGE" ist unsere Definition und Philosophie von Graffiti, weil die einzige Botschaft, die wir in unseren Arbeiten mitteilen wollen, unser Style ist.

123KLAN

06.0

"STYLE IS THE MESSAGE" is our philosophy and definition of graffiti because the only message we want to share in our pieces is our style.

123KLAN

WHEN THE STREETKNOWLEDGE MEETS TECHNOLOGY
AND GRAFFITI MELTS WITH GRAPHIC DESIGN.

. CREW
KLOR. *1972
SCIEN. *1974

. ARBEITSBEREICHE
. Logodesign
. Characterdesign
. Illustration
. Poster- und Flyergestaltung
. Stickerdesign
. T-Shirt-Design

. HISTORY
1989 SCIENs erstes Graffiti
1992 KLORs erstes Graffiti
1992 Gründung von 123KLAN als Graffiticrew
1995 erste Aufträge für grafische Arbeiten

Für 123KLAN als Graffiticrew ist es am wichtigsten, alle Weggefährten im gegenseitigen Vertrauen zu vertreten. 1994 haben wir unsere ersten Vektorschritte mit Illustrator 5 auf einem Macintosh performa 7500 unternommen.

Andere Designer wie Neville Brody ermutigten uns, Grafiken in ihrem Sinne als etwas Schönes, Anziehendes und Kreatives zu entwerfen. Brody ist wahrscheinlich einer der Ersten, der zeigte, dass sich Grafikdesign nicht nur auf Anzeigen oder Produktwerbung beschränkt, sondern darüber hinaus noch deutlich ansprechender und schöner sein kann.

1999 heirateten wir – manchem mag unsere Hochzeit eher wie eine Graffitijam erschienen sein – aber wir haben uns damals alle bestens unterhalten und tun es heute noch.

. JOB FOCUS
. logo design
. character design
. illustration
. poster and flyer design
. sticker design
. T-shirt design

. HISTORY
1989 SCIEN's first piece
1992 KLOR's first piece
1992 foundation of 123KLAN as a graffiti crew
1995 first commissioned graphical works

The main thing for 123KLAN as a graffiti crew is the representation of all like-minded people in mutual trust. We undertook our first vector steps in 1994 on a Macintosh performa 7500 by using Illustrator 5.

Designers like Neville Brody motivated us to create graphics by adopting their attitude which meant creating something that looks good, attractive and original. Brody is probably one of the first to demonstrate that graphic design is not solely a medium for advertising, promoting or selling something. It can do all of these things simultaneously but in a far more pleasant and beautiful way.

We married in 1999 – although to some people it may have looked more like a graffiti jam than a wedding – but we all had a good time then and we still have.

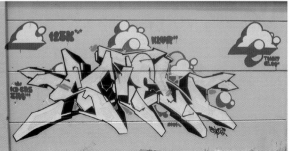

•001 LOGO. 2004
•002 KLOR. 2004
•003 SCIEN. 2004
•004 WANE(NYC)/KLOR/SCIEN. 2004
•005 DAM/WANE/SCIEN. mural. Lille. France. 2004

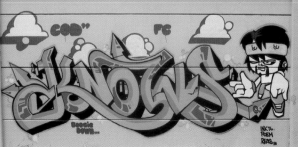

•006 + 011

. STYLE IS THE MESSAGE
Das ist unsere Definition und Philosophie von Graffiti,
weil die einzige Botschaft, die wir in unseren Arbeiten
mitteilen wollen, unser Style ist. Wir malen hauptsächlich
zu unserem eigenen Vergnügen in einem klassischen Stil
– Schriftzug, Figur, Schriftzug. Gerne ergänzen wir unsere
Arbeiten mit grafischen Komponenten, wie zum Beispiel
kleinen Logos oder kleinen vektorähnlichen Formen.

. STYLE IS THE MESSAGE
This is our philosophy and definition of graffiti because
the only message we want to share in our pieces is our
style. We mostly paint for our own pleasure in a classical
style – style, character, style. We also like to add some
graphic elements to our pieces, such as small logos
or vector-like shapes.

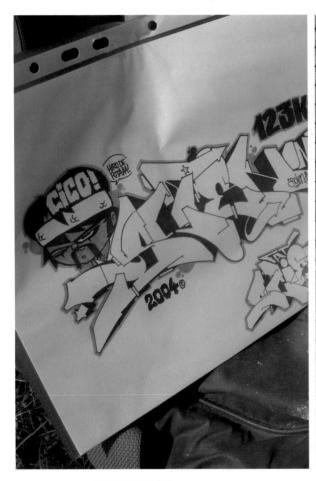

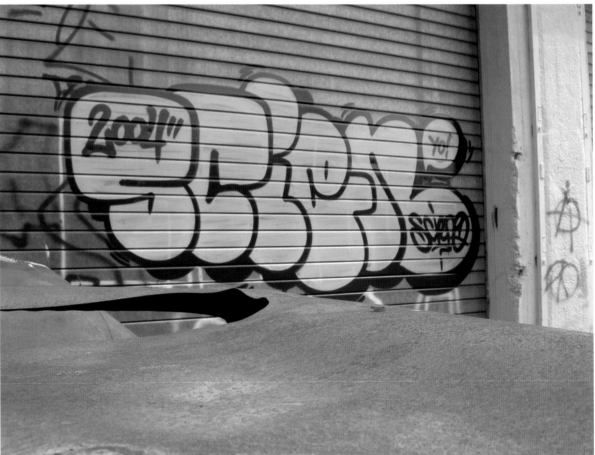

• 012 ++ 013

- - - - - - - - - - - - - - - - -
• 012 SCIEN. sketch. 2004
• 013 SCIEN. Throw-Up. Lahr. Germany. 2004

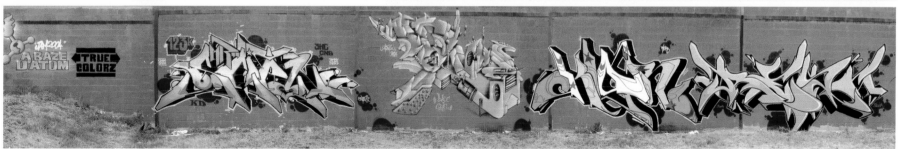

•014 SC. Throw-Up. Lille. France. 2003
•015 KLOR. mural. Lahr. Germany. 2004
•016 123K. mural. detail. 2004
•017 SCIEN. mural. Lille. France. 2004
•018 SCIEN/KLOR. mural. Lille. France. 2004
•019 SCIEN/ATOME/KLOR/RESO. mural. Lille. France. 2004

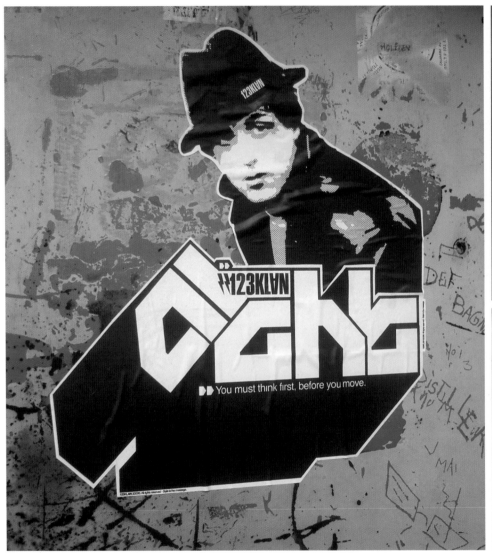

• 020 ++ 023

• 020 ++ 023 AIGHT. various posters. 2004

•024 POSTERS. various. 2004
•025 POSTERS. kitchen93/exhibition. Paris. France. 2004

•026

•027

- - - - - - - - - - - - - - - - - - -
•026 ILLUSTRATION. ALERGIA book. Spain. 2004
•027 THE NEW DEAL. 3D character design in collaboration with
Baptiste Jaquemet. 2004
check: http://thenewdealmusical.free.fr

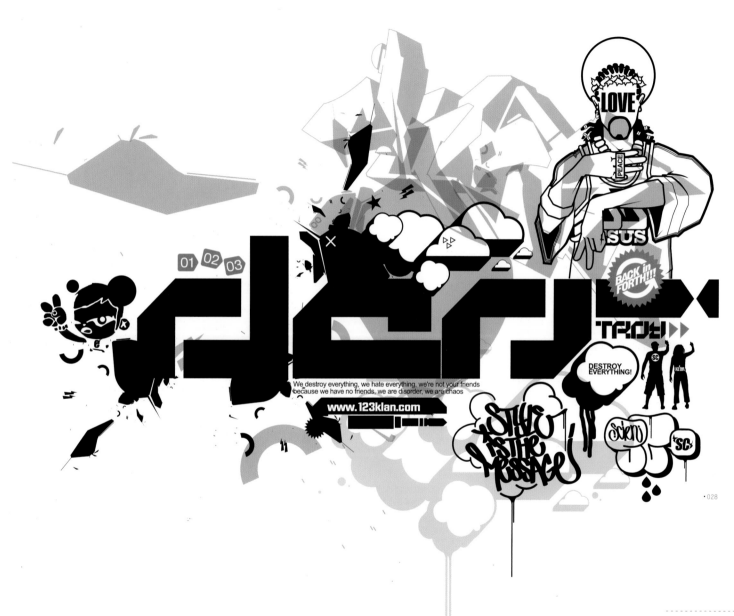

We destroy everything, we hate everything, we're not your friends because we have no friends, we are disorder, we are chaos

www.123klan.com

DESTROY EVERYTHING!

• 029

Recycle your environement Recycle your environement

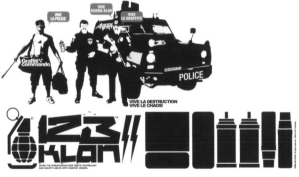

• 030

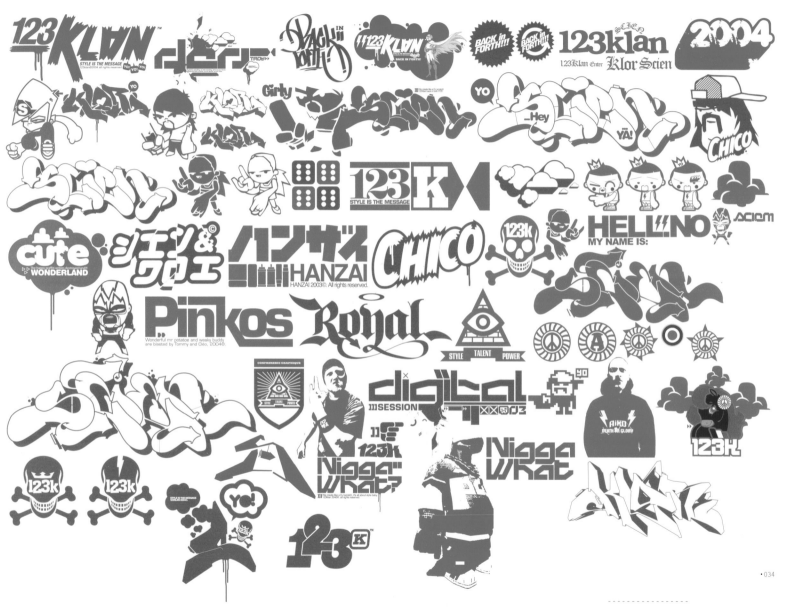

• 034

• 034 VARIOUS LOGOS. self promo and client work. 2003-2004

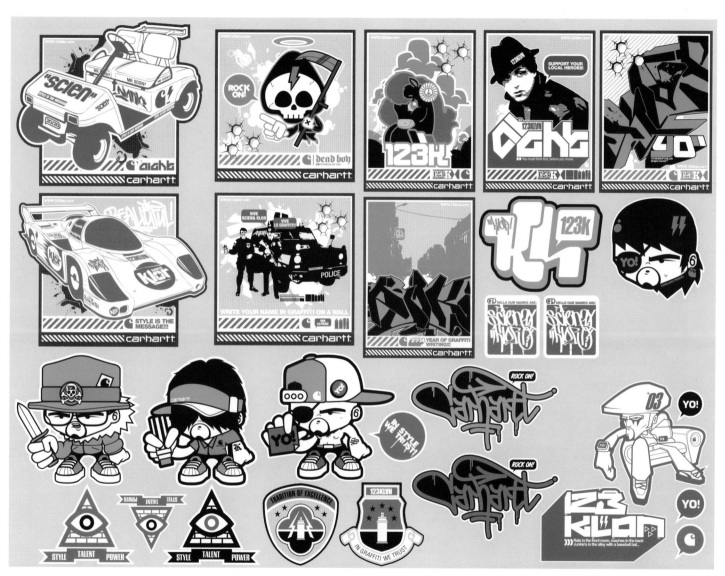

•035 VARIOUS STICKERS. carhartt Europe. 2004

.PROJEKT
IdN MY FAVOURITE CONFERENCE. Singapur. 2004

.BESCHREIBUNG
IdN MY FAVOURITE CONFERENCE war eine große Design-
konferenz, die von IdN (International designers Network
magazine) aus Hong Kong, China, organisiert wurde. Wäh-
rend der Tagung wurden die Künstler gebeten, in Zusam-
menarbeit Entwürfe für T-Shirts und grafische Poster zu
gestalten. Die Ergebnisse dieser Kooperationen wurden
während der gesamten Tagungsdauer im Konferenzsaal
ausgestellt.

.PROJECT
IdN MY FAVOURITE CONFERENCE. Singapore. 2004

.DESCRIPTION
IdN MY FAVOURITE CONFERENCE was a big graphic
design conference organised by IdN (International
designers Network magazine) from Hong Kong, China.
During this event artists were asked to collaborate
and develop a T-shirt design and a graphical poster.
The results were exhibited in the main hall throughout
the whole conference.

FRONT BACK

FRONT BACK

FRONT BACK

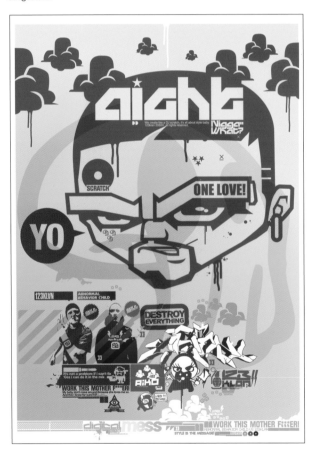

•036

•037

•036 + 037 POSTER/T-SHIRTS. realised during IdN MY FAVOURITE
CONFERENCE. Singapore. 2004

06.3

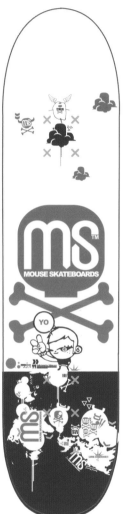
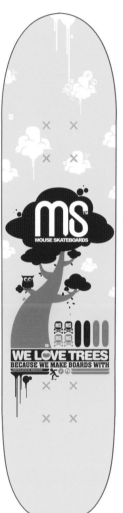
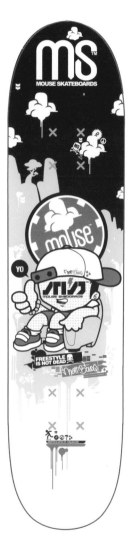
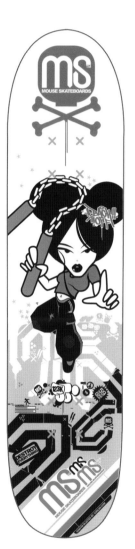

• 038 ++ 043

• 038 ++ 043 MOUSE SK8BOARDS. various designs for
Mouse sk8boards. 2004

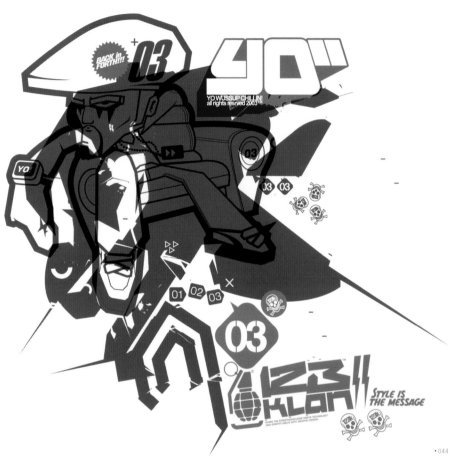

• 044

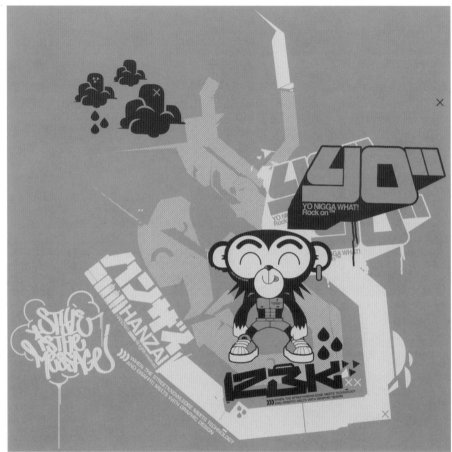

• 045

• 044 GRAPHIC. self promo. 2004
• 045 GRAPHIC. for 123KLAN bags. 2004
• 046 GRAPHIC. self promo. 2004

06.5 AUSBLICK

. Für uns gibt es eine enge Verbindung zwischen Graffiti und Grafikdesign. Beide Kunstformen sind kreativ. Sie versuchen, Elemente in einem spezifischen Raum zu organisieren; sei es ein Tag auf einer Wand oder das Logo auf einer Visitenkarte. Die Wirkungsstrategien sind visuell gleich. Vielleicht hat Graffiti weniger Aussagekraft als Grafikdesign, weil es nicht gelesen werden muss. Graffiti äußert sich in Formen, Farben und Stil.

. For us there is a real link between graffiti and graphic design. Both of these art forms are creative and are concerned with how to arrange elements in a given space. Whether it is a tag on a wall or a logo on a business card, the impact strategy is visually the same. Perhaps graffiti is less forceful than graphic design because graffiti does not have to be read, it's all about shapes and colours, all about style.

. KUNDENLISTE. CLIENTS LIST

. carhartt Europe
. mini cooper. USA
. wired magazine. USA
. Computer Arts magazine. UK
. Playstation magazine. USA
. stanton. USA
. Vadobag. Netherlands
. toy2r. Hong Kong
. Nike. USA
. musée d'art moderne de villeneuve
 d'ascq. France
. Mouse sk8boards. France
. Stussy
. Ecko Unltd.

. KONTAKT. CONTACT

Home. 01
Lille. France

Home. 02
http://www.123klan.com
scien-klor@123klan.com

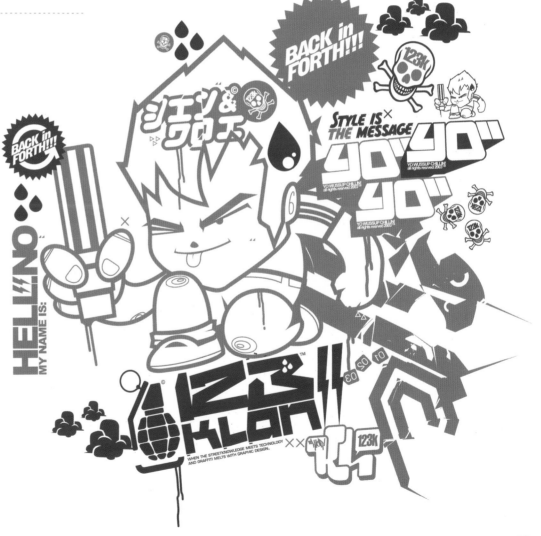

07.0

Die Einflüsse der Writingbewegung in der digitalen Grafikwelt und im Design sind heute nicht mehr wegzudenken. Dies ermöglicht eine Vielfalt an Variationen und Kombinationen durch schon bestehende fundamentale Elemente von Design und Graffiti.

TOAST. ATALIER

07.0

Today the world of digital graphics and design cannot be imagined without the influences of the Writing Movement. Countless variations and combinations are now possible through the fundamental elements of design and graffiti that already exist.

TOAST. ATALIER

. CREW
TOAST. Ata Bozaci. Creative Director. *1974
Remy Burger. Chief Application Development

. UNTERNEHMEN
Die ATALIER GmbH wird von den zwei Gründern und gleichberechtigten Mitinhabern Ata Bozaci und Remy Burger geführt. Das Team wird je nach Bedarf mit ausgesuchten Freelancern ergänzt.

. WIR MACHEN SPASS
Steuererklärung, Zahnarztbesuch, Stau auf der Autobahn – der Ernst des Lebens verfolgt uns alle auf Schritt und Tritt. Umso wichtiger sind die kurzen Pausen im Alltag – die wertvollen fünf Minuten, in denen man alles vergisst und einfach Spaß hat. Auf diese unbeschwerten fünf Minuten hat sich die ATALIER GmbH in Bern spezialisiert. Als Entwickler und Anbieter von Online-Spielen, -Wettbewerben und Animationen wissen wir, wie man auf sympathische Art Aufmerksamkeit weckt und sie auf ein bestimmtes Angebot oder eine Dienstleistung lenkt. Dank des einzigartigen Stils und der ausgereiften Konzepte sind unsere Produkte dabei keine x-beliebigen Pausenfüller, sondern kleine Unterhaltungskunststücke, über die man spricht und die man gerne wieder und wieder sieht.

Vielleicht glauben Sie nun, dass wir hier im ATALIER nur Spaß machen. Und damit haben Sie vermutlich sogar Recht. Es gibt jedoch zwei Dinge, die wir hier sehr ernst nehmen: unsere Arbeit und unsere Kunden.

. WIR MACHEN ES EINFACH
Niemand liest gerne lange Anleitungen und Erklärungen. Darum glauben wir, dass die einfachste Lösung meist auch die beste ist. Und diese zu finden ist harte Arbeit. Der erste Schritt führt uns dabei oft zurück, denn erst in der Reduktion offenbart sich das Unnötige und zeigt damit den Weg zur intuitiven Zugänglichkeit. Unser Motto lautet „sehen und verstehen". Statt den Betrachter mit optischem Ballast, überladenen Hintergründen und abrupten Stilwechseln zu verwirren, schaffen wir für jedes Projekt einen eigenständigen Kosmos aus klaren Formen, Strukturen und Farben. Je simpler das Endresultat wirkt, desto mehr Arbeit steckt in der Perfektion.

Dank der langjährigen Erfahrungen in den Bereichen Graffiti und Illustration sind wir uns der Gefahren der digitalen Technik voll bewusst. Wir legen deshalb Wert darauf, dass sich unsere Ideen nicht in der kalkulierten Kälte des technisch Machbaren verlieren. Stattdessen bestechen die ATALIER-Kreationen auch als Bits und Bytes mit Charakter und Lebendigkeit.

. COMPANY
The ATALIER GmbH is managed on an equal footing by its two co-founders and owners, Ata Bozaci and Remy Burger. If necessary, the team is accordingly supplemented by selected freelancers.

. WE WANT TO ENTERTAIN
Income tax returns, visits to the dentist, traffic jams on the motorway – the serious side of life follows us at every turn. A few short breaks in the daily routine are all the more important. These are the precious five minutes in which we forget everything and simply enjoy ourselves. The ATALIER GmbH in Berne, Switzerland, concentrates on these five minutes of fun. As developers and vendors of online games, competitions and animations we know how to attract attention in a pleasant way and direct it towards a specific offer or service. Thanks to a unique style and sophisticated concepts our products are not just any run-of-the-mill coffee break games but miniature show pieces that are talked about and watched again and again.

You are now probably thinking that we spend all our time in ATALIER having fun. You may be right there but there are two things that we take very seriously: our work and our clients.

. WE MAKE THINGS EASY
Nobody likes reading long directions and instructions. It is our belief that the simplest solution is usually the best. Finding this solution is hard work and often takes us back a few steps because it is primarily the process of reduction that discloses the unessential and leads the way to an intuitive access. Our motto is "seeing is understanding". Instead of confusing the viewer with optical ballast, overcharged backgrounds and abrupt changes of style we create an individual cosmos of distinct forms, structures and colours for each separate project. The easier the result appears to be, the more work we have put into perfecting it.

Our years of experience in the fields of graffiti and illustration have made us well aware of the dangers of digital technology. For this reason we make a point of not forfeiting our ideas to the calculated coldness of the technically feasible. In contrast to this, our ATALIER creations fascinate by their character and vitality, even in the form of bits and bytes.

• 001 ++ 005

- - - - - - - - - - - - - - - - - -
• 001 LOGO. 2004
• 002 TOAST. 2004
• 003 ++ 005 OFFICE. Berne. Switzerland. 2004

Wenn jemand 1+1 zusammenzählt und das Resultat 11 ergibt, kann es nur ein visueller Mensch sein. Die Besessenheit, mich mit Papier und Schreiber auszudrücken, fing bereits in der Wiege an.

1990, während der gestalterischen Grundausbildung, kam ich das erste Mal mit einem Sprüher in Kontakt. Kurz darauf war ich schon an der Wand und habe alles Mögliche besprüht. Damals nannte ich mich PRINZ. Bald traf ich Gleichgesinnte, mit denen ich kurz darauf die TCP (Those Creative Partners) gründete. Zwischen 1990 bis 1993 prägten wir das ganze Stadtbild. Wir malten so ziemlich alles an, was uns in die Quere kam. Ende 1993 splitterte sich unsere Crew auf. Die TCP blieb mit drei Mann Besatzung zwei bis drei Jahre bestehen und fiel schlussendlich ganz auseinander. In der Zwischenzeit entstand die PK (Porno Kids), fünf Leute, die sich ausschließlich mit Konzeptbildern auseinandersetzten. Ich wurde unbewusst von meiner Crew zum Charactermaler gepusht, obwohl ich mich ursprünglich mit Styles beschäftigte. Meine Figuren fanden ziemlich schnell Anklang in der Sprüherszene, da sich diese von der Technik und auch von der Aussagekraft gänzlich von anderen bestehenden Bildern unterschieden. LOOMIT hatte mich damals nach München eingeladen, an der Hall of Fame zu malen. Dieser gesprühte Clown, der über vier Meter hoch war, war der Sprung in alle Graffitimagazine. Ich malte unermüdlich überall. Ein Bild nach dem anderen erschien in Magazinen, obwohl ich überhaupt selten bis nie Fotos eingeschickt hatte.

1996 hatte ich meine vierjährige Grafikerausbildung mit Mühe hinter mich gebracht. Von Grafik wollte ich dann bis 1998 nichts mehr wissen und konzentrierte mich auf Ausstellungen und Graffitiaufträge. Das wenige Geld, was rein kam, deckte selten die lebensnotwendigen Bedürfnisse. Essen und Farben musste ich jeden Tag von neuem klauen.

In der Zeit in Basel teilte ich mit DREAM eine Zweizimmerwohnung. Seine Fähigkeit, mit Buchstaben zu spielen, entfachte in mir eine schon fast vergessene Leidenschaft – das Styling. Character wurden nebensächlich. In der Zeit musste ich viel nachholen und wurde auch andauernd von der Szene gedisst. Um in der Szene Flexibilität und Anonymität zu behalten, habe ich praktisch alle paar Monate meinen Namen gewechselt. Ich konnte mich daher sehr schnell entwickeln.

Dies hatte zur Folge, dass viele Sprüher meine Entwicklung nicht nachvollziehen konnten und dadurch auch überrumpelt wurden. DARE wurde meine wichtigste Ansprechperson und motivierte mich tagtäglich. Ich wurde in die TWS (The Wild Side) aufgenommen. 1998 fand ich in meine Heimatstadt Bern zurück, kaufte gleich den besten Rechner auf dem Markt und wollte all diese neuen Erfahrungen vom Rechner auf die Wand projizieren. Auch hier war ich wohl damals mit meinen Visionen nicht nachvollziehbar für viele Sprüher. Was auf dem Rechner entwickelt wird, kann nicht Graffiti sein, wurde argumentiert.

Ich wagte mich mit langsamen Schritten in die dritte Dimension. Das Ziel war, die Buchstaben in der zusätzlichen Dimension nicht einfach nur gut aussehen zu lassen, sondern mehr so zu konstruieren, dass sie in sich und von jeder Seite stimmig sind. Meine Buchstaben sollten den Raum beherrschen und dennoch den Regeln der Typographie gerecht werden, keine Scheinkonstruktionen sein, die nur von einer Sicht aus funktionieren.

Ata Bozaci aka TOAST

• 006 ++ 009

If someone adds 1+1 together and the result is 11, he or she can only be a visual person. The obsession to express myself with pencil and paper began in the cradle. During a basic course in design in 1990 I had my first contact with a sprayer. Shortly afterwards I was out and about spraying not only walls but anything else I could find. During this phase I called myself PRINZ. I soon met like-minded companions with whom I founded the TCP (Those Creative Partners) shortly afterwards. From 1990 to 1993 we left our marks all over the town. We painted nearly everything that got in our way. Our crew split apart at the end of 1993. The TCP kept going for two to three years with a team of three until it finally disbanded. In the meantime the PK (Porno Kids) emerged, five people who occupied themselves solely with concept pictures. Unknowingly I was pushed by my crew into the role of a character writer although I was originally more occupied with styles. My figures soon found favour with the writing scene because they differed totally from the existing pictures both technically and in their expressive force. Then LOOMIT invited me to Munich, Germany, to paint in the Hall of Fame. This sprayed clown was over four metres high and was my debut in all the graffiti magazines. I was indefatigable and painted everywhere. One picture after the other appeared in magazines although I hardly ever sent in any photos.

I had just about managed to finish my four-year study of graphics in 1996. I did not want to have anything more to do with graphics until later in 1998, so I devoted myself to exhibitions and graffiti orders. The little money that I earned rarely covered the costs for my vital needs. Every day I had to steal food and paint.

During my time in Basle, Switzerland, I shared a two-room flat with DREAM. His ability to play with letters aroused in me an almost forgotten passion for styling. Characters were now irrelevant. At the time I had a lot to catch up on and was constantly dissed by the scene. To gain anonymity and flexibility in the scene I changed my name nearly every few months. This enabled me to develop very quickly.

As a consequence, many writers could not retrace my development and it took them completely by surprise. DARE became my most important contact and gave me daily encouragement. I was admitted to the TWS (The Wild Side). In 1998 I returned to my home town of Berne, Switzerland, where I immediately purchased the best computer on the market in order to project all these new experiences onto the wall. Even at this stage many sprayers could not understand me or my visions. It was argued that something developed on a computer could not be graffiti.

Step by step I ventured into the third dimension. My intention was to make letters in the extra dimension not only look good, but to construct them so that they were coherent in themselves and when viewed from every side. My letters were meant to master a space while doing justice to typographical rules without being pseudo-constructions that can only be viewed effectively from one angle.

Ata Bozaci aka TOAST

•012

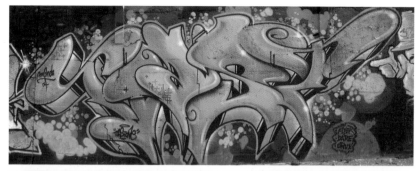

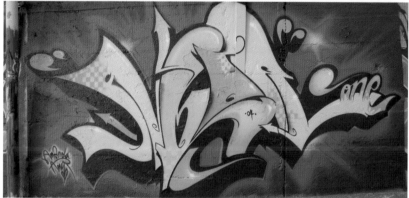

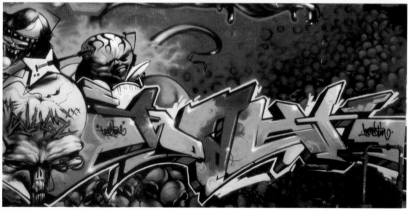

•013 + 015

- - - - - - - - - - - - - - - - - -

•012 DREAM. mural. Montpellier. France. 2002
•013 TOAST. mural. Berne. Switzerland. 2003
•014 AMOR. mural. Berne. Switzerland. 2004
•015 TOAST. mural. San Diego. USA. 2001

•016

•017 ++ 018

•016 GRUBFACE. sketch. 2002
•017 ++ 018 ROMA. sketches. 2004

•019 TOAST. sketchbook. 2004
•020 TOASTFLY. sketch. 2002

•021

•022 ++ 025

•026 ++ 041

•026 MURAT/MEDINA. wedding graphic. 2001
•027 TIN LAN. welcome card. 2002
•028 ATTENTION RABBIT. free work. 2004
•029 CUBE. poster. word exhibiton. 2004
•030 POSTMAN. flyer. postfinance. 2004
•031 CUBE. wedding card. 2004

•032 BILLY. welcome card. 2002
•033 TEDDY. welcome card. 2002
•034 SAFE SEX. free work. 2003
•035 DEVIL. flyer. reinraus production. 2001
•036 HIGH PROFILE. flyer. 2004
•037 DIE KLINIK. free work. 2004

•038 ++ 041 SWEET&SEXY. various flyer. 2003-2004

. KUNDE
OPEN AIR ST. GALLEN 04

. BESCHREIBUNG
Gestaltung eines Keyvisuals, das zum Thema OPEN AIR
ST. GALLEN passt. Bei der Veranstaltung handelt es sich
um eines der größten Musikfestivals der Schweiz, das
hauptsächlich von jüngerem Publikum besucht wird.
Der Wunsch des Kunden war es, eines der typischen
Insekten, die oft auf dem Open Air in St. Gallen anzutref-
fen sind, als Werbeträger darzustellen. Das Keyvisual
musste für diverse Anwendungen, wie z.B. Bühnen-
dekoration, Flyer, Poster, Eintrittskarten, T-Shirts usw.,
funktionieren.

Da das Open Air meistens von Regen begleitet wird, was
ein schlammiges und dreckiges Umfeld zur Folge hat,
haben wir uns auf eine Fliege geeinigt, da sie gerade an
solchen Orten oft anzutreffen ist. Die Fliege sollte zeit-
gemäß und grafisch dargestellt werden.

. CLIENT
OPEN AIR ST. GALLEN 04

. DESCRIPTION
The task was to design a keyvisual suitable to the subject
OPEN AIR ST. GALLEN. This event is one of the biggest
music festivals in Switzerland and is mainly frequented by
a younger audience. The client wanted us to use one of
the typical insects that are often found during this event
as a promotion image. The keyvisual had to be suitable
for use in various functions such as stage scenery, flyers,
posters, tickets, T-shirts etc.

During the open air festival it usually rains and this makes
the environment muddy and dirty. We thus agreed to take
the common fly as our theme because there are so many
of them at such events. The fly was to be presented in
a modern and graphical design.

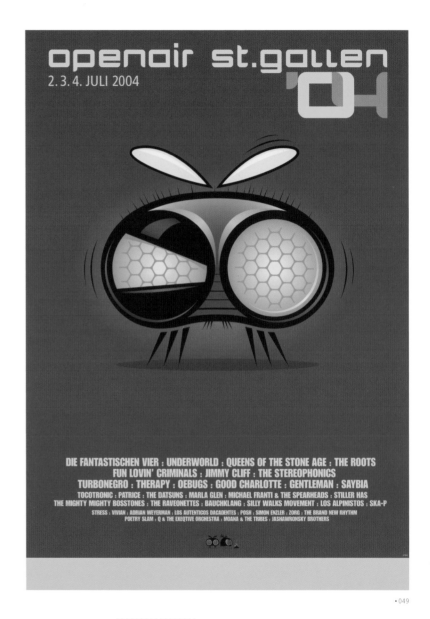

•042 ++ 048

•049

- - - - - - - - - - - - - - - - - -
•042 ++ 047 ST. GALLEN OPEN AIR 04. various studies. 2004
•048 ST. GALLEN OPEN AIR 04. poster draft. 2004
•049 ST. GALLEN OPEN AIR 04. final poster draft. 2004

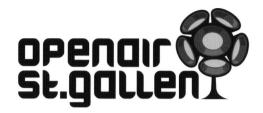

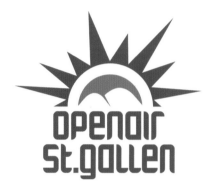

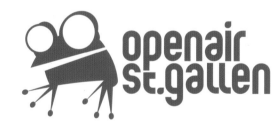

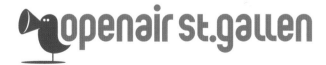

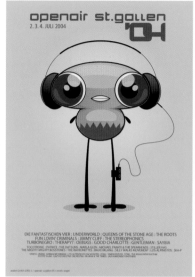

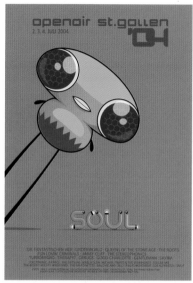

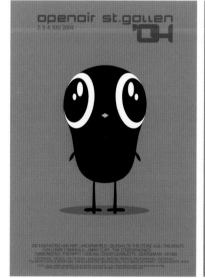

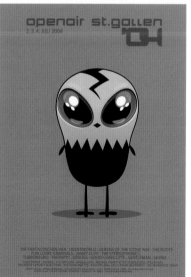

• 050 ++ 053

• 054 ++ 057

• 050 ++ 053 ST. GALLEN OPEN AIR. various logo studies for 2005
• 054 ++ 057 ST. GALLEN OPEN AIR. various poster drafts for 2005

. ONLINE-SPIELE UND -WETTBEWERBE
Wenn eine Firma auf sympathische Art über ein neues Produkt oder eine Dienstleistung informieren und idealerweise gleichzeitig auch noch die Kundendatenbank erweitern will, dann helfen wir weiter. Unsere maßgeschneiderten Online-Spiele und -Wettbewerbe verknüpfen massentaugliche Unterhaltung mit innovativem Design und gezielter Information. Jedes unserer Produkte umfasst ein Content Management System, das den Unternehmen hilft, Kundendaten zu sammeln und zu analysieren.

. PROJEKT
VIRUS ATTACK

. KUNDE
KPT Versicherungen, Bern, Schweiz

. BESCHREIBUNG
Bei der Einführung ihrer neuen Website wollte die KPT Firmengruppe ein dreisprachiges Online-Spiel (in Deutsch, Französisch und Italienisch) entwerfen. Das Spiel musste als Einzelspiel und Wettbewerbsspiel geeignet sein, um dem Unternehmen die Möglichkeit zu geben, in regelmäßigen Abständen neue Wettbewerbe einzuführen. Ferner verlangte die KPT Gruppe ein Shooting-Game mit dem KPT-Matrosen als Hauptfigur.

ATALIER entwarf ein Online-Spiel, bei dem der Spieler bei der Registrierung des Highscores seine Benutzerdaten eingeben musste. Mit Hilfe des Customer Management Systems konnte das Unternehmen die Benutzerdaten, Highscore-Rankings und Gewinner verwalten. Für das Spiel wurden Flash5, PHP4 und MySQL angewendet. ATALIER GmbH hatte die Idee, den Spieler in ein U-Boot zu stecken, das durch die Blutbahnen eines menschlichen Körpers fährt. Das Ziel des Spieles war es, verschiedene Viren zu töten, um den menschlichen Körper vor Krankheit zu schützen. Es ist ein einstufiges Spiel, das immer schwieriger wird, je weiter der Spieler vorankommt (ähnlich wie Tetris).

. ONLINE GAMES AND COMPETITIONS
If a firm is looking for a pleasant way to advertise new products or services and would like to upgrade the customer data base at the same time, we are there to help. Our customised online games and competitions combine mass-friendly entertainment with innovative design and targeted information. Each of our products includes a Content Management System which helps the company to collect and analyse customer data.

. PROJECT
VIRUS ATTACK

. CLIENT
KPT Versicherungen, Berne, Switzerland

. DESCRIPTION
With the launch of their new website, the KPT Group wanted to create a trilingual online game (German, French and Italian). The game had to work on its own as well as in competition so that the company could launch new contests at regular intervals. Furthermore, the KPT Group requested a shooting game with the KPT sailor as the leading figure.

ATALIER created an on-line game where the player had to provide user data when registering his or her high score. The company was able to administer user data, high score rankings and winners through the Customer Management System. The game was implemented in Flash5, PHP4 and MySQL. ATALIER GmbH came up with the idea of putting the player into a submarine that travels through the bloodstream of a human body. The aim of the game was to kill a variety of different viruses in order to protect the human body from illness. It is a one-level-game that increases in difficulty according to the user's progress (similar to Tetris).

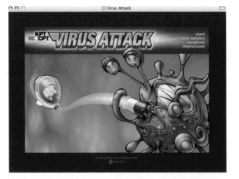

 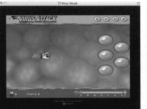 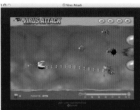

• 058 ++ 067

•058 ++ 067 VIRUS ATTACK. online game for KPT Versicherungen.
done with FLASH5, Illustrator and Dreamweaver. 2002
play the game on FADINGS DIGITAL

. PROJEKT
EURO 2004 GAME

. KUNDE
Schweizer Milchproduzenten, Bern, Schweiz

. BESCHREIBUNG
ATALIER GmbH entwarf ein Multispieler Online-Spiel mit
Macromedia Flash Communication Server. Swissmilk
konnte mit dem Customer Management System die Daten
über Spieler, Highscore-Rankings, Vorgänge und Gewinner
verwalten. Für das Spiel wurden Flash MX, Flash Communi-
nication Server, PHP4 und MySQL angewendet.

. PROJECT
EURO 2004 GAME

. CLIENT
Schweizer Milchproduzenten, Berne, Switzerland

. DESCRIPTION
ATALIER GmbH designed a multiplayer online game with
Macromedia Flash Communication Server. Swissmilk was
able to administer the data of the player, high-score
ranking, event and winner using the Customer Manage-
ment System. The game was implemented with FlashMX,
Flash Communication Server, PHP4 and MySQL.

· 068 ++ 078

· 068 ++ 078 EURO 2004 GAME. online game for Schweizer
Milchproduzenten. done with FLASH5, Illustrator
and Dreamweaver. 2004

. PROJEKT
DIGITALGEMÄLDE

. BESCHREIBUNG
Durch präzises Konstruieren und Aneinanderfügen der
Buchstaben soll das Feld der Typographie ausgeweitet
werden. Die „Buchstabenarchitekturen" sind auf der Drei-
fluchtpunktperspektive aufgebaut, was dem Betrachter
das Gefühl für Tiefe und Räumlichkeit der Buchstaben
vermitteln soll. Die Herausforderung liegt darin, die
Gesetze der Typographie und die Ästhetik der einzelnen
Buchstaben im Raum anzuwenden.

Die Umsetzung der Arbeiten geschieht in drei Phasen. Die
Konstruktion erfolgt als klassische, skizzenhafte Darstel-
lung auf Papier. Danach wird das Bild eingescannt und
auf dem Rechner reingezeichnet, Die Reinzeichnung wird
ausgeplottet, auf Holzplatte aufgezogen und anschließend
laminiert (Schutzfolienbeschichtung).

. PROJECT
DIGITAL PAINTINGS

. DESCRIPTION
The precise construction and joining of letters should
widen the field of typography. These "letter architectures"
are arranged on a three point perspective that aims at
giving the observer a feeling for the depth and spatiality
of the letters. The challenge lies in applying the laws of
typography and aesthetics to the individual letters in
a space.

The work is carried out in three phases. The construction
is a classical sketch on paper. This picture is then scan-
ned and drawn on the computer. The computer drawing
is plotted, mounted on a wood plate and then laminated
(lamination sheet).

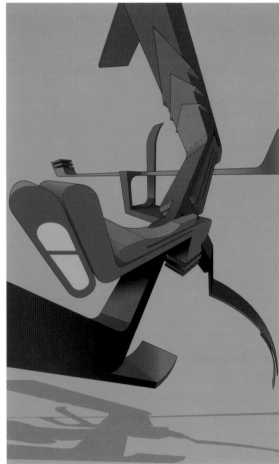

• 080

• 079

• 079 SKETCH. for digital style. 2002
• 080 SATAN IN HEAVEN. digital style. 2002

- - - - - - - - - - - - - - - - - - -
•081 NIE OHNE SEIFE WASCHEN. digital style. 2003
•082 WHITE S. digital style. 2004

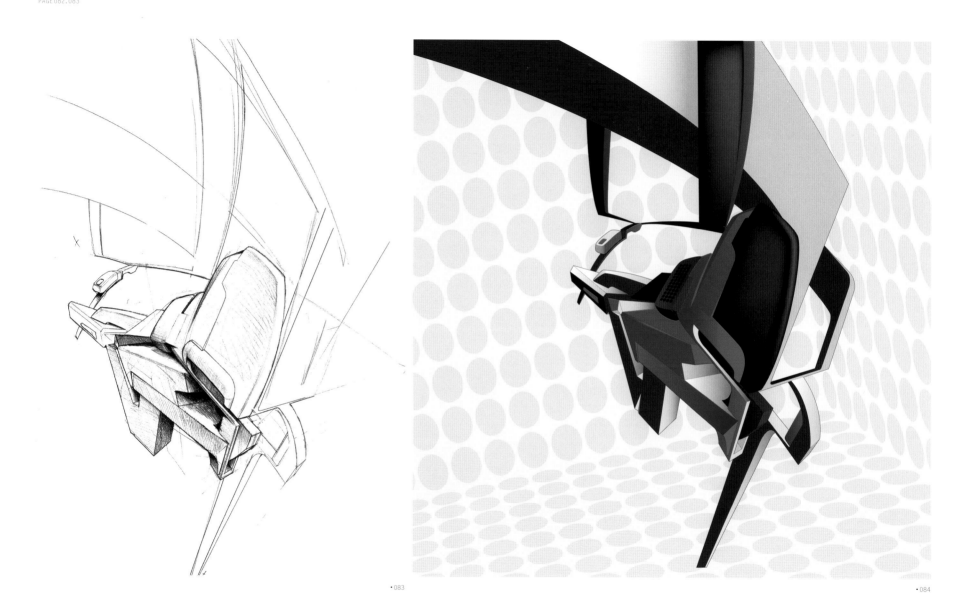

• 083

• 084

• 083 + 084 HENDRIK. sketch and realisation. 2004

Obwohl es lange den Anschein hatte, dass Graffiti in seiner ursprünglichen Form nie massentauglich sein wird, haben viele Writer diese Graffitiphilosophie ins Grafische adaptiert und für Ottonormalverbraucher zugänglich gemacht. Die Einflüsse der Writingbewegung sind heute in der digitalen Grafikwelt und im Design nicht mehr wegzudenken. Dies ermöglicht eine Vielfalt an Variationen und Kombinationen durch schon bestehende fundamentale Elemente von Design und Graffiti. Dieses bringt natürlich auch Gefahren mit sich. Zwei so verschiedene und doch eng verwandte Bildsprachen zu kombinieren, ist eine Herausforderung, der nicht jeder gewachsen ist.

Darum wäre es sinnvoll, genügend Wissen und Erfahrung über die jeweiligen Gebiete zu sammeln, bevor man damit in die Öffentlichkeit tritt.

Although it seemed for a long time that graffiti in its primary form would never find mass approval, many writers have converted this philosophy into graphics and made graffiti accessible to the man in the street. Today the world of digital graphics and design cannot be imagined without the influences of the Writing Movement. Countless variations and combinations are now possible through the fundamental elements of design and graffiti that already exist. There are of course certain dangers in this. Combining two such different yet closely related visual languages is a challenge that not everyone is equal to.

It is therefore wise to gather sufficient knowledge and experience in the appropriate fields before appearing in public.

. KUNDENLISTE. CLIENTS LIST

. 0711 Records. Germany
. Access Sports Travel. New Zealand
. Adesso Communications AG. Switzerland
. Art Directors Club ADC. Switzerland
. British American Tobacco. Switzerland
. Bundesamt für Flüchtlinge EJPD. Switzerland
. CKYRA. USA
. Der Bund. Switzerland
. Die Mobiliar Versicherungen. Switzerland
. Fettes Brot. Germany
. Intersport International. Switzerland
. Kopfnicker Records. Germany
. KPT Versicherungen. Switzerland
. Nike AG. Switzerland
. OLMO. Switzerland
. Openair St. Gallen 2004. Switzerland
. Osiris. USA

. Postfinance. Switzerland
. Pride 2000. Switzerland
. Regardez. Switzerland
. Restaurant Bierhübeli. Switzerland
. Restaurant Kaufleuten. Switzerland
. SMP Schweizer Milchproduzenten. Switzerland
. Snowparadise. Switzerland
. SODA. Switzerland
. Sweet&Sexy. Switzerland
. Swisscom. Switzerland
. Swissradio. Switzerland
. Tribal Gear. USA
. True Colors. Switzerland
. Wrecked Industries. Switzerland
. Yellow World. Switzerland

. KONTAKT. CONTACT

Home. 01
Berne. Switzerland

Home. 02
http://www.atalier.com
info@atalier.com

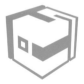
TOASTSUPPLY.COM

•085 OLD LOVERS. illustration. 2004

Gearbeitet wird inzwischen, nach vielen tausend gestalteten Dingen, schnell und professionell. Aber immer mit geballter Hingabe und vor allem mit der manischen Gestaltungswut, die ich schon immer an unserem Traum am meisten geliebt habe.

KK1. TYPEHOLICS

After designing thousands of objects, our work has become quick and professional. However, what I have always loved most about our dream is the absolute commitment and above all, the manic creative energy.

KK1. TYPEHOLICS

. CREW
KK1. Felix Schlüter. *1973
HB1. Henning Weskamp. *1973
P1. Sebastian Rohde. *1976
4M. Benjamin Kakrow. *1976

. UNTERNEHMEN
1994 erstes Plattencover von F1 für Absolute Beginner
1997 Gründung von TYPEHOLICS durch KK1 und
 erstes Büro im Eimsbush Basement, Hamburg
1998 HB1 joins the band
1999 P1
2000 4M
2003 Umzug ins neue Büro in Hamburgs St. Pauli

. ARBEITSBEREICHE
. Corporate Identity, Corporate Design
. Logoentwicklung
. Plattencover- und CD-Cover-Gestaltung
. Buch-, Broschüren- und Kataloggestaltung
. Illustration
. Poster- und Flyergestaltung
. Clips, Animation, On-Air-Design
. Internetseiten und Webflyer
. Fassaden- und Innenraumgestaltung
. Postproduktion für Musikvideos
. Fontdesign

. COMPANY
1994 first record cover of F1 for Absolute Beginner
1997 foundation of TYPEHOLICS by KK1 and first
 office at Eimsbush Basement, Hamburg, Germany
1998 HB1 joins the band
1999 P1
2000 4M
2003 move to a new office in Hamburg St. Pauli,
 Germany

. JOB FOCUS
. Corporate Identity, Corporate Design
. logo design
. record and CD cover design
. book, brochure and catalogue design
. illustration
. poster and flyer design
. clips, animation, on-air design
. internet pages and web flyer
. facade and interior design
. postproduction for music videos
. font design

TYPEHOLICS
STUNNING GRAFFICS

•001 ++ 002

•003

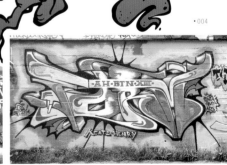

•004

- - - - - - - - - - - - - - - - - -
•001 TYPEHOLICS CREW
•002 OFFICE. St. Pauli. Hamburg. Germany. 2004
•003 HOME. http://www.typeholics.de
•004 TYPEHOOL. character. 2004
•005 KEATS. mural

- - - - - - - - - - - - - - - - - -
•006 HENRY. mural
•007 PUNK. mural
•008 FORM. mural
•009 ABSOLUTE BEGINNER - ILL STYLES.
 mural by KEATS and MR. IRIE. 1994

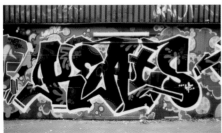

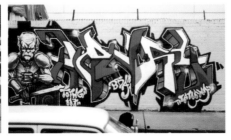

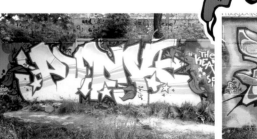

•005 ++ 008

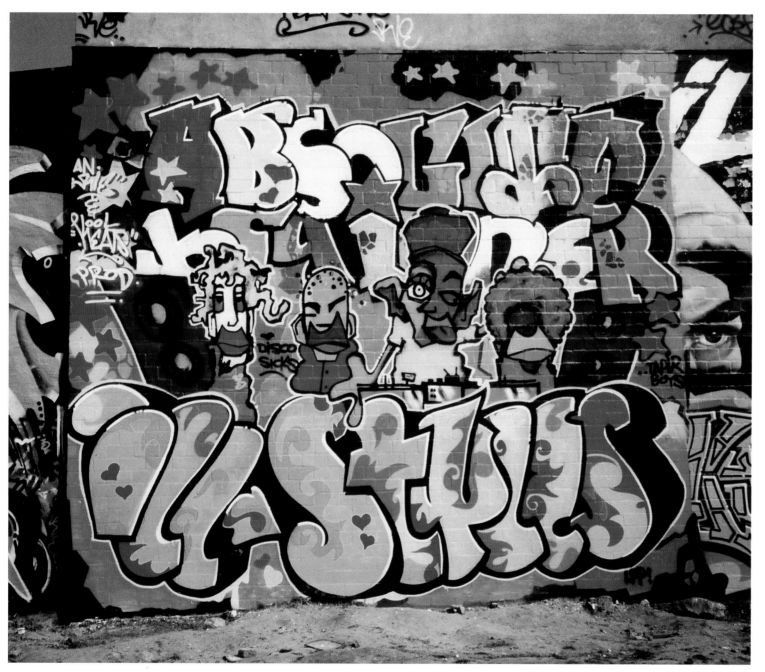

1994. Im April des Jahres besprühte ich, damals 20-jährig, eine riesige Backsteinmauer in Hamburg-Altona mit meinem damaligen Malpartner MR. IRIE an einem sonnigen Samstagnachmittag.

Daran war nichts Besonderes, gemalt wurde zu dieser Zeit viel. Nur dieses Mal waren da noch ein Haufen struppiger HipHopper, mit dem damaligen Namen Absolute Beginner, die mit prüfendem Blick das Entstehen ihres Plattencovers beobachteten. Das Bild wurde, trotz wackeliger Holzleiter, bald fertig und kurze Zeit später als Verpackungsgestaltung von dem damaligen Punklabel Buback Tonträger auf die aufkeimende Deutsche HipHop-Szene losgelassen. Eine Designwerkstatt mit Namen TYPEHOLICS begann als mein Traum zu existieren. Noch heute schaffe und überwache ich die gesamte visuelle Erscheinung der inzwischen groß gewordenen Band. Auf das Beginner-Cover und T-Shirt folgten zahllose, damals natürlich ausschließlich von Hand gezeichnete, Flyer und Plakate und einige andere Cover.

Freunde sind wir geblieben, wie mit vielen weiteren Bands und Musikern, die seit Jahren ihre veröffentlichten Tonträger und alles darum dem mittlerweile aus vier Mitgliedern bestehenden Grafikbüro TYPEHOLICS in die Hände legen.

1994 bis 1997. Ich studierte Kommunikationsdesign, vor allem aber lernte ich in dieser Zeit die neue Wunderwaffe zu bedienen: den Apple-Computer!

1997 lernte ich ein paar Jungs in ihrer Tiefparterre-Wohnung mitten in Eimsbüttel kennen und verbrachte die nächsten dreieinhalb Jahre fast täglich dort. Die drei Jungs waren Tim Dollmann, der spätere Geschäftsführer des Independent Labels Eimsbush Entertainment. Die beiden anderen waren Samy Deluxe und Tropf, die alsbald mit ihrem DJ Dynamite unter dem Namen Dynamite Deluxe die deutsche HipHop-Welt auf den Kopf stellen sollten. Die Beginner, das Bo, Ferris, Dendemann, Illo und viele Graffitiwriter waren fast jeden Tag da. Es wurde gerappt, produziert, gezeichnet und gefeiert. Eimsbush war geboren. Zeitgleich unterschrieben die Beginner einen Plattenvertrag bei Universal – mein erster Grafikjob für ein Majorlabel – und: für Geld! Die Beginner stürmten die Charts, während die Demotapes von Dynamite Deluxe zu uns zurückgeschickt wurden. Der inzwischen geschäftlich etwas versiertere Jan Eißfeldt schmiss etwas Geld in den Pott, ich machte das erste Eimsbush Tape-Cover, Marcus das erste Eimsbush-Logo. Sämtliche folgende der zahlreichen Eimsbush Veröffentlichungen wurden von TYPEHOLICS gestaltet.

1998 unterschrieben Dynamite Deluxe bei der EMI, die Grafikjobs wurden mehr und mehr: Beginner, Dynamite Deluxe, Eimsbush, Cleptomanicx Skateboards und Festivals wie Flash/Maximum HipHop gehörten jetzt zum festen Kundenstamm.

2001 arbeitete ich schon fast drei Jahre in unserem Minibüro mit den Eimsbush-Jungs in Eißfeldts und Bos Wohnung und Studio. Als sich die T-Shirt-Kartons an allen Wänden bis zur Decke stapelten und die Musikindustrie die jungen Musiker und uns hofierten, wurde beschlossen gemeinsam in ein größeres Hauptquartier zu ziehen. Ich wiederum beschloss, dass ich nach vier Jahren 24-7-365 Grafikwahnsinn alleine dringend Verstärkung brauchte. Ich musste meinen guten Freund und Graffitimaler Henning Weskamp dazu überreden, seine Talente in die Dienste meiner kleinen Idee zu stellen. TYPEHOLICS, eingebettet in das quirlige Musikerumfeld, bestand nun aus zwei Gestaltern. Schon kurze Zeit davor hatte Sebastian Rohde, mein inzwischen geschätzter Freund, auf zwielichtige Art und Weise die Gestaltung des Christmas-Millennium-Eimsbush-Newsletters während meiner Ferien an sich gebracht, der mir prompt so gut gefiel, dass Sebastian in unsere Gruppe eingeladen und aufgenommen wurde.

Als es immer noch schwierig für uns war, alle Jobs mit genug Liebe und ohne Herzinfarkt zu schaffen, wusste wiederum Sebastian Rat: Wir konnten den Altonaer Graffitiprofi Benjamin Kakrow als viertes Mitglied für unser Team gewinnen. Wir arbeiteten inzwischen mit einem kleinen Netzwerk in Eimsbush, Sebastian und Benjamin noch meist zu Hause.

2003. Erst jetzt gelingt es uns, ein gemeinsames Büro mitten auf St. Pauli zu beziehen.

2004. Renovierung und endlich ein ernsthaftes Netzwerk unserer Macs, farbige Blitze erhellen ab jetzt täglich den Hamburger Kiez. Gearbeitet wird inzwischen, nach vielen tausend verschiedenen gestalteten Dingen und einer beeindruckenden Liste zufriedener Kunden, schnell und professionell. Aber immer mit geballter Hingabe, auch fürs Detail – und vor allem mit der manischen Gestaltungswut, die ich schon immer an unserem Traum – TYPEHOLICS – am meisten geliebt habe!

Danke Homeboys
Felix Schlüter aka KK1

1994. On a sunny Saturday afternoon in April, when I was twenty years old, I sprayed a gigantic brick wall in Hamburg-Altona, Germany, together with MR. IRIE who was my painting partner at the time.

In those days there was a lot of painting going on, so this was nothing special, except that this time some rather unruly HipHoppers called Absolute Beginner were keeping a critical eye on the development of their record cover. In spite of a rickety wooden ladder the picture was soon completed and shortly afterwards it was let loose on the budding German HipHop scene in the form of a package design for the former punk label Buback Tonträger. My dream of a design studio with the name TYPEHOLICS had come true. Today I am still responsible for designing and supervising the complete visual image of the group which is now a major band. The Absolute Beginner cover and T-shirt were followed by countless flyers, posters and some more covers. In those days it was normal to do all drawings by hand.

We are still friends with this band, just as we are with the many other bands and musicians who for years now have been putting their releases and everything connected with them into the hands of the TYPEHOLICS graphic office, which now consists of four members.

1994 to 1997. I studied communications design but for me the most important thing during this time was that I learned to operate a new wonder weapon: the Apple computer!

1997. I got to know a few young men in their basement flat in the middle of Eimsbüttel (a district of Hamburg) and for the next three and a half years I spent nearly every day there. One of these three men was Tim Dollmann, the later managing director of the independent label Eimsbush Entertainment. The other two were Samy Deluxe and Tropf who, under the name Dynamite Deluxe, were on the brink of turning the German HipHop scene inside out with their DJ Dynamite. Die Beginner, das Bo, Ferris, Dendemann, Illo and many graffiti writers were there nearly every day. We rapped, produced, drew and celebrated. Eimsbush was born. At the same time Die Beginner signed a record contract with Universal – my first graphic job for a major label and – for money! Die Beginner stormed the charts whereas the demo-tapes of Dynamite Deluxe were returned to us. Jan Eißfeldt, who had now become more business-like, threw some money in the pot, I made the first Eimsbush Tape cover and Marcus the first Eimsbush logo. TYPEHOLICS designed all of the many following Eimsbush releases.

1998. Dynamite Deluxe signed a contract with EMI. There were more and more graphic jobs: Die Beginner, Dynamite Deluxe, Eimsbush, Cleptomanicx Skateboards and festivals such as Flash/Maximum HipHop now all belonged to our regular clientele.

2001. Until now I had been working for almost three years in our mini-office with the Eimsbush boys in Eißfeldt's and Bo's flat and studio. When the T-shirt cartons began to pile up against the walls right up to the ceiling and we and the young musicians were courted by the music industry, it was decided that we should move together to larger headquarters. I then decided that after four years of solitary 24-7-365 graphic frenzy I desperately needed a reinforcement. I had to persuade my good friend and graffiti painter Henning Weskamp to place his talents into the service of my humble ideas. TYPEHOLICS, imbedded in the lively music scene, now consisted of two designers. Shortly before this, my now cherished friend, Sebastian Rohde, took advantage of the fact that I was on holiday and very cunningly set about designing the Christmas Millennium Eimsbush Newsletter. I was immediately so impressed with this that Sebastian was invited to join our group and became a member.

As it was still difficult for us to carry out all jobs with the necessary commitment without getting a heart attack, Sebastian had another idea. We managed to persuade Benjamin Kakrow, a graffiti professional from Hamburg-Altona, to become the fourth member of our team. Meanwhile we were working with a small network in Eimsbush and Sebastian and Benjamin usually worked from home.

2003. Only now did we succeed in moving to a joint office in the centre of St. Pauli in Hamburg, Germany.

2004. The office was redecorated and our Macs at last had an effective network. Since then coloured lightning flashes illuminate the Hamburg Kiez (Hamburg's party and red-light district) every day. After designing thousands of objects and collecting an impressive list of satisfied clients, our work has become quick and professional. However, what I have always loved most about our TYPEHOLICS dream is the absolute commitment, even to details, and above all, the manic creative energy.

Thanks Homeboys
Felix Schlüter aka KK1

•010 VARIOUS TYPEHOLICS-STUFF
Photo: Cecil Arp. http://www.cecil-arp.org

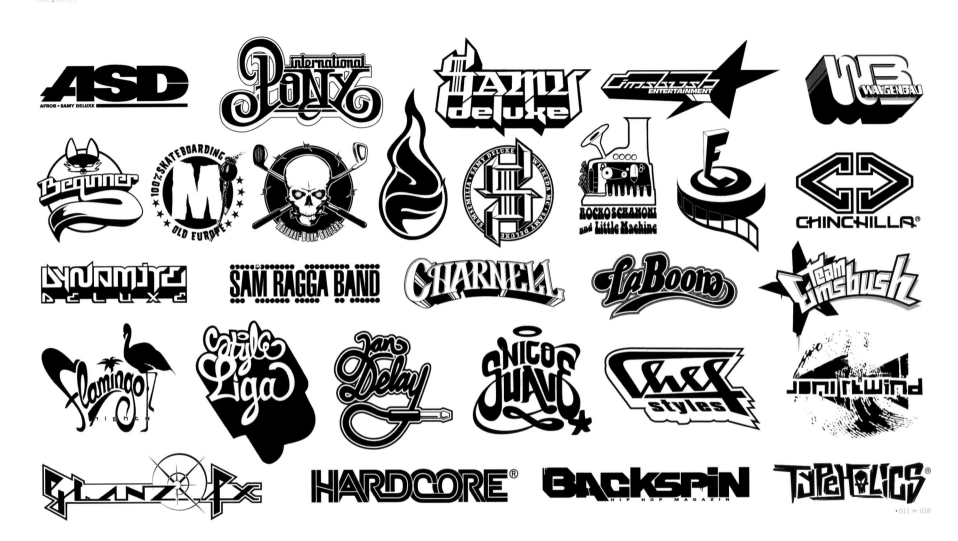

08.3

. PROJEKT
STYLELIGA

. KUNDE
Eimsbush Entertainment

. BESCHREIBUNG
Styleliga war eine insgesamt achtteilige Serie, auf der namhafte HipHop-Artists unter falschem Namen Singles bei Eimsbush Entertainment rausbringen konnten. Die Coverdesigns zeigten Skizzen besonders beliebter Graffitimaler wie SKENA (AH), JONAS 13, RAZOR (COS), ZAK (BIA), MR. IRIE (SF), AIDS (BTN), ENTER (BTN) und MILK (TFP).

. PROJECT
STYLELIGA

. CLIENT
Eimsbush Entertainment

. DESCRIPTION
Styleliga was an eight-part series in which well-known HipHop artists could bring out singles under false names by Eimsbush Entertainment. The cover designs featured sketches of very popular graffiti writers such as SKENA (AH), JONAS 13, RAZOR (COS), ZAK (BIA), MR. IRIE (SF), AIDS (BTN), ENTER (BTN) and MILK (TFP).

· 041

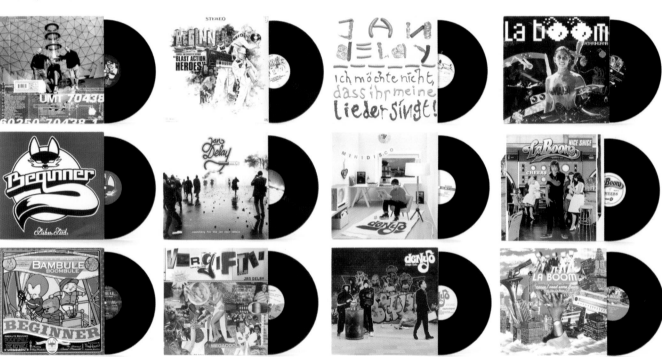

· 042 + 044 · 045 + 047 · 048 + 050 · 051 + 053

· 041 STYLELIGA. various record sleeves
· 042 BEGINNER. Hammerhart. 1999
· 043 BEGINNER. Liebes Lied. 1998
· 044 BEGINNER. Boombule - Bambule Remixed. 2002
· 045 BEGINNER. Blast Action Heroes. 2003
· 046 JAN DELAY. Searching for the Jan Soul Rebels. 2001
· 047 JAN DELAY. Vergiftet. 2001

· 048 JAN DELAY. Ich möchte nicht,
 dass ihr meine Lieder singt. 2001
· 049 DENYO. Minidisco. 2001
· 050 DENYO. Single Sells. 2001
· 051 LA BOOM. Atarihuana. 2002
· 052 LA BOOM. Cheers. 2002
· 053 LA BOOM. Cause I need some Boom. 2002

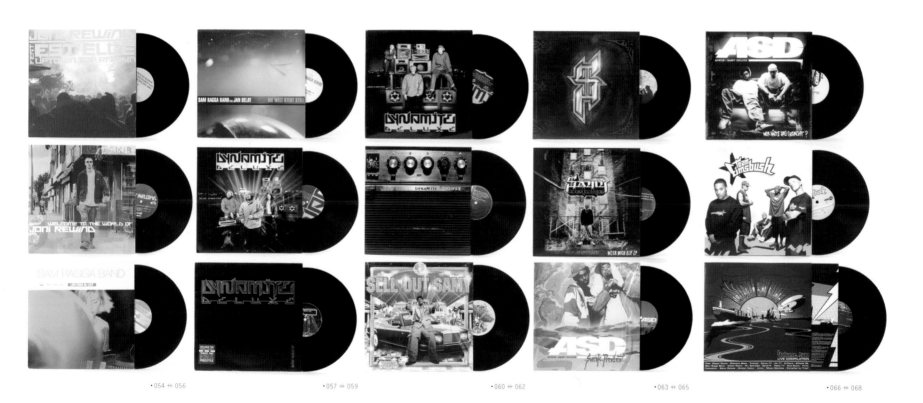

•054 ++ 056 •057 ++ 059 •060 ++ 062 •063 ++ 065 •066 ++ 068

- - - - - - - - - - - - - - - - - - -

•054 JONI REWIND. Uptown Top Rankin'. 2002
•055 JONI REWIND. Welcome to the world of
 Joni Rewind. 2002
•056 SAM RAGGA BAND. Loktown Hi-Life. 2002
•057 SAM RAGGA BAND. Die Welt steht still. 2002
•058 DYNAMITE DELUXE. Deluxe Soundsystem. 2000
•059 DYNAMITE DELUXE. Ladies & Gentlemen. 2000

- - - - - - - - - - - - - - - - - - -

•060 DYNAMITE DELUXE. Wie Jetzt. 2000
•061 DYNAMITE DELUXE. Grüne Brille. 2000
•062 SAMY DELUXE. Sell Out Samy. 2001
•063 SAMY DELUXE. Samy Deluxe. 2001
•064 SAMY DELUXE. Weck mich auf. 2001
•065 ASD. Sneak Preview. 2003

- - - - - - - - - - - - - - - - - - -

•066 ASD. Wer hätte das gedacht?. 2003
•067 TEAM EIMSBUSH. Vol.1. 2003
•068 HH CITY HEFTIG 2

. PROJEKT
INTERNATIONAL PONY

. BESCHREIBUNG
International Pony ist die in Hamburg ansässige Band-
formation aus DJ Koze, Erobique und dem ursprünglichen
Fischmobber Cosmic DJ. Erfreulicherweise sprengte das
Artwork den bis dato recht HipHop-lastigen Grafikrahmen
von TYPEHOLICS. Der elektronischen Soulmusik der Band
galt es nun, ein passendes Artwork zu verpassen. Aus
groben Kugelschreiber-Vorskizzen des beliebten Entertai-
ners Erobique entstanden die maßlos aufwändigen und
detaillierten Freehandillustrationen. Die Illustrationsserie
kam so gut an, dass das englische Avantgarde Label
Skint (Fatboy Slim), die International Pony in England
vertrieb, sich ein eigenes Artwork für eine nur dort er-
scheinende Single anfertigen ließ.

. PROJECT
INTERNATIONAL PONY

. DESCRIPTION
International Pony is the Hamburg-based band formation
with DJ Koze, Erobique and Cosmic DJ, originally from
Fischmob. Fortunately the artwork went beyond the
scope of the TYPEHOLICS graphic range which had
previously put the emphasis on HipHop. The band's
electronic soul music now required matching artwork.
The rough ball-point sketches of the popular entertainer
Erobique were developed into excessively complex and
detailed Freehand-illustrations. The series of illustrations
was so successful that the English avant-garde label
Skint (Fatboy Slim), that markets International Pony in
England commissioned us to design a separate piece
of artwork for a single that was appearing there.

• 069

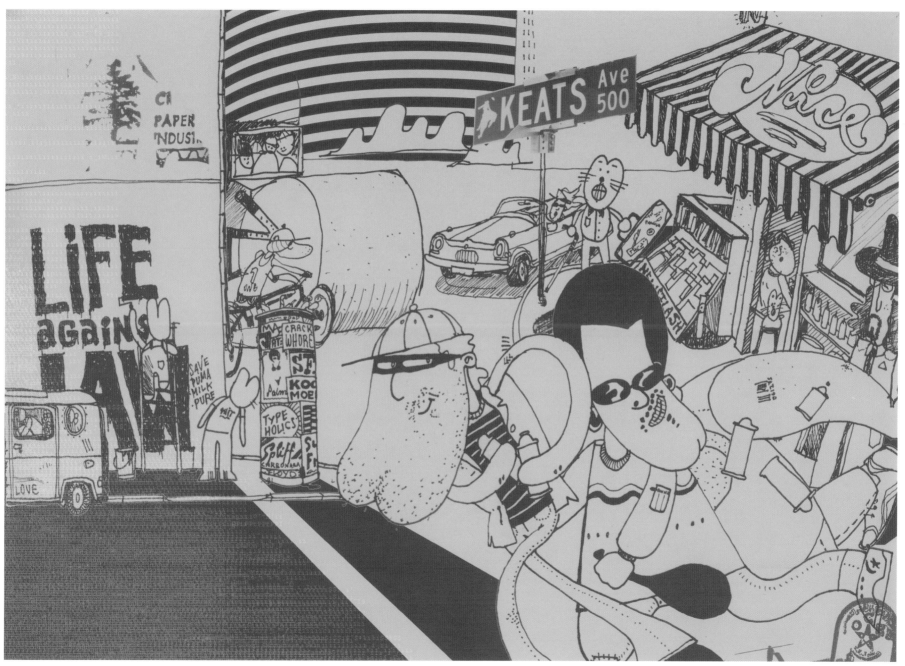

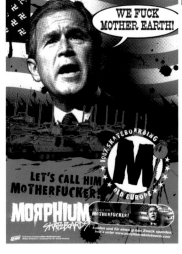

•071 HAMBURG IM PORT FESTIVAL. stage banner. 2004
Photo: Stefan Malzkorn. malzkorn@malzkornfoto.de

•072 HAMBURG IM PORT FESTIVAL. poster. 2004
•073 CHEF STYLES. ad
•074 AFROB/NIKE. AF 1. tour poster
•075 MORPHIUM SKATEBOARDS. ad
•076 FIRE TOUR 2001. tour poster and tour video. 2001

•077 ++ 084 TREASURE ISLE DANCEHALL. flyer series for Waagenbau.
Hamburg. Germany. 2004

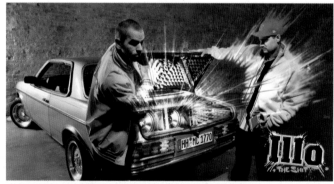

•085 ILLO - WEHR DICH. ep artwork. 2004
•086 SAMY DELUXE. album artwork. 2004

•085 ++ 086

•087 •088 + 091 •092 + 095

CLASH 2002. CLEPTOMANIA

•087 CLASHBOARDS TOPSIDE
•088 P.ANKER (winner)
•089 KK1 (second place)
•090 HB1 (third place)
•091 4M (fourth place)

CLASH 2003. PUBERTY

•092 4M (winner)
•093 HB1 (second place)
•094 F1 (third place)
•095 P.ANKER (fourth place)

• **PROJEKT**
THE CLEPTOMANICX SKATEBOARD CLASH

• **BESCHREIBUNG**
Das Projekt entstand aus der interessanten Fragestellung, was passieren würde, wenn die vier TYPEHOLICS-Grafiker, untereinander streng abgeschottet, zum gleichen Thema ein Motiv im Wettbewerb machen würden. Durch unseren lieben Freund Pitt, Boss von Cleptomanicx Skateboards (http://www.cleptomanicx.de), konnten wir diesen ego-intriganten Plan sehr gut umsetzen. Er bot uns eine mehrteilige Kollaboration unserer beiden Firmen an, wir schlugen ein und eine lustige, aber sehr beknackte Zeit brach herein. Die selbst auferlegten Bedingungen waren nämlich, dass wir vier absolut nichts voneinander sehen durften, weder Idee, noch Farben, noch Machart. Vom einen auf den anderen Tag herrschten Zwietracht und Spionagealarm in unserem kleinen Büro.

Erst am Tag der Pokalverleihung durch Pitt wurden uns gemeinsam die fertig gedruckten Boards gezeigt und die Harmonie – leicht getrübt durch anfängliche Druckfehler – war wieder hergestellt. Bisher gab es zwei Clashes – der Dritte ist in Planung und wir freuen uns schon wieder auf Verschwörermienen und lesegesperrte Festplatten.

• **PROJECT**
THE CLEPTOMANICX SKATEBOARD CLASH

• **DESCRIPTION**
The idea for the project arose from the interesting question, what would happen if the four TYPEHOLICS designers were to compete in designing a motif on the same subject while being completely isolated from one another. Our dear friend Pitt, boss of Cleptomanicx Skateboards (http://www.cleptomanicx.de), was very cooperative in helping us to carry out this devious egocentric plan. He suggested a collaboration of both our companies. We agreed and a comical but rather crazy time descended upon us. Under these self-imposed conditions, the four of us were not permitted to see anything of each other's work, including ideas, colours or design. At a moment's notice our small office was dominated by discord and spying alarms.

This lasted until the day when Pitt awarded the cup and we could all show our printed boards and restore the harmony that had been slightly disturbed by initial misprinting. There have been two clashes up to now. The third one is planned and we are looking forward to returning to conspiratorial habits and disk locks.

•096 HANDMADE RAMPDESIGN. 2004
•097 ROLLEN ALLER. 2004
•098 SCHICK DICH. 2004
•099 CLEPTO WHEELS. 2004

•096 + 099

. PROJEKT
HAMBURG CITY GRAFFITI

. BESCHREIBUNG
Das Hamburg City Graffiti Buch wurde angeregt durch
SAMZ, einen Hamburger Writer der Sonderklasse.
Er hatte sich in den Kopf gesetzt, das lange schon
fehlende Buch über die letzten 20 Jahre aus und über
Hamburgs Writing zu realisieren. Um herauszufinden, ob
wir dieses umfangreiche Projekt gemeinsam realisieren
können, trafen wir uns und die Planung begann. Ein Jahr
lang sammelten wir Fotos, stellten in jedem Hamburger
Sprühartikelfachhandel Briefkästen auf, in die jeder-
mann anonym Photos, Texte oder alles, was interessant
erschien, einwerfen konnte. Es wurden zahlreiche Inter-
views geführt – interessanterweise auf beiden Seiten des
Zauns: Ebenso wie strafverfolgte Kunstkriminelle kamen
die leidgeplagten Eltern derselben, Staatsanwälte und
Jugendrichter zu Wort. Auf diese Weise – und vor allem
eben, weil das Buch von-uns-für-uns ist – vermittelt es
einen guten Einblick über die letzten zehn Jahre für jeden,
der an der Hamburger Graffitiszene interessiert ist. Trotz
der umfangreichen Arbeit hatten wir selbstverständlich
noch keine Ahnung, welcher Verlag unser wunderbares
Projekt verlegen sollte. Die Stylefile Herren vom Publikat
Verlag waren aber schnell zu begeistern und so waren wir
leider gezwungen in acht Wochen die 180 Seiten so cool
zu layouten, wie unser gutes altes Hamburg es verdient
hatte. Für uns hieß die schnelle Entscheidung, gekoppelt
mit nahem Veröffentlichungsdatum: 60 Tage lang selten
mehr als fünf Stunden Schlaf, den Rest der Zeit waren
Kapitel zu ordnen, chronologische Entstehungsdaten zu
erinnern und Seiten zu gestalten.

Das Ergebnis ist das beste und einzige Buch über
Hamburgs Kunst auf Straßen und Zügen – Hamburg City
Graffiti!

. PROJECT
HAMBURG CITY GRAFFITI

. DESCRIPTION
The Hamburg City Graffiti book was suggested by SAMZ,
a Hamburg writer in a class of his own. He got it into his
head to produce this long-due book dealing with the last
twenty years of writing in Hamburg. We met to find out
if we could cooperate on carrying through this extensive
project and the planning started. For a whole year we
collected photos and set up letter boxes in all the retail
shops selling spray articles in Hamburg, in which photos,
texts or anything else of interest could be dropped
incognito. An interesting fact is that many interviews were
held on both sides of the fence. Prosecuted artistic cri-
minals and their sorely afflicted parents on the one side,
and public prosecutors and juvenile court magistrates
on the other side, all had their say. This approach and
the fact that the book is primarily by-us-for-us provides
the interested reader with a good insight into how the
graffiti scene in Hamburg has developed over the last
ten years at least. In spite of the considerable work-load,
we still did not have the faintest idea who would publish
this wonderful project. The Stylefile gentlemen from
the Publikat publishing company were quickly won over.
Unfortunately this only left us eight weeks to make a
layout of the 180 book is primarily by-us-for-us our good
old city of Hamburg deserves. For us, this quick decision
coupled with the close publication date meant that for a
period of sixty days we rarely had more than five hours
sleep. The remaining time was spent arranging the
chapters, remembering the chronological dates of origin
and designing the pages.

The result is the best and only book about art on the
streets and trains of Hamburg – Hamburg City Graffiti!

· 100

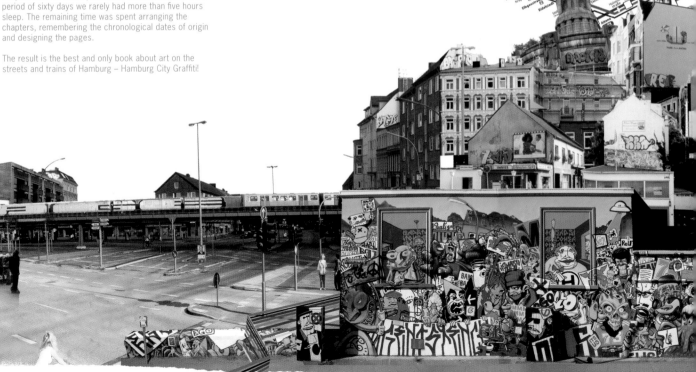

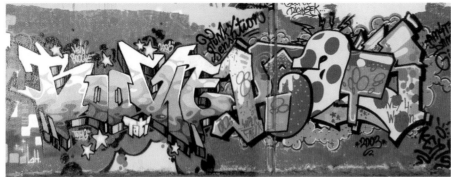

. **KUNDENLISTE.** CLIENTS LIST

. EMI Electrola
. Sony Music
. Columbia
. Universal Music
. Four Music
. Motor Music
. Mercury
. Island Records
. Greenpeace
. Def Jam Germany
. Polymedia Catalogue Marketing
. WEA
. Maximum HipHop (HipHop Tage
 in Hamburg) 1999-2002
. Karsten Jahnke Konzeptdirektion
. Eimsbush Entertainment
 (Mitgesellschafter und Gründer)
. Eimsbush Wear
. Golden Pudel Club
. Nobistor
. Buback Tonträger
. Yo Mama's Records
. Kiddo Records
. Groove Attack
. Vaul&Späth Management
. Chinchilla Recordings
. Wüste Filmproduktionen
. LaGente
. LODOWN magazine
. BLOND magazine
. Chef Styles
. Enfants Terrible
. Rap.de.records
. Cleptomanicx Skateboards
. Morphium Skateboards
. Waagenbau

. **KONTAKT.** CONTACT

Home. 01
Typeholics. stunning graffics
Hamburg. Germany

Home. 02
http://www.typeholics.de
contact@typeholics.de

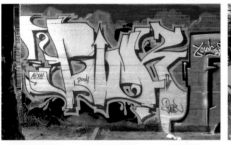 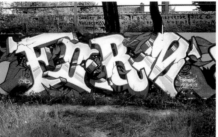

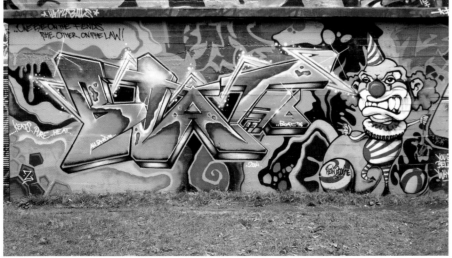

ACTION SPEAKS LOUDER THAN WORDS! ACTION SPEAKS LOUDER THAN WORDS!

•101 ++ 104

•100 HAMBURG CITY GRAFFITI. concept and layout.
released at Publikat publishing. ISBN 3-980-7478-6-7.
2003

•101 BOOGIE/KEATS. mural. 2003
•102 PUNK. mural. 2004
•103 FORM. mural. 2005
•104 BOAT. mural. 2004

09.0

Graffiti, Grafik oder Kunst – das sind für uns schon
lange keine Begriffe mehr, die sich in Bezug auf
unser Schaffen voneinander trennen lassen.
Sämtliche Einflüsse schmelzen zusammen und
finden gefiltert durch die Persönlichkeit ihren
Ausdruck in dieser oder jener Form.

VIAGRAFIK

09.0

For a long time now we have not been able to treat
the concepts of graffiti, graphics or art as sepa-
rate elements in our creative work. All influences
flow together and are expressed in different ways
by different personalities.

VIAGRAFIK

. CREW
GEIST 13. Tim Bollinger. *1976
MNWRKS. André Nossek. *1975
BOE. Leo Volland. *1974
SIGN. Till Heim. *1977
N6. Robert Schwartz. *1975

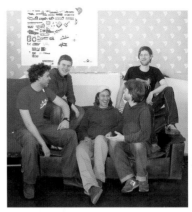

. UNTERNEHMEN
1998 Gründung der Gruppe
2003 erstes Büro in Mainz, Bürobetrieb
 mit ständiger Präsenz
2004 Umzug nach Wiesbaden

. COMPANY
1998 foundation of the crew
2003 first office in Mainz, Germany,
 permanent manned office
2004 move to Wiesbaden, Germany

. ARBEITSBEREICHE
. Corporate Identity, Corporate Design
. Platten- und CD-Cover-Gestaltung (auch Musikvideos)
. Buch-, Broschüren- und Kataloggestaltung
. Illustration
. Poster- und Flyergestaltung
. Clips, Animation, on-air-Design
. Internetseiten und Webflyer
. Fassaden- und Innenraumgestaltung
. Schriftentwicklung

. JOB FOCUS
. Corporate Identity, Corporate Design
. record and CD cover design (also music videos)
. book, brochure and catalogue design
. illustration
. poster and flyer design
. clips, animation and on-air-design
. web pages and web flyers
. facade and interior design
. font design

. HISTORY
BOE, GEIST13 und N6 starteten ihre Graffitilaufbahn
1991. SIGN begann 1994 und MNWRKS begann auch
Mitte der 90er, in Form von Underground-Plakaten und
Schablonen seiner politischen Meinung in den Straßen
von Mainz Ausdruck zu verschaffen. Nach der Gründung
von VIAGRAFIK als Graffiti- und Designercrew 1998, stieß
MNWRKS 2001 als Letzter zur heutigen Formation.

Während BOE ab 1998 hauptsächlich mit seinen schwarz-
silbernen Wandbildern und reduzierten Buchstaben auf
sich aufmerksam machte, kam der Durchbruch für die
Crew mit der Einladung zur Urban Discipline 2002.

. HISTORY
BOE, GEIST 13 and N6 started their graffiti-career in
1991. SIGN started in 1994 and in the mid-nineties
MNWRKS began to decorate the streets of Mainz by
putting up subversive posters and stencils to vent his
political opinion. VIAGRAFIK was founded as a graffiti
and design crew in 1998. The last member of the
present team, MNWRKS, joined in 2001.

While BOE managed to draw attention to himself by
doing black and chrome murals with reduced letters,
the breakthrough for the crew came with an invitation
to the Urban Discipline in 2002.

• 001 ++ 003

• 001 VIAGRAFIK CREW. 2004
• 002 OFFICE. Wiesbaden. Germany. 2004
• 003 HOME. http://www.viagrafik.com

• 004 SIGN. mural. Mainz. Germany. 2004
• 005 GEIST 13. mural. Wiesbaden. Germany. 2002
• 006 BOE. mural. Mainz. Germany. 2003

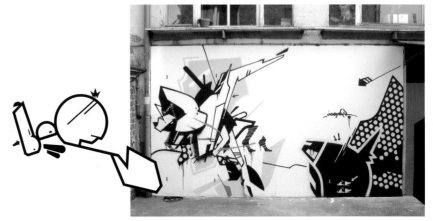

• 004 ++ 005

• 006

Im Spannungsfeld von Studium, beruflicher Tätigkeit in Designagenturen und fortlaufender künstlerischer Arbeit erarbeitete sich VIAGRAFIK während der letzten Jahre immer eigenständigere Resultate. Bei Wandproduktionen mit der Sprühdose wurde das ursprüngliche Stylewriting immer stärker mit Methoden der Grafik, wie z.B. Komposition, Konstruktion und Reduktion, vermischt. Und auch formale und ästhetische Erkenntnisse, die aus der Auseinandersetzung mit Architektur und freier Kunst herrührten, prägten zunehmend den Stil von VIAGRAFIK. Auf der anderen Seite wirkte sich der von der Graffitimalerei geschulte Ehrgeiz, einen eigenen Stil zu entwickeln, auf das Design von VIAGRAFIK, sowohl im Grafik- als auch im Bewegtbildbereich aus. Wann immer es die Aufgabe erlaubt, versuchen wir, eine eigene Formensprache und den spielerischen Umgang mit den Elementen, den wir vom Graffiti her gewohnt sind, mit ins Spiel zu bringen, um alternative Welten zu kreieren. Durch unser eigenes, breit gefächertes Leistungsangebot und unseren Firmensitz, an dem wir mit einer Fotografin, einer Firma für 3D-Animationen und Internetleuten zusammensitzen, sind wir in der Lage, auch umfassende Projekte selbst zu bearbeiten.

FROM WALL TO SCREEN TO EVERYTHING.

Neben einer stark ausgeprägten formalen Auseinandersetzung mit den beschriebenen Sparten fand aber auch eine inhaltliche Weiterführung des künstlerischen Arbeitens im öffentlichen Raum statt. Im Rahmen der als Streetart bezeichneten Bewegung war es insbesondere MNWRKS/SLAVE, der gegen Ende der 90er Jahre anfing, seine als Grafiker erworbenen Fähigkeiten in Form von Schablonen, Plakaten und Aufklebern in die Straßen zu tragen, um seinen politischen Ansichten Ausdruck zu verschaffen. Mittlerweile haben die einzelnen Mitglieder von VIAGRAFIK unterschiedliche Schwerpunkte in ihrer künstlerischen Arbeit, deren Zusammenführung und Kombination immer wieder eine neue Herausforderung darstellt.

During the last hectic years between studies, jobs in design agencies and continuous artistic activities, the VIAGRAFIK crew has developed results of increasing originality. The style writing initially used for wall productions with spray cans was combined with graphical techniques such as composition, construction and reduction. Formal and aesthetic elements that we came across in the fields of architecture and free art had a formative influence on the VIAGRAFIK style. On the other hand, the ambition to create an individual style that is cultivated by graffiti art has also influenced VIAGRAFIK's style of graphics and animation. Whenever possible, we try to apply our own language of forms to the task in hand and create alternative worlds through the playful treatment of elements, which is a customary practice in graffiti. Due to the wide diversity of our services and the fact that we share our office with a photographer, a 3-D animation studio and a web design agency, we are in a position to handle large projects on our own.

FROM WALL TO SCREEN TO EVERYTHING.

In addition to a distinct formal concentration in the sectors described above we continued our artistic work in the public sector where we concentrated on developing content. In the late nineties it was MNWRKS/SLAVE in particular who started to apply the skills he had acquired as a graphic artist to the street art scene. He used stencils, posters and stickers to give vent to his political opinions. Meanwhile each member of VIAGRAFIK has his own individual priorities in his artistic work. Reuniting and combining these different priorities always presents a new challenge.

• 007 N6. mural. Wiesbaden. Germany. 2003
• 008 VIAGRAFIK. mural. Wiesbaden. Germany. 2003

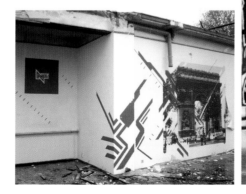

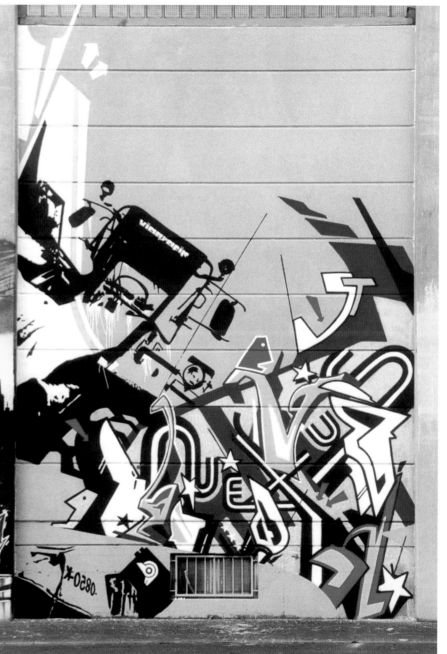

09.2

•009

•010

•009 N6/BOE. mural. Modena. Italy. 2004
•010 BOE. little BOE with his big E. 2004

. PROJEKT
Corporate Identity

. KUNDE
KAUZ

. BESCHREIBUNG
Kreation einer Modemarke und deren Erscheinungsbild.
Die Marke sollte sich möglichst wenig an der aktuellen
Konkurrenz orientieren und von einem eigenständigen
Image, das auf dem künstlerischen Background von
VIAGRAFIK und WORLDATELIER basiert, umgeben sein.
Zielgruppen sind, um die Marke zu etablieren, Trendsetter
des gesamten Street-Culture-Bereiches, die selbstbe-
wusst ihre Eigenständigkeit/-artigkeit betonen wollen.

Mit dem Markennamen KAUZ, der im Deutschen auch
einen Sonderling bezeichnet, und einer sehr eigenwilligen
und variablen Gestaltung, sowohl der Produkte als auch
der weiteren Markenerscheinung, wird ein kreatives Bild
der Marke erzeugt. Alle T-Shirts haben einen anders-
farbigen Ärmel als signifikantes Markenzeichen. Konzep-
tionelle Mottos, unter denen die Kollektionen in limitierter
Auflage entwickelt werden, sollen dem Käufer nicht nur
die geschmackliche, sondern auch die inhaltliche
Identifikation mit KAUZ ermöglichen. Titel der ersten
Kollektion: Kill Boredom Series.

http://www.kauzwear.com

. PROJECT
Corporate Identity

. CLIENT
KAUZ

. DESCRIPTION
The assignment was to create a fashion label with its
own distinctive character. The label should avoid similarity
with current competitors and be identified by an individual
image based on the artistic background of VIAGRAFIK and
WORLDATELIER. A specific target group was chosen to
establish the label. This group consisted of trend-setters
from the whole street culture scene, who want to demon-
strate their self-confidence, individuality and singularity.

In German the word KAUZ is used to describe an eccen-
tric. With its own distinctive and flexible design the label
generates a creative image and is easily recognisable on
other brand products. The T-shirts each have different
coloured sleeves as a significant trade-mark. Limited
collections will be designed with conceptual mottoes so
that the consumer can identify himself with the KAUZ
design as well as with its message. The title of the first
collection is: Kill Boredom Series.

http://www.kauzwear.com

•011

•011 KAUZ. stationery and business cards. 2004
•012 ++ 015 KAUZ. Kill Boredom Series. 2004
•016 KAUZ. logo. 2004

•012 ++ 016

LINOTYPE KILLER™ · PS FONT MAC/PC

CCCP UNION INLINE™ · PS FONT MAC/PC

NECURA 0.1™ · PS FONT MAC/PC

CISCAL 831™ · PS FONT MAC/PC

• 017 ++ 025

• 026 ++ 029

• 017 STRUGGLE. cloaka design. 2003
• 018 33 MAILORDER. 2002
• 019 OUTBURST RECORDS. 2002
• 020 FAULTIER NACHHILFEINSTITUT. 2002
• 021 PREACHERS CLUB. 2004

• 022 FATUM SURFBOARDS. 2004
• 023 GET ALIVE MTV. 2005
• 024 DJ COUSEN. 2002
• 025 N6 TOYS. 2003

• 026 LINOTYPE KILLER. font design. 1998
• 027 CCCP UNION INLINE. font design. 2002
• 028 NECURA 0.1. font design. 2002
• 029 CISCAL 831. font design. 2002
download VIAGRAFIK fonts on FADINGS DIGITAL

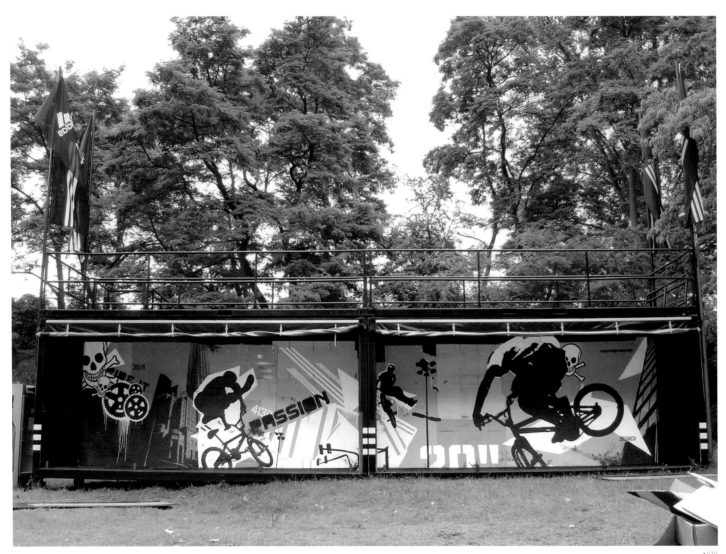

•030

•030 ADIDAS. showroom at BMX world. Cologne.
Germany. 2004

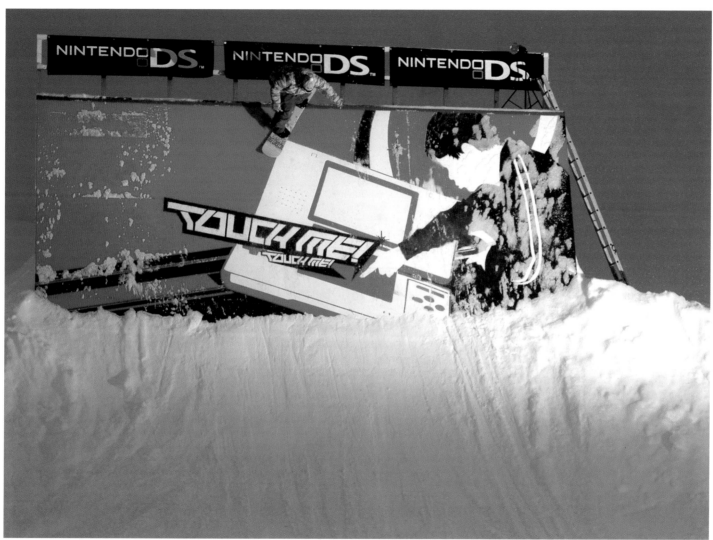

•031 WALLRIDE. Nintendo's DS-Console.
promotion campaign. 2005

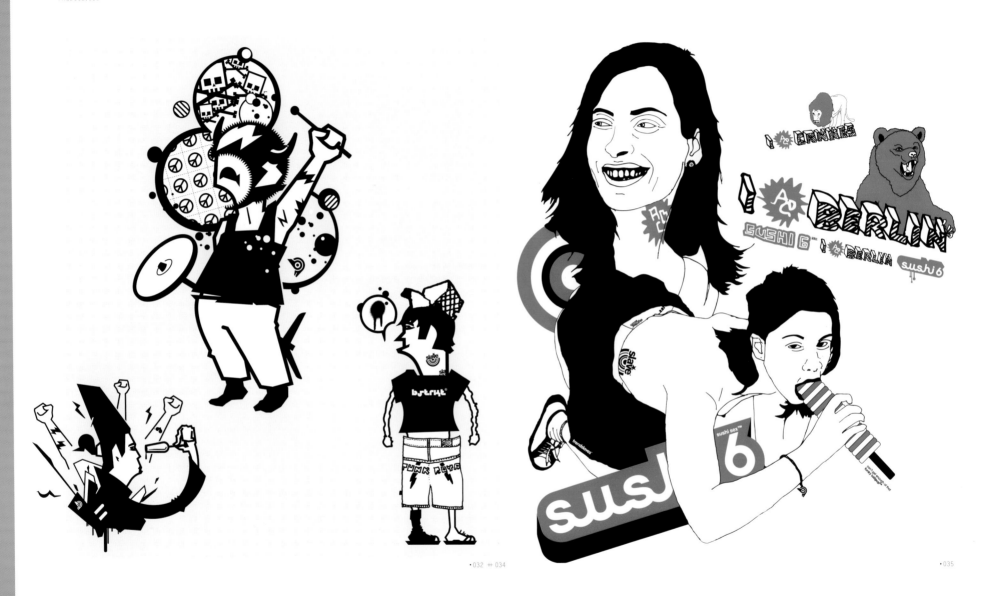

• 032 + 034

• 035

• 032 ANIMAL COLLECTIVE. illustration. INTRO magazine. 2003
• 033 ANNIVERSARY. illustration. INTRO magazine. 2003
• 034 I AM SO TRENDY. illustration. INTRO magazine. 2003
• 035 I ADC BERLIN. sushi. ADC Germany

. PROJEKT
FUNKSTÖRUNG

. KUNDE
!K7 Records

. BESCHREIBUNG
Zum Release der neuen LP von FUNKSTÖRUNG wurden
verschiedene Künstler und Designer gebeten, visuelle
Interpretationen der einzelnen Tracks in Form von
animierten Clips anzufertigen. Diese wurden auf einer
zusätzlichen DVD herausgegeben.

Im Clip zum Track „The Zoo" breiten sich abstrakte
Gebilde zu den sphärischen Klängen der Musik im Raum
aus. Kontrastiert werden die langsamen und beruhigen-
den Klänge und Bewegungen des Objektes von der
hektischen Anhäufung und Auflösung von Menschen-
haufen im Zeitraffer.

. PROJECT
FUNKSTÖRUNG

. CLIENT
!K7 Records

. DESCRIPTION
At the release of the new FUNKSTÖRUNG LP different
artists and designers were invited to prepare visual
interpretations of the individual tracks in the form of
animated clips. These were also released on a supple-
mentary DVD.

In the clip to "The Zoo" abstract forms spread themselves
out in space in time to the spherical sounds of the music.
The movements of the objects were slow and soothing
in contrast to the crowds of people hectically gathering
and breaking up in fast motion.

• 036 ++ 040

• 041 ++ 049

• 036 ++ 040 FUNKSTÖRUNG. screenshots. 2004
• 041 ++ 049 CROSS MEDIA LAB. trailer for CrossMediaNight
at the HfG Offenbach. Germany. 2003
see the trailer on FADINGS DIGITAL

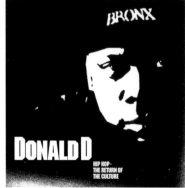

• 056 ++ 060

• 050 ++ 055

• 050 FLANGER. record cover. diploma work. 2002
• 051 ATROX. record cover. 2003
• 052 FUNKSTÖRUNG. record cover. not realised
• 053 BOCHUMWELT. record cover. diploma work. 2002
• 054 DJ ONE. record cover. 2002
• 055 DONALD D. record cover. 2003

• 056 FREEDOM. Fanatic Snowboards
• 057 LOLITA. Fanatic Snowboards
• 058 STARSHIP. Fanatic Snowboards
• 059 NO NAME. Fanatic Snowboards
• 060 POWER AND GLORY. Fanatic Snowboards

. PROJEKT
Mailorderkatalog. 2003

. KUNDE
SHREDQUARTERS SNOWBOARDSHOP

. BESCHREIBUNG
Halbjährlich bringt der Shop einen Katalog in einer
Auflage von 10.000 Stück heraus. Knapp 1.500 Produkte
sind auf 64 Seiten unterzubringen.

Im Zuge des Wiederauflebens von Punk in Musik und
Mode wurde der Sommerkatalog mit vielen trashigen
Details versehen, ohne dass diese zu sehr von den
Produkten ablenken. Die Rahmengestaltung wurde so
flexibel gehalten, dass jede Doppelseite optisch neue
und überraschende Anreize bietet.

. PROJECT
Mail order catalogue. 2003

. CLIENT
SHREDQUARTERS SNOWBOARDSHOP

. DESCRIPTION
Twice a year the shop brings out a catalogue with a
circulation of 10,000 copies. About 1,500 products are
displayed on 64 pages.

To hail the revival of punk music and fashion we designed
the summer catalogue with a multitude of trashy motifs
that did not distract the reader's attention from the pro-
ducts. The design was so flexible that each double page
could feature new and surprising incentives.

•061 ++ 063

•061 SHREDQUARTERS MAILORDER. catalogue cover. 2003
•062 ++ 063 SHREDQUARTERS MAILORDER. double-page spreads. 2003

•064

•065 +·067

. PROJEKT
OPEN OHR FESTIVAL. 2004

. KUNDE
Stadt Mainz

. BESCHREIBUNG
Jährlich findet das OPEN OHR FESTIVAL in Mainz statt.
Traditionell ist es der Anspruch der Organisatoren, das
Festival unter einem politisch kontroversen Motto laufen
zu lassen, welches dann auch in Foren diskutiert werden
kann.

Das Thema „Arbeit Abschaffen" inspirierte uns zu einer
ganzen Schwemme unterschiedlicher Bildideen, von
denen wir auch sechs zu Plakatvorschlägen ausarbei-
teten. Zu sehen ist jenes, das uns als das Gelungenste
erscheint, da es neben einem eindrucksvollen Wort-Bild-
Bezug auch durch seine schlichte Ästhetik besticht,
die nicht zu zeitgeistig ist und eine breite Zielgruppe
ansprechen kann.

Die Veranstalter entschieden sich letztlich für einen ande-
ren unserer Vorschläge, der das Thema weniger drastisch
illustriert und somit nicht Gefahr lief, von den Entschei-
dungsträgern auf städtischer Seite abgelehnt
zu werden.

. PROJECT
OPEN OHR FESTIVAL. 2004

. CLIENT
City of Mainz, Germany

. DESCRIPTION
Every year the OPEN OHR FESTIVAL takes place in Mainz,
Germany. Traditionally, the organisers launch the festival
under a politically controversial motto that serves as
a theme for different discussion forums.

The theme "Arbeit Abschaffen" (abolish work) gave us
inspiration for countless different visual ideas. Six of
these ideas were made into drafts for posters. The one
shown above is the one we consider to be the most
successful. It is compelling in its word and image content
and has a minimalist aesthetic design that is not over-
trendy and can appeal to a broad target group.

The organisers finally chose a different poster that
illustrated the theme less drastically and was more likely
to be accepted by the municipal authorities.

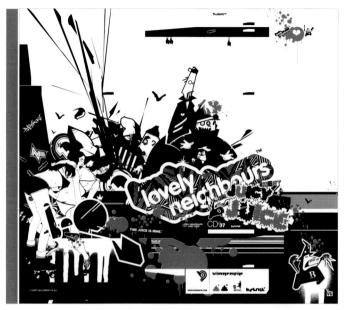

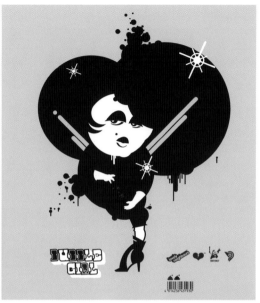

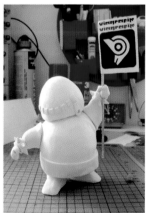

• 074

• 068 ++ 073

• 068 LOVELY NEIGHBOURS. illustration.
 JUICE magazine. 2004
• 069 BUBBLEGIRL. self-promo. 2004
• 070 ++ 072 ELMAR UND HERBERT. N6-toys. 2000-2004
• 073 SADOTOY. N6-toy. 2004
• 074 FUNKBRETT. GEIST13. free work. 2004
• 075 SADOBOYS. N6. illustrations. 2004

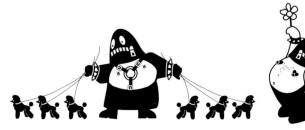

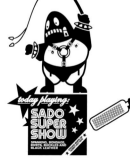

• 075

. PROJEKT
SLANTED. Ausstellung im Klingspor Museum.
Offenbach am Main. 2004

. BESCHREIBUNG
Das Klingspor Museum lud uns ein, als Kontrastpro-
gramm zur international operierenden Designagentur
PENTAGRAM in einem Raum des Museums auszustellen.
Desweiteren sollten wir dem Publikum im Rahmen der
Museumsnacht im Hof des Klingspor eine Performance
darbieten.

Mit Flyern und der Gestaltung einer Litfasssäule in der
Offenbacher Innenstadt machten wir im Vorfeld auf die
Performance aufmerksam. Zur Museumsnacht selbst
bauten wir ein Konstrukt aus Holz und Pappe, welches
wir schließlich noch bemalten. Das Gebilde steht in
spannungsvollem Kontrast zu der historischen Kulisse
des alten Offenbacher Rathauses. Unser Ziel, die
gewohnte Atmosphäre des Ortes zu stören und eine Stim-
mung von Unruhe und Aufbruch zu erzeugen, haben wir
erreicht, wie uns die Reaktionen der Passanten zeigten.

. PROJECT
SLANTED. Exhibition at the Klingspor Museum.
Offenbach/Main, Germany. 2004

. DESCRIPTION
We were invited by the Klingspor Museum to present an
exhibition in one room of the museum as a contrast
programme to the exhibition of the internationally
operating design agency PENTAGRAM. We were further-
more requested to do a performance for the public in
the courtyard of the museum during the "Museumsnacht".

We promoted the performance with flyers and decorated
an advertising column in the centre of Offenbach. For
the "Museumsnacht" we built a construction of wood
and cardboard which we then painted. The construction
stood in dramatic contrast to the historical backdrop of
Offenbach's former town hall. Judging by the reactions
of the passers-by, we seemed to have achieved our aim
which was to disturb the usual atmosphere of the place
and create a mood of agitation and displacement.

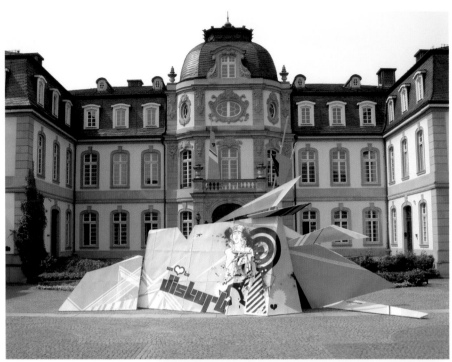

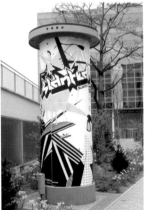
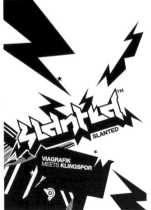

•076 ++ 077

•078 ++ 080

•076 SLANTED. advertising column. Offenbach. Germany. 2004
•077 SLANTED. flyer. 2004
•078 SLANTED. performance's result. Offenbach. Germany. 2004
•079 SLANTED. N6. object. 2004
•080 SLANTED. live performance. Offenbach. Germany. 2004

. Graffiti, Grafik oder Kunst – das sind für uns schon lange keine Begriffe mehr, die sich in Bezug auf unser Schaffen voneinander trennen lassen. Sämtliche Einflüsse schmelzen zusammen und finden gefiltert durch die Persönlichkeit ihren Ausdruck in dieser oder jener Form.

Die Form, das Formale, sind diejenigen, die seit jeher den vielfältigen Einflüssen aller möglicher historischer, kultureller und sozialer Sparten ausgesetzt waren – förmlich nach ihnen gesucht haben. Während „reines" Graffiti unserer Meinung nach seine Möglichkeiten wohl ziemlich erschöpft hat, liegt im Aufeinandertreffen mit Design eine Bereicherung der Form mit Berechtigung und Zukunft. Ob die „eigene" Form jedoch auch kommerziell erfolgreich ist, hängt nicht nur von den handwerklichen Fähigkeiten des Schaffenden ab, sondern zu guter Letzt natürlich auch von dessen Ideen und Visionen und seiner Fähigkeit, diese zu verkaufen. Dadurch werden die Graffix letztendlich zum Design.

. For a long time now we have not been able to treat the concepts of graffiti, graphics or art as separate elements in our creative work. All influences flow together and are expressed in different ways by different personalities.

The symbolic form has always been exposed to multiple historical, cultural and social influences for which it has always been searching. In our opinion "pure" graffiti has exhausted most of its possibilities. However, when form is enhanced by the combination with design, it has a justifiable future. Whether or not one's own form is commercially successful depends on the technical skill of the artist and his ideas and visions and ability to sell these. Thus graffix become design.

. **KUNDENLISTE.** CLIENTS LIST

. WEA Records
. MTV Networks GmbH & Co OHG
. VOLKSWAGEN AG
. Polydor Zeitgeist Records
. Home Records
. Konvex/Konkav Records
. Fanatic Snowboards
. Matrix Club. Switzerland
. Dorian Gray. Frankfurt. Germany
. Electrolux Records
. Sony Music
. Linotype
. Motorola
. Opel
. Messe Frankfurt
. K2 Kickboards
. Afri Cola
. Objektform
. Sozialministerium
 Baden-Württemberg

. Computer Arts magazine
. INTRO magazine
. US Forty
. JUICE magazine
. BLOND magazine
. Trust magazine
. Grönland Records
. Hot Shit Records
. JMS
. 3Deluxe
. Nescafé
. Agfa
. adidas
. Shredquarters Snowboardshop
. Railslide Sk8Shop
. Citiworks
. Stadt Kronberg
. Stadt Schwalbach
. Jugendamt Stadt Mainz

. **KONTAKT.** CONTACT

Home. 01
Wiesbaden. Germany

Home. 02
http://www.viagrafik.com
info@viagrafik.com

10.0

HELLO wird durch seine urbane Kunst zum grafischen Aufwiegler. Auf diesem vagen Terrain von Ideen entwickeln sich ästhetische, intuitive und engagierte Arbeiten.

HELLO

10.0

Through his urban art HELLO has become an agitator in the world of graphics. This vague territory of ideas fosters aesthetic, intuitive and dedicated works.

HELLO

. CREW
HEKS. *1980
HEPT. *1979

. UNTERNEHMEN
Entstehungsjahr: 1999
Arbeitsort: Ursprünglich Grenoble, Frankreich, die Stadt in der wir die Agentur HELLO und die Kleidermarke HIXSEPT gegründet haben. Zurzeit haben wir unseren Hauptsitz in Barcelona, Spanien.

. ARBEITSBEREICHE
. Modedesign
. Buchgestaltung
. Illustration
. Grafikdesign
. Malerei
. Schriftentwicklung

. HISTORY
Die Agentur ist aus der Idee zweier französischer Graffitikünstler entstanden. 1999 haben wir die Marke HIXSEPT gegründet, die den Auftakt gab, Graffitielemente auf Kleidungsstücke zu bringen. HIXSEPT konnte zeigen, dass Innovation auf textilem Trägermaterial noch möglich war. Das Copyleft-Logo der Marke – ein spiegelverkehrtes Copyrightzeichen – ist das Ergebnis einer Geisteshaltung: sich am Rande aller Grundwerte befinden.

Wir rühmen das Unregelmäßige, das Gegenteilige, das Asymmetrische, das Lockere, das Zufällige. Die Kreation eines Kleidungsstückes erfolgt über die Suche nach einem Konzept, einer starken Idee.

Das HELLO Büro, die Agentur für Kommunikationsdesign, arbeitet mit anderen Unternehmen zusammen, die unterschiedliche Schwerpunkte haben. Ebenso entwickeln wir Publikationsprojekte im Kunstbuchbereich, planen Ausstellungen für eigene künstlerische Arbeiten und führen diese durch.

.. KONTAKT. CONTACT

Home. 01
Barcelona. Spain

Home. 02
http://www.formuledepolitesse.com
http://www.hixsept.com

. COMPANY
Established: 1999
Place of work: originally Grenoble, France. Here we founded the agency HELLO and the fashion label HIXSEPT. Present location: Barcelona, Spain

. JOB FOCUS
. fashion design
. book design
. illustration
. graphic design
. painting
. font design

. HISTORY
The agency is a joint concept of two French graffiti artists. In 1999 we founded the fashion label HIXSEPT which was the prelude to incorporating graffiti elements in clothes design. HIXSEPT proved that innovations in textiles are still possible. The copyleft logo – a reflected copyright sign – gives an insight into the label's message, which is to keep to the edge of common values.

We praise the concepts of the erratic, the contrary, the asymmetrical, the carefree and the coincidental. Our search for a concept or a compelling idea can inspire the creation of a garment.

HELLO the agency for communications design cooperates with other companies with different focuses. Furthermore we create editorial projects with focus on art books and also the planning and realisation of exhibitions showing our art works.

. 001 . 002

. 001 HEKS
. 002 HEPT
. 003 STUDIO. Grenoble. France. 2004

10.1

hello

bureau de ~~style~~ et de ~~communication graphique~~

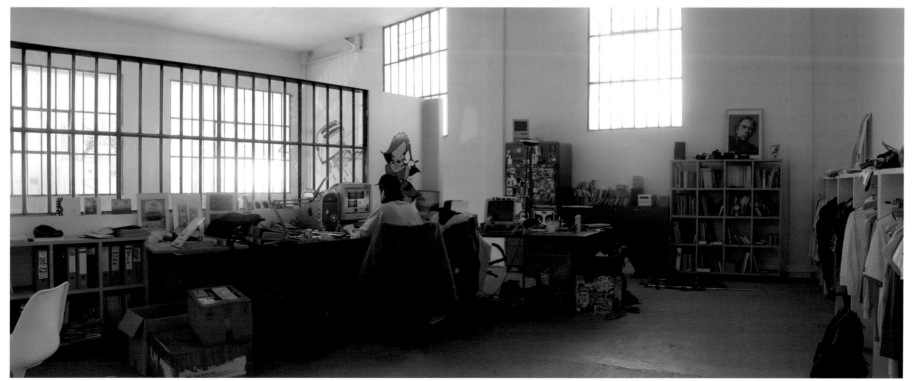

. PROJEKT
MANO IZQUIERDA

. BESCHREIBUNG
Wir machen Graffiti seit 1995 und malen momentan so
vereinfacht wie möglich. Ohne uns Zügel aufzuerlegen,
malen wir mit Restdosen, Original-Caps und mit der linken
Hand und versuchen somit die Basis von Graffiti wieder
zu finden.

Um die „nicht saubere Seite" unserer Bilder zu um-
schreiben, haben wir diesen Malstil MANO IZQUIERDA
(linke Hand) genannt. Unsere Schriftzüge oder Character
laufen und entstehen spontan. Graffiti mit der zweiten
Hand, mit größter Einfachheit gemacht.

. PROJECT
MANO IZQUIERDA

. DESCRIPTION
We have been painting graffiti since 1995 and at present
we are keeping it as simple as we can. Without setting
ourselves any limits we use rest cans and original caps
and paint with the left hand to try to find the origins
of graffiti.

To paraphrase the "non-clean side" of our pieces, we
gave this style the name MANO IZQUIERDA (left hand).
The letters and characters evolve and progress spon-
taneously. This is graffiti done with the second hand,
executed with the greatest simplification.

• 004 ++ 027 HEKS/HEPT. murals. 2004-2005

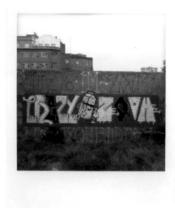
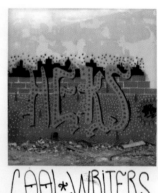

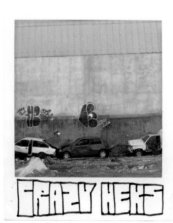
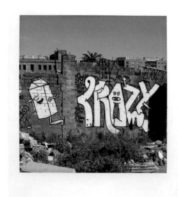

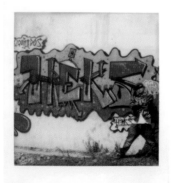

• 004 ++ 012

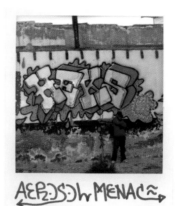

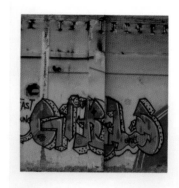

RIEN N'EST VRAI
TOUT EST PERMIS

AEP:⊃l► MENAC∼

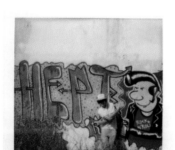

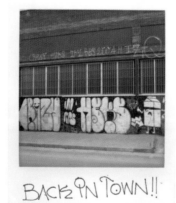

COOL →HEKS

BACK ON TOWN!!

. PROJEKT
HIXSEPT - ART IS NOT A CRIME. FUCK THE BUFF

. BESCHREIBUNG
Dieser von der New Yorker Crew UNITED ARTISTS
kreierte Slogan wurde auf U-Bahnen gemalt und auf
Wände getaggt. Er klingt wie eine Opposition zur
MTA (der New Yorker Nahverkehrsgesellschaft).
Er prangert die täglichen Reinigungsarbeiten an den
Waggons an, die in ganzen Nächten mit Graffiti über-
zogen wurden und in nur wenigen Minuten „gebufft"
(gereinigt) wurden.

Um unser Thema „Ich verabscheue Graffiti" zu ver-
vollständigen, produzieren wir die Neuauflage des von
den New Yorker UNITED ARTISTS in den 80er Jahren
getragenen T-Shirts.

. PROJEKT
HIXSEPT - ANTI-GRAFFITI NETWORK

. BESCHREIBUNG
Weit vor New York sind in Philadelphia die ersten Formen
von Tags entstanden. Daraus haben sich verschiedene
Maßnahmen entwickelt, um dieser ständig wachsenden
Bewegung zu begegnen: Von der Stadt initiierte Plakat-
kampagnen um gegen Graffiti anzukämpfen, zahlreiche
Verhaftungen der Tagger, Entstehung des „Philadelphia
Anti-Graffiti Network" und Anstiftung zur Denunziation
durch das Aussetzen von Kopfgeldern, um Graffitimaler
zu stoppen.

Um unser Thema „Ich verabscheue Graffiti" zu ver-
vollständigen, produzieren wir die Neuauflage des von
dem Anti-Graffiti-Dienstleister Philadelphias in den 80er
Jahren getragenen T-Shirts.

. PROJEKT
HIXSEPT - ZAUN. BACKSTEIN. FICK DIE POLIZEI

. BESCHREIBUNG
Diese Kleiderserie ist eine Interpretation urbaner
Elemente, die im Laufe von Reisen fotografiert wurden,
durch grafische Aufarbeitung. Diese auf Textil gesieb-
druckten grafischen Kreationen interpretieren die
bekannten Textilmotive Burlington (Zaun) und
Streifenmuster (Backstein).

. PROJECT
HIXSEPT - ART IS NOT A CRIME. FUCK THE BUFF

. DESCRIPTION
This slogan, created by the New York crew UNITED
ARTISTS, was painted on subways and tagged on walls.
It sounds like a confrontation with the MTA (Metropolitan
Transportation Authority in New York). It flaunts the daily
cleaning of the subways. It takes all night to paint a
subway and then it is cleaned up, "buffed", in a few
minutes the next day.

To conclude our theme "I hate graffiti", we are producing
a new edition of the T-shirt worn by New York's UNITED
ARTISTS in the nineteen-eighties.

. PROJECT
HIXSEPT - ANTI-GRAFFITI NETWORK

. DESCRIPTION
The first forms of tags were developed in Philadelphia,
long before they came to New York. In consequence,
various sanctions were imposed to counter this con-
stantly growing movement. The city wanted to put
a stop to graffiti painting and initiated anti-graffiti poster
campaigns, arrested countless taggers, founded the
"Philadelphia Anti-Graffiti Network" and put out head
money as an incitement to denounce graffiti artists.

To conclude our theme "I hate graffiti", we are producing
a new edition of the T-shirt worn in the nineteen-eighties
by the "Anti-Graffiti" service staff in Philadelphia.

. PROJECT
HIXSEPT - FENCE. BRICK. FUCK THE POLICE

. DESCRIPTION
This clothing series is a graphical interpretation of urban
elements that were photographed on journeys. These
graphical creations are printed on textiles and reproduce
the well-known motives Burlington (fence) and stripe
pattern (brick).

• 028 ++ 029

• 030 ++ 031

•032 ++ 033 •034 ++ 035 •036 ++ 037

•032 ++ 033 FENCE. 2004
•034 ++ 035 BRICK. 2004
•036 ++ 037 FUCK THE POLICE. 2004

. PROJEKT
HIXSEPT EST IRREGULIER
(HIXSEPT ist irregulär)

. BESCHREIBUNG
Winter- und Sommerkatalog 2003/04
Format 14cm x 17cm, 110 Seiten
Darin werden auch die Grafikarbeiten von 16 Künstlern
vorgestellt.

. PROJECT
HIXSEPT EST IRREGULIER
(HIXSEPT is irregular)

. DESCRIPTION
winter and summer catalogue 2003/04
size 14cm x 17cm, 110 pages
It also presents the graphical works of 16 artists.

•038 ++ 039

•040 ++ 041 •042 ++ 043

•038 M. VERDEIL. season 2003
•039 M. VERDEIL. season 2004
•040 AKROE. season 2003
•041 MISS VAN. season 2003
•042 M. VERDEIL. season 2003
•043 TOASTER. season 2004

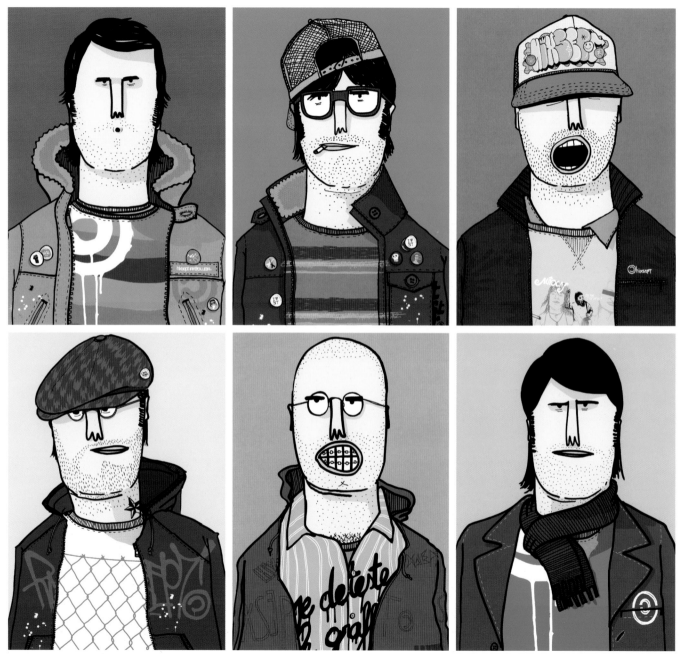

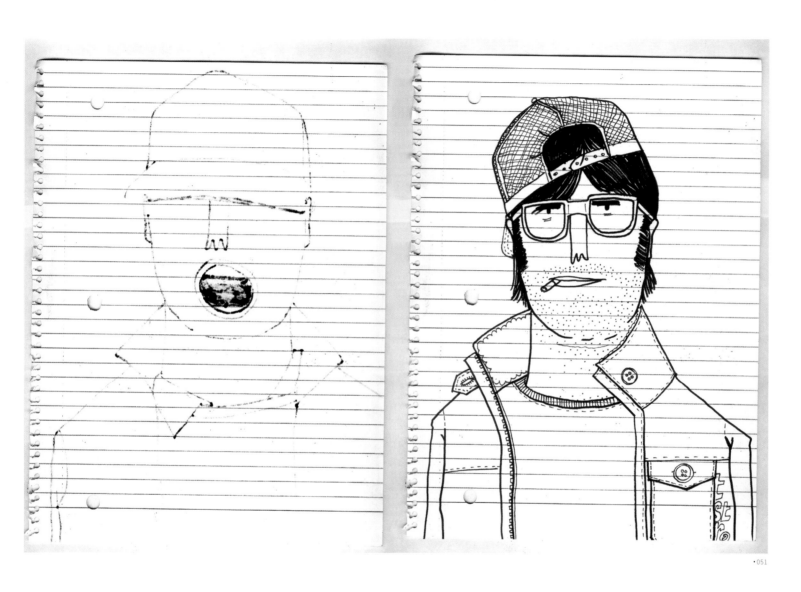

•051

•045 + 051 VARIOUS ILLUSTRATIONS. advertising campaign. winter 2004

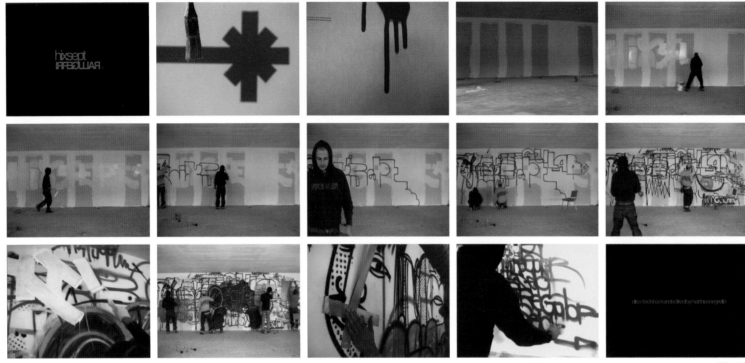

• 052 ++ 066

- - - - - - - - - - - - - - - - - - -
• 052 ++ 066 3"40. a video produced by Matthias Negrello. 2003

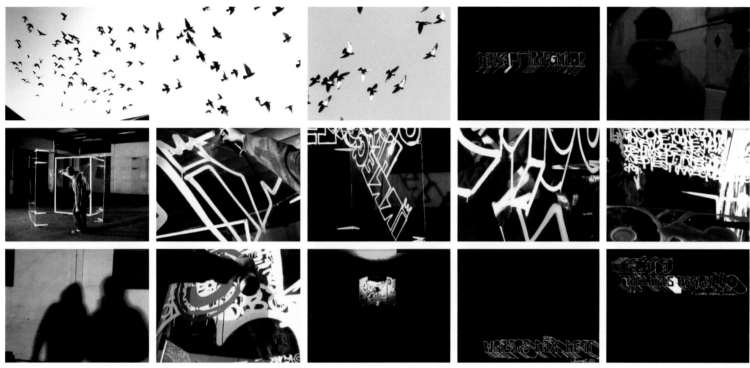

• 067 ++ 081

• 067 ++ 081 5"33. a video produced by Matthias Negrello. 2003
see the film on FADINGS DIGITAL

HAUT clarendon

ABCDEFGHIJKLM NOPQRSTUVWXYZ
abcdefghijklmnopqrstuvwxyz
0123456789

· 082

. PROJEKT
CLARENDON HAUT

. BESCHREIBUNG
Wir haben über einen neuen CLARENDON-Stil nachgedacht. Dies ist die Geburtsstunde der CLARENDON HAUT. Diese Kreation besteht darin, zwei Schrifttypen miteinander zu vermischen: CLARENDON (eine Type für den Druck), deren Buchstaben von Graffitimalern mit einer Farbrolle umgesetzt wurden. Diese ist auf der Basis der CLARENDON BOLD entstanden; sie wird mit einer Farbrolle gemalt und muss in einer bestimmten Höhe angebracht werden. Die für die Umsetzung verwendeten Farben sind weiß und schwarz. Wegen ihres historischen Inhaltes wurde die CLARENDON anderen Schrifttypen vorgezogen.

Die CLARENDON oder „der Buchstabe der industriellen Revolution" erblickte im Jahre 1845 in der Fann Street Foundry das Licht der Welt. Seine Form verdanken wir dem Typographen Robert Besley. Ihr Name verweist auf die CLARENDON der Oxford Press. Sie ist Teil der Ägyptischen Familie, der serifenbetonten Linear-Antiqua. In einer 1850 veröffentlichten Werbung machte Besley seine Schrift bekannt: „Die brauchbarste Schriftart, die ein Drucker in seiner Werkstatt haben muss, ist die CLARENDON". Sie hebt ein Wort oder eine Linie auf einer Rechnung oder einer Titelseite hervor und überdeckt nicht die anderen Linien. Die CLARENDON wurde mit großer Sorgfalt entwickelt, wodurch ihr Ausdrucksstärke und Kraft verliehen wurden. Sie verhindert die krumme Uneleganz der antiken oder ägyptischen Buchstaben und die Erscheinung eines gewöhnlichen römischen Buchstabens, der durch einen zu häufigen Gebrauch verdickt wurde. Die CLARENDON wurde vielmehr für den Textkörper der damaligen Publikationen, insbesondere für Tageszeitungen, verwendet. Gleichwohl wurde das Konzept, eher eine Bold als eine Kursive, zum Hervorheben eines Textes oder Wortes mit der CLARENDON erfunden. Diese Einzigartigkeit machte sie über lange Zeit hinweg zu einem Synonym für Bold-Buchstaben. Sie diente sogar dazu, bei manchen Spezialisten die Familie der ägyptischen Schrifttypen neu zu benennen.

Die von Graffitimalern mit Farbrollen umgesetzten Buchstaben sind gegen Ende der 80er Jahre entstanden. Vorreiter dieser Art von Schriftenmalerei sind COST und REVS. Dieses Duo hat in Manhattan Parkplatzwände mit Schriftzügen bemalt. Ihre Arbeiten waren von den Dächern aus sichtbar – denn von dort aus wurden sie auch produziert, in Form von Großbuchstaben mit weißer Wandfarbe. Die Einfachheit der Buchstaben, wie auch die Art und Weise ihrer Umsetzung, war eine grundlegend andere als die des traditionellen Graffiti. Dieser Stil ist sehr rasch zu einer angesehenen Alternative geworden und wurde auch von anderen Graffitimalern aufgegriffen. Im Laufe der Zeit sind Writer wie KR, ESPO oder auch SACE durch den Gebrauch derselben Art von Schrift bekannt geworden. Dieser Schrifttyp hat sich ebenfalls in Sao Paulo, Brasilien – wo Wände, Gebäude und Dächer mit Farbrollerschriften bedeckt sind – verbreitet. Die CLARENDON HAUT ist somit das Kreuzung dieser beiden Geschichten. Einerseits die konventionelle Kreation eines Typographen und andererseits die sich am Rande der Graffitibewegung befindlichen Graffitimaler, die mit Farbrollen illegal Schriften auf die Fassaden der Städte malen.

Die Existenz der CLARENDON HAUT könnte gleichermaßen wie die der CLARENDON Bold, Light, Roman, Black legitimiert werden. Gleichwohl soll diese Kreation nicht zum Ziel haben, einen für den Gebrauch geeigneten typografischen Stil hervorzubringen. Wir haben es vorgezogen, aus konzeptionellen und ästhetischen Gründen die CLARENDON HAUT zu entwickeln.

. PROJECT
CLARENDON HAUT

. DESCRIPTION
We thought about developing a new CLARENDON style. This was the birth of CLARENDON HAUT. This creation is made by combining two typefaces. CLARENDON is a print typeface whose letters were painted by certain writers with a paint roll. It evolved on the basis of CLARENDON BOLD which is painted with a paint roll. It has to be set at a certain height and is painted in black and white. We preferred CLARENDON to the other typefaces because of its historical background.

The CLARENDON or "the letter of the industrial revolution" was born in 1845 in the Fann Street Foundry. The shape was created by the typographer Robert Besley. The name CLARENDON refers to the Oxford Press. This typeface is part of the Egyptian typeface, the Linear Antiqua sans-serif. Besley presented this type in an advertisement published in 1850: "The most useful typeface a printer needs in his workshop is CLARENDON". It can highlight a word or a line on an invoice or front page without covering the other lines. CLARENDON was constructed very carefully and thus commands considerable power of expression and strength. It avoids the angular awkwardness of the antique or Egyptian typefaces without resembling the usual Roman typeface that was thickened through excessive use. CLARENDON was often used for the text body of former publications (especially for daily newspapers). At the same time the idea was born to use CLARENDON instead of bold or italic to highlight a word or a text. This uniqueness made CLARENDON a synonym for bold letters over a long period of time and was used by some specialists to rename the family of the Egyptian typeface.

The paint roll letters written by graffiti artists evolved in the late nineteen-eighties. The forerunners of this kind of writing are COST and REVS. This duo painted on the walls of parking lots in Manhattan. Their works could be seen from rooftops from where they were also produced. They wrote their names in capital letters using white paint. The simplicity of the letters and the way they were executed were a complete innovation in comparison to traditional graffiti. This style was soon respected as a good alternative and was used by other graffiti writers. In the course of time other writers such as KR, EPSO or SACE became well-known through the use of this type of writing. This type of writing has also spread to Sao Paulo where walls, buildings and roofs are covered with paint roll letters. CLARENDON HAUT emerged from crossing these two histories. On the one side there is the conventional creation of a typographer and on the other side there are graffiti writers on the fringes of the graffiti movement who illegally paint letters with paint rolls on the fronts of city buildings.

The existence of the CLARENDON HAUT typeface could be as equally legitimate as the existence of CLARENDON Bold, Light, Roman, Black. However this was not created with the intention of developing a useful typographical style. We preferred to create CLARENDON HAUT for conceptual and aesthetic reasons.

· 082 CLARENDON HAUT. 2004
· 083 CLARENDON HAUT. in use. 2004

• 084

. PROJEKT
JE TAGUE COMME TU FUMES
(Ich tagge wie du rauchst)

. BESCHREIBUNG
Dieser Satz handelt von der Beziehung zwischen der
Notwendigkeit der Raucher eine Zigarette zu rauchen
und der Tagger zu taggen. Während manche taggen,
rauchen andere und umgekehrt. Sie tun dies nur um Zeit
zu töten, aus Bedürfnis, ohne jeglichen Grund, um sich
einen bestimmten Stil zu geben, aus Lust, aus Gewohn-
heit, aus Besessenheit.

. PROJECT
JE TAGUE COMME TU FUMES
(I tag like you smoke)

. DESCRIPTION
This sentence is about the relation between a smoker's
need to smoke and the tagger's need to tag. While some
are tagging, others smoke, and vice versa. They do this
just to kill time, out of necessity, for no reason at all,
to give themselves a certain air, for fun, out of habit or
because it is an obsession.

10.5

• 085 ++ 093

• 084 ++ 093 JE TAGUE COMME TU FUMES. 2004

11.0

Unser kreatives Schaffen ist eine Symbiose unserer langjährigen Erfahrung als Graffiti- und Streetart-Künstler, gepaart mit Grafikdesign und alltäglichen visuellen Eindrücken. Die Grenzen – fließend, unsere Motivation – seit der ersten Graffitiskizze ungebrochen.

BACKYARD 10

11.0

Our artistic creations are a symbiosis of our long standing experience as graffiti and street art artists, coupled with graphic design and everyday visual impressions. The boundaries between all these are fluid and since the first graffiti drawing, our creative impetus has remained intact.

BACKYARD 10

• 001 ++ 003

. CREW
C100/SILK. Christian Hundertmark. *1974
OLSEN/SIAM. Oliver Landgraf. *1973
LOCAL HERO. Harold Lazaro. *1978

. UNTERNEHMEN
BACKYARD 10 wurde im Dezember 2003 gegründet.
Unsere Basis ist München.

. ARBEITSBEREICHE
. Corporate Identity, Corporate Design
. Produktgrafik
. Platten- und CD-Cover-Gestaltung
. Buch-, Broschüren- und Kataloggestaltung
. Poster- und Flyergestaltung
. Webdesign
. Messestand- und Innenraumgestaltung
. Schriftgestaltung
. Motion Graphics
. zusätzlich haben wir 2004 das Modelabel
 Usual Suspect™ gegründet

. HISTORY
C100
1989 Start der Graffitilaufbahn
1995 Studium Grafikdesign
1999 Festanstellung bei der Agentur For Sale
2000 Freelancetätigkeit für diverse Designbüros
 und eigene Kunden
2000 Start der ersten Streetartaktivität
2001-2003 Teil des Kollektivs Designliga
2004 Gründung BACKYARD 10

LOCAL HERO
1992 Start der Graffitilaufbahn
1997 Studium Grafikdesign
2001 Festanstellung bei der Agentur D-Office
2002 Festanstellung bei der Agentur
 MartinEtKarczinski
2002 Start der ersten Streetartaktivität
2003 Freelancetätigkeit für diverse Designbüros
 und eigene Kunden
2004 Gründung BACKYARD 10

OLSEN
1989 Start der Graffitilaufbahn
1996 Studium Grafikdesign
2000 Festanstellung bei der Agentur D-Office
2001 Freelancetätigkeit für diverse Designbüros
 und eigene Kunden
2000 Start der ersten Streetartaktivität
2001-2003 Teil des Kollektivs Designliga
2004 Gründung BACKYARD 10

. COMPANY
BACKYARD 10 was founded in December 2003.
Our base is in Munich, Germany.

. JOB FOCUS
. Corporate Identity, Corporate Design
. product graphics
. record and CD cover design
. book, brochure and catalogue design
. poster and flyer design
. web design
. booth and interior design
. font design
. motion graphics
. in addition we introduced the fashion label
 Usual Suspect™ in 2004

. HISTORY
C100
1989 start of career in graffiti
1995 study of graphic design
1999 regular employment at the For Sale agency
2000 freelance work for different design companies
 and own clients
2000 start of first street art activities
2001-2003 member of the Designliga collective
2004 foundation of BACKYARD 10

LOCAL HERO
1992 start of career in graffiti
1997 study of graphic design
2001 regular employment at the D-Office agency
2002 regular employment at the
 MartinEtKarczinski agency
2002 start of first street art activities
2003 freelance work for different design companies
 and own clients
2004 foundation of BACKYARD 10

OLSEN
1989 start of career in graffiti
1996 study of graphic design
2000 regular employment at the D-Office agency
2001 freelance work for different design companies
 and own clients
2000 start of first street art activities
2001-2003 member of the Designliga collective
2004 foundation of BACKYARD 10

• 001 ++ 003 BACKYARD 10. Crew - in the mix. 2004
• 004 MOGLY. office regulars
• 005 HOME. http://www.backyard10.com
• 006 ++ 008 OFFICE
• 009 POSTER. self promo. 2004

• 004 ++ 005

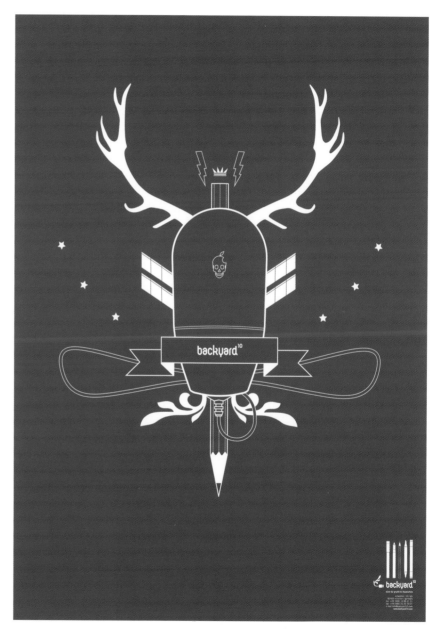

Von 1989 bis 1998 malten wir traditionelles Graffiti in Form von Charactern und Styles. Beeinflusst durch unser Grafikdesign-Studium nahmen Faktoren wie Komposition, grafische Regeln sowie das Ausprobieren neuer Materialien und Techniken Einfluss auf unsere Arbeit. Das Spektrum erweiterte sich und wir begannen zusätzlich Werkzeuge wie Klebeband, Marker und Poster zu verwenden.

Unsere Vorbilder und Inspirationen liegen mittlerweile nicht nur im Graffitibereich, sondern erstrecken sich von Malern über andere Designer bis zu Architekten und Künstlern. Durch diesen ständigen Austausch ergeben sich neue Horizonte – die Grenzen zwischen täglicher Auftragsarbeit und freien Jobs zerfließen. Oft entstehen durch spontane Ideen und Schnappschüsse Anregungen und Inspirationen für neue Projekte bzw. Jobs.

From 1989 to 1998 we concentrated on painting traditional graffiti in the form of characters and styles. Our work was influenced by our studies in graphic design and was governed by factors such as composition, graphic rules, and experiments with new materials and techniques. Gradually we widened our range and started to use additional tools such as adhesive tape, markers, and posters.

Meanwhile we no longer look to the graffiti scene alone for our role models and sources of inspiration but to a wider spectrum ranging from painters and other designers to architects and artists. This constant exchange opens up new horizons and fuses the borders between routine orders and independent work. We often find inspiration for new projects or jobs through spontaneous ideas and snapshots.

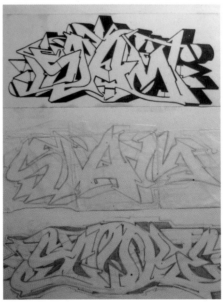
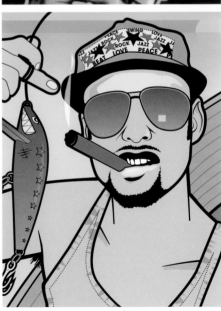

•010 CANVAS
•011 SKETCHES. 1998
•012 CHARACTER. spraypaint. 1997
•013 ILLUSTRATION. 2002
•014 CHARACTER SKETCHES. 2000
•015 MURAL. acrylics/spraypaint. 2004
•016 ELECTRIC STUDY. photography. Greece. 2001

•017 POSTER. Amsterdam. Netherlands. 2004
•018 TYPE STUDIES. sugar cubes. 2004
•019 BAUMINSEL. editorial illustration
 for LEVEL 47. 2004
•020 POSTER. Munich. Germany. 2004
•021 MURAL. detail. Munich. Germany. 2000

•010 ++ 011

•012 ++ 013

. PROJEKT
PLATTENCOVER

. KUNDEN
verschiedene

. BESCHREIBUNG
Als Designer achten wir selbstverständlich auch sehr auf das Artwork der Musik, die wir uns im Plattenladen kaufen. Etwaige Fehlkäufe, die auf das zu gut gestaltete Cover im Verhältnis zur Musik zurückzuführen sind, inbegriffen.

Folglich entwickeln wir auch eine große Begeisterung an der Gestaltung von Platten- und CD-Covern. Trotz Rückgang der Verkaufszahlen und Resignation in der Musikindustrie bietet sich uns immer wieder die Chance, Artwork für Musik zu gestalten. Meistens handelt es sich hierbei glücklicherweise auch um Veröffentlichungen, die unserem persönlichen Geschmack entsprechen. Zu einigen Acts entstanden durch die gute Zusammenarbeit mittlerweile Freundschaften.

. PROJECT
RECORD COVER

. CLIENTS
various

. DESCRIPTION
As designers it goes without saying that we pay close attention to the artwork of the music we buy in record stores. Unfortunately this also includes possible mispurchases where the cover design is a great deal better than the music.

As a result of this we are very enthusiastic about designing covers for records and CDs ourselves. In spite of the fact that the recording industry is suffering from a decline in sales figures and is in a mood of resignation, we still occasionally have the opportunity to design artwork for music. Fortunately these publications are usually to our own personal taste. In the meantime we have made new friends by working together with some of the performers.

- - - - - - - - - - - - - - - - - - -
•022 DJ EXPLIZIT/DJ MAN AT ARMS. The crew's combined. CD cover. 2004
•023 MAIN CONCEPT
•024 MAIN CONCEPT. Plan 58. 2001
•025 RAPTILE. da basilisk's eye. record cover. 2001
•026 INTRUDAS. Penetrate the empty Space. record cover. 2004

• 027 ++ 029

• 030 ++ 033

• 034 ++ 037

• 038 ++ 041

• 027 ZERWIRK. Bar/Restaurant/Club. 2004
• 028 NORTH KITEBOARDING. 2004
• 029 SUMO. North Kiteboarding. 2004
• 030 ANTIPHON. record label. Universal. 2004
• 031 WOLKE 7. 2004

• 032 USB. 2004
• 033 BOOGIE MONSTERS. Ampere Club.
 Munich. Germany. 2004
• 034 BURTON. type study.
 JDK. Vermont. USA. 2005
• 035 USUAL SUSPECT. 2004
• 036 NORTH WETSUITS. 2004

• 037 USUAL SUSPECT. 2004
• 038 NORTH KITEBOARDING. 2004
• 039 RAT PACK. film production. 2002
• 040 CMYBROWN. T-shirt design. 2004
• 041 KAFE. latino magazine. 2004

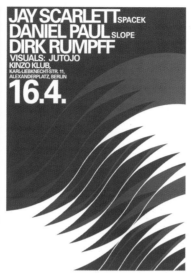

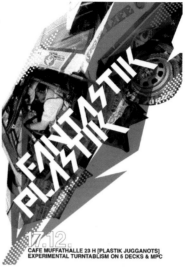

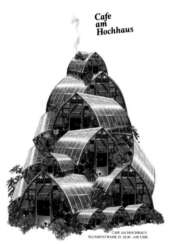

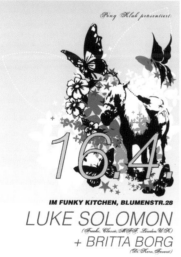

• 042 ÷ 043

• 044 ÷ 045

• 046 ÷ 047

• 048 ÷ 049

• 050

• 042 OFFTRACK MEETS BEST WORKS. poster. KINZO Klub. 2005
• 043 CAFE AM HOCHHAUS. flyer series for a bar. 2005
• 044 FANTASTIK PLASTIK. flyer series for a monthly
 club night. 2002
• 045 OFFTRACK/LUKE SOLOMON. poster for club event.
 KINZO Klub. Berlin. Germany. 2004

• 046 OFFTRACK. flyer. KINZO Klub. Berlin. Germany. 2004
• 047 BOOGIE MONSTERS. flyer series. Ampere Club.
 Munich. Germany. 2004
• 048 FANTASTIK PLASTIK. flyer series. 2002
• 049 CANDY CLEVER. flyer for club event. 2004
• 050 DISKA TEAM VS !K7 SYSTEM. flyer. 2004

. PROJEKT
PRODUKTDESIGN

. KUNDE
North Kiteboarding

. BESCHREIBUNG
Seit Ende 2001 zählt North Kiteboarding zu einem der
größten Kunden von BACKYARD 10. Ursprünglich mit
ein paar Anzeigenvorschlägen begonnen, erstreckt sich
das Auftragsvolumen von Boarddesigns über Poster-
und Kataloggestaltung bis zu DVDs und Kitedesign. Die
Aufgabenstellung, der wir gegenübergestellt sind, ist sehr
komplex, da wir zwar einen weiten kreativen Freiraum
zugestanden bekommen, unsere Designs aber trotzdem
zu einer bestimmten Zielgruppe passen müssen.

Diese stellt sich zu 70% aus Männern zwischen 25-45
zusammen, die sich selbst als jung geblieben betrachten
und es auch sind, da sie einen Extremsport ausüben,
aber trotzdem eine gewisse Seriosität im Design
erwarten. Diese müssen sowohl auf eine Trend setzende
als auch technisch versierte Marke schließen lassen. Im
Detail betrachtet unterscheidet sich der Kiter von Skate-
board- bzw. Snowboardfahrern, obwohl im Sport ähnliche
Parallelen klar erkennbar sind.

Die Marke ist seitdem stetig gewachsen, mittlerweile
ist North neben Naish Kiteboarding weltweit an der
Marktspitze. Zwei der von uns gestalteten Boards waren
in Folge die meist verkauften Kiteboards.

. PROJECT
PRODUCT DESIGN

. CLIENT
North Kiteboarding

. DESCRIPTION
North Kiteboarding has been one of BACKYARD 10's
biggest clients since late 2001. What started off as a
few ideas for adverts now ranges from board design,
through poster and catalogue design, to DVD and kite
design. These designs confront us with highly complex
task definitions. Although we are granted a wide scope
of creative freedom, our designs have to suit a specific
target group.

Up to 70% of this group are men between the ages of
25-45 years, who see themselves as being young. How-
ever although they are actually young enough to practise
an extreme sport, they still expect designs to show a
touch of sophistication. These designs must imply a
brand that is both a trend-setter and technically adept.
When examined in more detail, the kiter is found to be
quite different to the skateboard or snowboard riders,
although the parallels in the type of sport are obvious.

Since then the brand has continued to grow and
meanwhile North Kiteboarding is market leader on the
international market, next to Naish Kiteboarding. Two
boards designed by us were in succession the kiteboards
with the highest sales.

• 051 ++ 058

- - - - - - - - - - - - - - - - - - -
•051 M2 WILL JAMES. kiteboard pro model. 2003
•052 SUMO. kiteboard. 2004
•053 ROCKETFISH. kiteboard. 2004
•054 JAIME HERRAIZ. kiteboard pro model. 2003
•055 DRAGON. kiteboard. 2003

- - - - - - - - - - - - - - - - - - -
•056 SUMO. kiteboard. 2003
•057 M2 WILL JAMES. kiteboard pro model. 2004
•058 JAIME HERRAIZ. kiteboard pro model. 2004
•059 ++ 060 NORTH KITEBOARDING. action shots. 2003/2004
Photos: Stephen C. Whitesell

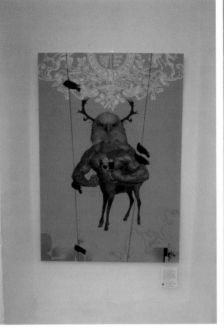
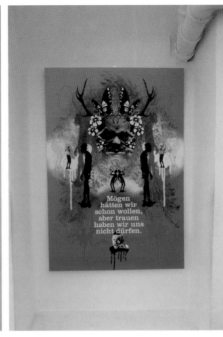
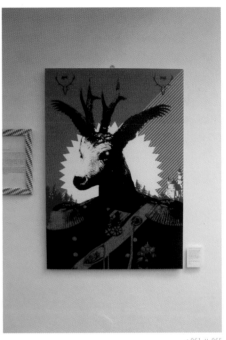

• 061 ++ 065

. PROJEKT
SO G'SEHN. Ausstellung in der Serie A.
München. 2004

. BESCHREIBUNG
Zusammen mit dem Fotografen Denis Pernath organisier-
ten wir im Mai 2004 eine Ausstellung zum Thema Bayern.
Da wir alle stolze Münchner sind, lag es nahe, endlich
eine Ausstellung unserer Heimat zu widmen. Der Titel SO
G'SEHN, hochdeutsch „so gesehen", ist eine bayerische
Redewendung. Denis' Fotografien zeigten Momentaufnah-
men des täglichen Lebens in Bayern – Bilder, die zeigen,
warum wir unseren Freistaat trotz der repressiven Politik
lieben und noch immer hier wohnen.

BACKYARD 10 erstellte Illustrationen der Fantasiefigur
Wolperdinger. Dies ist ein sagenumwobenes Fabelwesen,
welches laut bayerischem Volksmund im Wald lebt und
bisher nur von wenigen Leuten wirklich erblickt wurde.
Das Tier gleicht einer Kreuzung mehrerer Arten (Gans,
Biber, Reh, etc). Wir gestalteten, dank überlieferter Phan-
tombilder, Beschreibungen und eigener Vorstellung, meh-
rere Wolperdinger, wobei eine der ausgestellten Grafiken
zusätzlich im August 2004 den Titel des französischen
Designmagazins Étapes zierte.

. PROJECT
SO G'SEHN. Exhibition in the Serie A.
Munich, Germany. 2004

. DESCRIPTION
In May 2004 we organised an exhibition on the subject of
Bavaria, together with the photographer Denis Pernath.
As we are all proud of coming from Munich, Bavaria's
capital, it was dear to our hearts to dedicate the exhibi-
tion to our home territory. The title was SO G'SEHN, a
phrase in Bavarian dialect which means something like
"that's how I see it". Denis's photographs were snap-shots
of daily life in Bavaria – pictures that show why we love
our State of Bavaria and why we are still living here in
spite of the repressive policy of the federal government.

BACKYARD 10 created illustrations of the fantasy figure
Wolperdinger. According to Bavarian folklore, this is a
legendary mythical creature that lives in the woods and
has only ever been seen by very few people. The creature
is a hybrid of several types of animal, such as goose,
beaver, deer, etc. Thanks to traditional illustrations,
descriptions, and our own fantasy we created several
Wolperdingers. One of the exhibited graphics was additi-
onally used in August 2004 to adorn the title page of the
French design magazine Étapes.

- -
•061 ++ 065 SO G'SEHN. exhibition at Serie A.
Munich. Germany. 2004
•066 ÉTAPES. magazine cover. June 2004
•067 ++ 068 WOLPERDINGER. illustrations. 2004

• 066

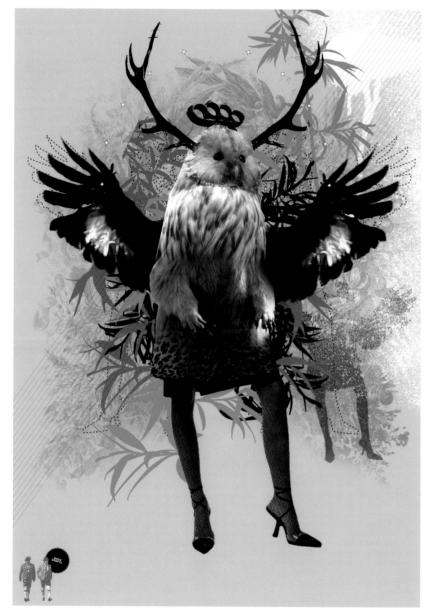

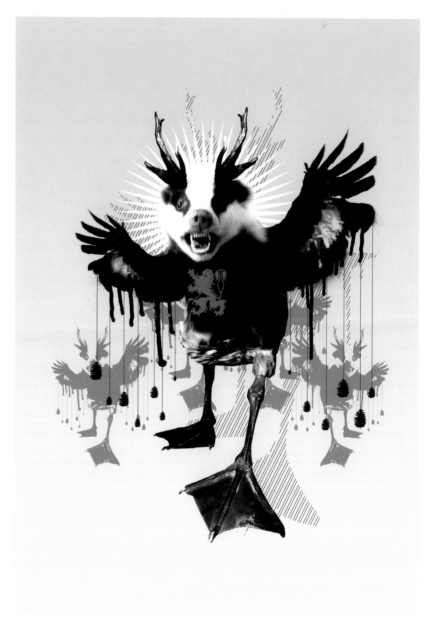

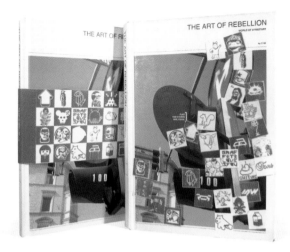

•069

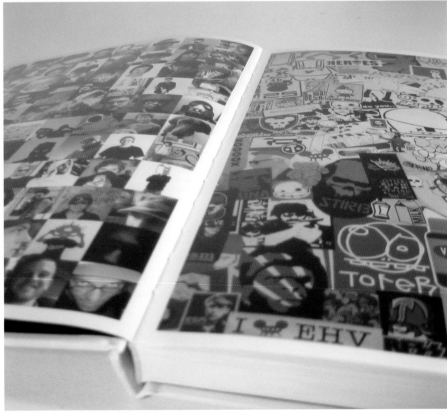

•070 ++ 072

. PROJEKT
THE ART OF REBELLION

. BESCHREIBUNG
Ende der neunziger Jahre wurde die weiterentwickelte Form von Graffiti, Streetart, immer populärer. Durch das plötzliche Wegfallen dogmatisch auferlegter Schranken entdeckten viele die neuen progressiven Möglichkeiten der Kombination Graffiti-Grafik-Design-Straßenkunst.

Zu diesem Zeitpunkt gab es keine Publikation im Handel, die sich ausschließlich mit dem Thema Streetart beschäftigte und ihre Protagonisten vorstellte, so wie man dies von Büchern wie „Subway Art" oder „Spraycan Art" kannte. Durch die Motivation, Teil einer neuen Bewegung zu sein, wurden erste Konzepte und Gestaltungsvorschläge entwickelt. Parallel wurde via Internet der Kontakt zur weltweiten Streetartszene vertieft.

Mit Publikat als Verlag wurde im Oktober 2003 das Buch „The Art of Rebellion" von C100 erstveröffentlicht. Der Weg bis zur finalen Fertigstellung war mit viel Überzeugungsarbeit sowie einigen Hürden, wie z.B. verloren gegangenen Daten durch defekte Festplatten gepflastert. Das Buch ist mittlerweile in der vierten Auflage erschienen und erhielt viel positive Resonanz.

. PROJECT
THE ART OF REBELLION

. DESCRIPTION
In the late nineties there was a steady increase in the popularity of street art, which is an enhanced form of graffiti. As dogmatically imposed restraints suddenly disappeared many graffiti artists discovered new and progressive possibilities in the combination of graffiti, graphic design and street art.

At that time there was no publication on the market solely dedicated to the subject of street art and the presentation of its protagonists in the same way as the books "Subway Art" or "Spraycan Art" were. The motivation to be a part of a new movement led to the development of first concepts and suggestions for compositions. Parallel to this, the Internet intensified contacts to the international street art scene.

The book "The Art of Rebellion" by C100 was first published by the Publikat publishing company in October 2003. Many obstacles such as lost data and defective hard disks hindered the completion of the book and it took a lot of dedication to overcome these obstacles. In the meanwhile the book has appeared in its fourth edition and has met with much positive response.

•069 ++ 072 THE ART OF REBELLION. concept and layout.
released at Publikat publishing. ISBN 3-980-7478-3-2.
2003

•073 ++ 077

. PROJEKT
PAPIERSTAU

. BESCHREIBUNG
Angespornt durch den Erfolg des Buches realisierten wir
im Sommer 2004 ein weiteres Projekt: Papierstau.
Dies ist ein schwarz-weiß kopiertes Fanzine in einer limi-
tierten Auflage von 100 Stück, bestückt mit einer
Mix CD des DJ Kollektivs Plastik Jugganots. 35 Designer,
Streetartkünstler und Illustratoren schickten uns ihre In-
terpretation zum Thema „Traffic". Viele namhafte Künstler
wie z.B. Rinzen, A' (Clarissa Tossin), Kid Acne, G*, Eko,
Supakitch, Yacht Associates, Erosie sandten Beiträge ein
und machten Papierstau Nr.1 zu einem Erfolg.

http://www.backyard10.com/papierstau

. PROJECT
PAPIERSTAU (PAPER JAM)

. DESCRIPTION
Encouraged by the success of the book we carried out
a further project in the summer of 2004: Papierstau.
This is a black and white copied fanzine in a limited
edition of 100 issues, supplemented with a mix CD of
the DJ collective Plastik Jugganots. 35 designer, street
art artists, and illustrators sent us their interpretations
of the subject "traffic". Many well-known artists such as
Rinzen, A' (Clarissa Tossin), Kid Acne, G*, Eko, Supakitch,
Yacht Associates, and Erosie submitted contributions and
helped to make Papierstau No.1 a success.

http://www.backyard10.com/papierstau

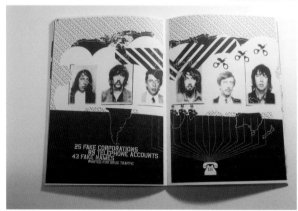

•078 ++ 080

•073 ++ 077 THE ART OF REBELLION. release party at
Registratur. Munich. Germany. 2003
•078 ++ 080 PAPIERSTAU. Fanzine. "Traffic". 2004

. PROJEKT
USUAL SUSPECT. Modelabel

. BESCHREIBUNG
2004 wurde unter BACKYARD 10 das Modelabel Usual Suspect™ gegründet. Ziel der Marke ist es, diverse Textilien durch grafische sowie illustrative Motive zu veredeln und zu verkaufen. Diese größtenteils von uns selbst gedruckten Exemplare werden in limitierten Auflagen international an Boutiquen und Shops geliefert. Außerdem kann man Usual Suspect™ auch über den Webshop beziehen. Die Haltung der Polizei und des Rechtsstaates, so wie wir sie als aktive Graffitimaler jahrelang erfahren durften, beeinflusste uns bei der Namensfindung. Der übliche Verdächtige ist sich seiner schwierigen Situation bewusst, kennt aber auch die Möglichkeiten, diesen gängigen Verdächtigungsrastern und Vorurteilen zu entweichen bzw. sie für seine eigenen Zwecke zu manipulieren.

Das Einnähen der Etiketten und Labels wird von Insassen der bayerischen Justizvollzugsanstalten erledigt.

http://www.usualsuspect.de

. PROJECT
USUAL SUSPECT. fashion label

. DESCRIPTION
In 2004 BACKYARD 10 introduced the fashion label Usual Suspect™. The aim of the label is to sell various textile products that have been enhanced by graphic and illustrative designs. We print most of these textiles ourselves in limited editions and deliver them to boutiques and shops all over the world. In addition, Usual Suspect™ products can be purchased over our web shop. The name search for our label was influenced by our long-lasting experiences with the attitudes of the police and the state authorities towards graffiti painters. The usual suspect is aware of his difficult situation while at the same time knowing how to escape from prevalent prejudices and dragnet investigations or how to manipulate them to serve his own purpose.

The sewing of tabs and labels is carried out by the inmates of Bavarian prisons.

http://www.usualsuspect.de

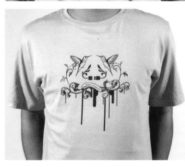
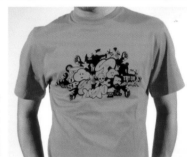

•082 + 085

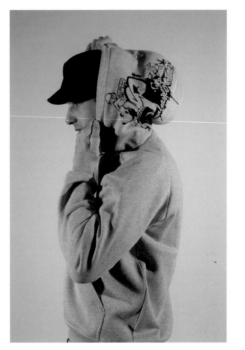

•081

•086 + 087

•081 + 085 USUAL SUSPECT. various designs. 2004
•086 + 088 USUAL SUSPECT. screen printing. 2004
•089 CHARACTERS. 2005

11.5 AUSBLICK

11.5 OUTLOOK

. Für eine glückliche Zukunft: Glaube an deine Träume, töte deine Idole, genieße das Leben, erstelle stets Datensicherungen, sei freundlich, sage NEIN, ignoriere diese Ratschläge – stay tuned.

. For a happy future: believe in your dreams, kill your idols, enjoy life, backup your work, be friendly, say no, ignore this – stay tuned.

. **KUNDENLISTE. CLIENTS LIST**

. Burton Snowboarding
. Forum Snowboarding
. Fanatic Snowboarding
. Oakley
. North Kiteboarding
. Prada
. Kangaroos
. Puma
. Mattel Interactive
. Vaude Backpacks
. US40
. Mistral Surfboards
. Centurion Bikes
. Bergamont Bikes
. Kangaroos
. K2
. F2
. KIX
. Universal

. Grönland Records
. BMG Ariola
. Groove Attack
. Compost Records
. Ratpack Film
. Goldkind Film
. Deutsche Städte Reklame
. Deck 8
. Publikat Verlag
. Gingko Press
. HB Pure
. Zerwirk
. Teamtheater Pathos
. Soul Videomagazin
. Die Registratur
. Erste Liga
. Funky kitchen
. Offtrack
. KINZO Klub. Berlin. Germany

. **KONTAKT. CONTACT**

Home. 01
Munich. Germany

Home. 02
http://www.backyard10.com
info@backyard10.com

12.0

„We are not from the ghetto", wir kommen aus einem Schmelztiegel aus 80er Jahre Graffiti, HipHop-Mythen und französischer Ländlichkeit.

INKUNSTRUCTION

12.0

"We are not from the ghetto", we come from the melting-pot of nineteen-eighties graffiti, HipHop myths and French provinciality.

INKUNSTRUCTION

. CREW
ST BRECE. Guillaume Antzenberger. *1976
SAME. Samuel Francois. *1977
PICO. Renaud Combes. *1977

. UNTERNEHMEN
2001 Gründung der Crew
2003 erste gemeinsame grafische Arbeiten und erste
Veröffentlichungen
2004 Gründung des INKUNSTRUCTION Art&Design
Studios

Niort, Metz und Valence sind die Städte, in denen wir
leben und arbeiten. Je nach Projekten oder Aufträgen
organisieren wir uns in der Form, dass wir entweder
über Internet arbeiten oder uns in einem der drei
Büros treffen.

. ARBEITSBEREICHE
. Platten- und CD-Cover-Gestaltung
. Modedesign
. Illustration
. Malerei, Fassaden- und Innenraumgestaltung
. Buch-, Broschüren- und Kataloggestaltung
. Poster- und Flyergestaltung
. Schriftgestaltung
. Corporate Identity, Corporate Design
. Internetseiten und Webflyer

. HISTORY
Wir haben alle drei mit Graffiti zwischen 1989 und 1992
angefangen. INKUNSTRUCTION ist 2001 aus der Begeg-
nung zwischen SAME und ST BRECE entstanden; 2002
stieß PICO dazu. Am Anfang beschränkte sich unsere
Zusammenarbeit lediglich auf Ausstellungen, T-Shirt- und
Postereditionen.

Seit 2003 arbeiten wir gemeinsam an Aufträgen, sowohl
im grafischen als auch in anderen Bereichen, wie z.B.
Modedesign und Innenraumgestaltung.

. KONTAKT. CONTACT

Home. 01
Niort. France. West
Home. 02
Metz. France. East
Home. 03
Valence. France. South

Home. 04
http://www.inkunstruction.com

. COMPANY
2001 foundation of the crew
2003 first joint graphic works and first publications
2004 foundation of INKUNSTRUCTION Art&Design
Studios

Niort, Metz and Valence are the towns where we live and
work. We organise ourselves according to the project or
order in question and either use the Internet for our work
or meet up in one of the three offices.

. JOB FOCUS
. record and CD cover design
. fashion design
. illustration
. painting, facade and interior design
. book, brochure and catalogue design
. poster and flyer design
. font design
. Corporate Identity, Corporate Design
. web pages and web flyers

. HISTORY
The three of us embarked on graffiti between 1989
and 1992. INKUNSTRUCTION was devised at a meeting
between SAME and ST BRECE in 2001; PICO joined in
2002. In the early stages we only worked together for
exhibitions and the design of T-shirts and poster editions.

Since 2003 we have been cooperating on orders in the
field of graphic design and in other fields such as fashion
and interior design.

•001 ++ 002 •003 ++ 004

inkunstruction studio
Art&Design

•001 ST BRECE. 2005
•002 ST BRECE. office. 2005
•003 PICO. 2005
•004 PICO. office. 2005

• 005 + 006

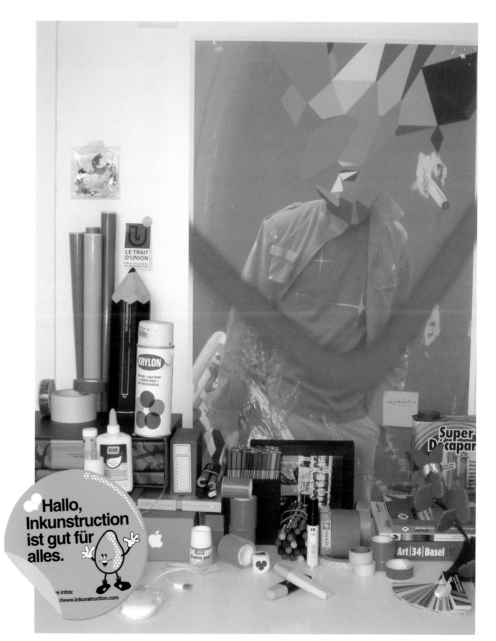

• 005 SAME. 2005
• 006 SAME. office. 2005
• 007 OFFICE. 2005

• 007

Wir haben alle drei zwischen 1989 und 1992 mit Graffiti angefangen. Unsere Werdegänge sind verschieden, doch haben wir die Etappen – vom Arbeiten mit Buchstaben über 3D bis hin zu großen Produktionen – durchlaufen. Als wir uns 2001 begegneten, waren wir alle etwas müde geworden, das Graffiti zu praktizieren, das uns einmal angezogen hatte. So ist INKUNSTRUCTION aus dem Wunsch heraus entstanden, sich mit den Problemen von Graffiti, Malerei und Visualisierung im Allgemeinen zu beschäftigen – uns mit anderen Sphären auseinanderzusetzen. Die Energie des Graffiti bleibt in unseren Arbeiten aber sehr lebendig:

AS SPONTANEOUS AS GRAFFITI!

Aus der Lust heraus, zu sprühen und andere Leute kennen zu lernen, hat sich unsere Haltung entwickelt und unser Handlungsspielraum erweitert. Es ist dieses gemeinsame Bedürfnis nach Ausdruck, das uns dazu bewegt, eine Wahl für unsere eigenen Wege zu treffen: Kunstschulen, Architektur, Kommunikation oder angewandte Kunst. Diese Einblicke haben uns den Zugang zu anderen Medien als Aerosolfarben geöffnet und uns in Folge die Möglichkeit gegeben, Projekte in anderen Bereichen durchzuführen: Diverse Publikationen, Grafikdesign, Kunst, denn „INKUNSTRUCTION IST GUT FÜR ALLES".

Obwohl es ein wenig anmaßend klingt, steht diese Aussage für unseren Wunsch, mit unterschiedlichen Medien zu arbeiten, um verschiedene, aber sich doch ergänzende Entwicklungen einzugehen. Es stellt sich nicht die Frage, überall Graffiti einzusetzen, sondern unsere Arbeiten durch das Verwenden geeigneter Medien verständlicher zu machen. Unsere Verschiedenheit und die sich daraus ergebende gegenseitige Ergänzung ist eine unserer Stärken. Die Tatsache, dass wir uns Hunderte von Kilometern auseinander befinden, ermöglicht uns, eine individuelle Entwicklung zu durchlaufen und somit ständig neue und unterschiedliche Elemente in die globale Arbeit von INKUNSTRUCTION einfließen zu lassen.

Diese Interaktion ermöglicht uns einen größeren Abstand zu unseren Einzel- und auch Gruppenarbeiten.

The three of us embarked on graffiti between 1989 and 1992. Although we developed differently we all passed through the same stages from working with letters, through 3D up to large productions. When we met in 2001 we had become rather tired of the type of graffiti that had fascinated us before. INKUNSTRUCTION was born from a desire to concentrate on the problems of graffiti, painting, and visualisation in general, as well as the desire to analyse other spheres. The energy of graffiti is still very much alive in our work:

AS SPONTANEOUS AS GRAFFITI!

Our appetite for spraying and getting to know other people is the basis for our approach and has also broadened our scope. This common need for expression compels us to make our own choices: art schools, architecture, communications or the applied arts. This insight has opened up the gateway to media other than aerosol colours and consequently given us the chance to execute projects in other areas including various publications, graphic design, and art because "INKUNSTRUCTION IST GUT FÜR ALLES" (INKUNSTRUCTION is good for everything).

It might sound somewhat presumptuous but this statement stands for our wish to work with various media in order to understand different but complementary developments. This is not just a question of a universal use of graffiti but rather an attempt to make our work more coherent by adopting the appropriate media. One of our strong points is the mutual interaction that results from our different characters. The fact that we live hundreds of kilometres apart enables each of us to develop individually so that we can always contribute new and different elements to the global work of INKUNSTRUCTION.

This interaction makes it possible for us to see both our individual and team projects with greater detachment.

•008 ⊹ 010

•008 ⊹ 010 MURAL. main station Milan. Italy. 2004

12.2

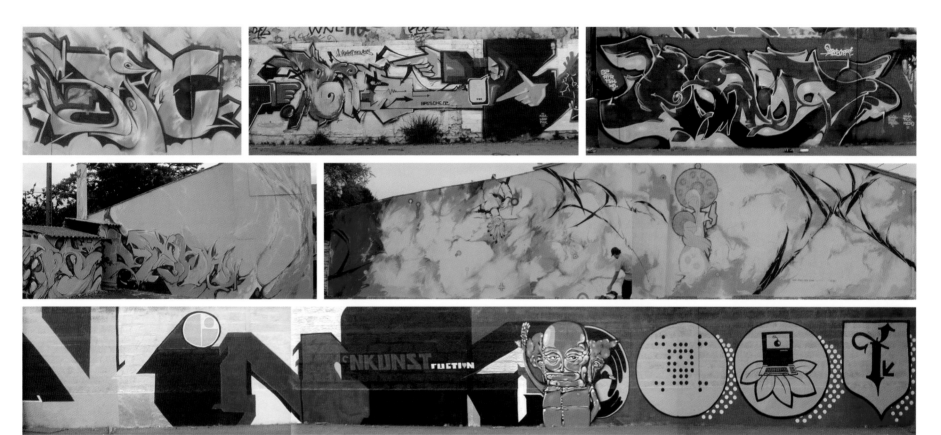

•011 ++ 016

•011 SAME. mural. Luxembourg. 2004
•012 BRES. mural. Avignon. France. 2004
•013 BRES. mural. Niort. France. 2003
•014 SAME/BRES. mural. Niort. France. 2003
•015 BATTLE. SAME and PICO vs. OTWO (Rockgroup). Niort. France. 2004
•016 SAME/BRES. mural. Niort. France. 2003

•017 ++ 019

•020 ++ 028

•017 ++ 028 SKETCHES. 2004

. PROJEKT
LOGO? SKATEBOARDS. 2004

. BESCHREIBUNG
Entwicklung eines Skateboard-Designs, eines T-Shirts und
eines Mesh-Caps für die Skate-Marke Logo? (Serie Sofa).
Wir vertieften die Idee eines Tapetenmusters, das auf die
verschiedenen Untergründe übertragen wurde.

. PROJEKT
WORLDSIGNS. 2003

. BESCHREIBUNG
Für Worldsigns 03 lud uns Olivier Stak ein, an seinem
Beitrag „du bureau de création à la gallerie d'art" (vom
Designbüro zur Kunstgalerie) teilzunehmen. Er hat uns
auch die Covergestaltung anvertraut, mit einer einzigen
Einschränkung: Es musste schwarzweiß sein. Hier hatten
wir die Möglichkeit, unser Schaffen, darunter die Illu-
stration „Ultimate aircraft baguarre", vorstellen zu können
– eine Arbeit, die sich der Idee von PHOTOSHOP SUCKS
annähert, da sie auf der Basis von Letraset und anderen
Paustechniken entstanden ist und, außer dem Scan, frei
von digitaler Verarbeitung war. (Danke Olivier)

. PROJEKT
LE TICKET. 2003

. BESCHREIBUNG
Als sich Worldsigns 03 in dem kostenlosen Brüsseler
Magazin LE TICKET vorgestellt hat, wurde uns von Olivier
Stak ein weiteres Mal die Covergestaltung angeboten.

. PROJECT
LOGO? SKATEBOARDS. 2004

. DESCRIPTION
Development of a skateboard design, a T-shirt and
a mesh cap for the Skateboard brand LOGO? (Sofa
series). We elaborated the idea of a wallpaper pattern
that was copied onto different backgrounds.

. PROJECT
WORLDSIGNS. 2003

. DESCRIPTION
Olivier Stak invited us to take part in his contribution
"du bureau de création à la gallerie d'art" (from design
bureau to art gallery) for Worldsigns 03. We were ent-
rusted with the cover design on one condition only – that
it was in black and white. This gave us the opportunity
to present our creative work, including the illustration
"Ultimate aircraft baguarre". This work comes near to
the idea of PHOTOSHOP SUCKS as it is developed on the
basis of Letraset types and other tracing techniques and
was not digitally processed, apart from the scan.
(Thank you Olivier)

. PROJECT
LE TICKET. 2003

. DESCRIPTION
Olivier Stak made us a further proposal for the cover
design of the free Brussels magazine LE TICKET for the
introduction of Worldsigns 03.

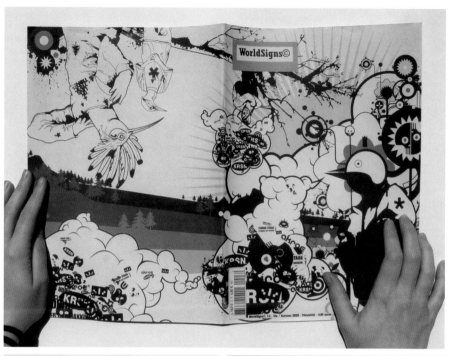

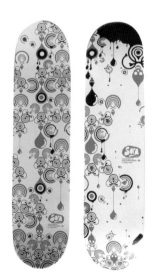

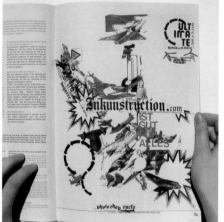

• 030 ++ 032

•029 LOGO? SKATEBOARDS. serie SOFA. front and back.
 3-coloured screenprint. 2004
•030 ++ 031 WORLDSIGNS 03. 2003
•032 LE TICKET. cover design. 15cm x 21cm. 2003

•029

. PROJEKT
FUNKSTÖRUNG. 2004

. BESCHREIBUNG
Aufgrund eines Vorschlages von ST BRECE für das Projekt „Isolation Remix" auf der Funkstörung Homepage, sind wir kontaktiert worden, um das Design der ersten Maxi zu erarbeiten. Dieses Projekt ist eine Zusammenarbeit zwischen Funkstörung, Mark McPherson (Fotografie), Yok (Character) und uns. In Folge dieser ersten Zusammenarbeit schlugen sie uns vor, das Design des Albums und der folgenden Maxi zu entwerfen. Daraufhin trat „Die Gestalten Verlag" an uns heran, um das Cover des Buches/DVD „Isolated TripleMedia" zu gestalten.

Die anfängliche Idee bestand darin, von den von McPherson gelieferten Fotos ausgehend, einen urbanen Lebensraum mit vektoriellen Elementen zu mischen. Dieses Projekt hat es uns erlaubt, Lacke und Pantone-Farben zu verwenden und somit Vorschläge zu machen, die wir bei anderen Projekten, bei denen das Produktionsbudget kleiner ist, nicht hätten machen können. Zudem konnten wir die Designs auf unterschiedliche Medien wie beispielsweise Plakate, Flyer und T-Shirts transferieren.

Und Nachfolger von The Designers Republic sein – das ist einfach traumhaft.

. PROJECT
FUNKSTÖRUNG. 2004

. DESCRIPTION
As a result of a proposal from ST BRECE for the "Isolation Remix" project on the Funkstörung homepage, we were contacted to work out the design for the first maxi-CD. This project is a collaboration between Funkstörung, Mark McPherson (photography), Yok (character) and ourselves. As a result of this first collaboration they suggested that we draft the design for the album and the following maxi-CD. Thereupon "Die Gestalten Verlag" approached us about the design for the cover of the book/DVD "Isolated TripleMedia".

The initial idea, based on the photos supplied by McPherson, was to infuse an urban environment with vectorial elements. This project permitted us to use varnish and Pantone colours and thus make proposals that we could not have made on other projects where the production budget is smaller. Moreover, we could transfer the designs onto different media, such as posters, flyers and T-shirts.

To be the successors of The Designers Republic is simply fantastic.

·033 FUNKSTÖRUNG. Moon Addicted/Chopping Heads.
 four colour printing and partial gloss varnish. 2004
·034 FUNKSTÖRUNG. Fat Camp Feva/Disconnected.
 four colour printing and partial gloss varnish. 2004
·035 Album Funkstörung Disconnected (!K7162CD)
 four colour printing and partial gloss varnish.
 three colour screenprint on the CD jewel case. 2004

·033 ++ 034

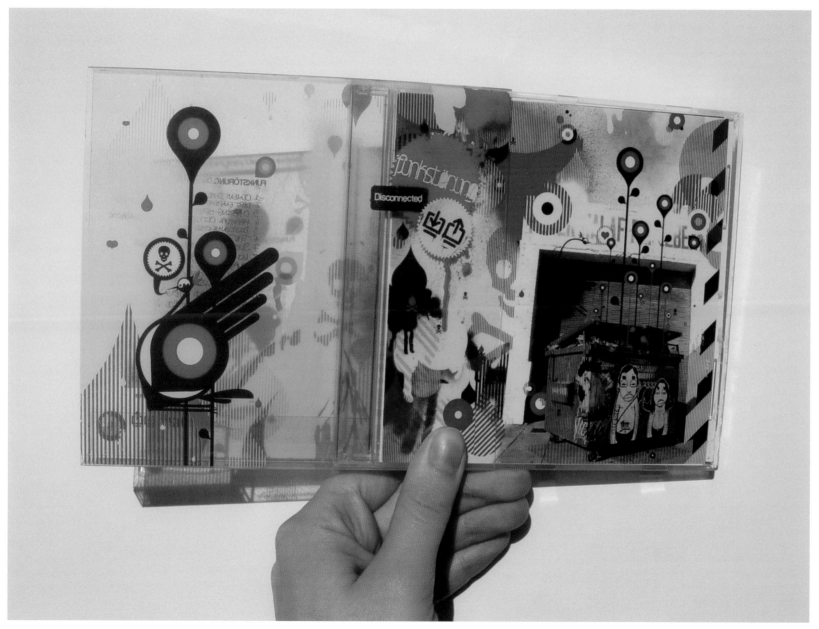

. PROJEKT
THIS T-SHIRT IS DESIGNED AND ROCKED
BY INKUNSTRUCTION. 2004/05

. BESCHREIBUNG
Schon seit Beginn unserer Zusammenarbeit haben wir
Produktionen auf Textilien entwickelt. Dieses Mal wollten
wir aber eine Mini-Kollektion herstellen, deren Ziel es nicht
war, INKUNSTRUCTION hervorzuheben, sondern ganz im
Gegenteil, eine Serie zu kreieren, die Illustrationen und
Dekorationen zeigt.

Aus diesem Grund stellen unsere Grafiken „Light", „Toten-
kopf" oder „Sternenhimmel" dar. Diese T-Shirt-Serie war
auch Anlass für eine fotografische Arbeit, die im Portfolio
unserer Internetseite, aber auch in Publikationen wie
SPOON, NAIXT, etc. Verwendung fand.

. PROJECT
THIS T-SHIRT IS DESIGNED AND ROCKED
BY INKUNSTRUCTION. 2004/05

. DESCRIPTION
Right from the beginning of our cooperation we have
been developing productions on textiles. This time it was
not our intention to produce a mini collection for bringing
out INKUNSTRUCTION but rather to create a series
showing illustrations and decorations.

This is why our graphics depict "Light", "Skull" or
"Starry Sky". This T-shirt range was also the occasion
for the photographic work used in the portfolio of our
Internet page as well as in publications such as SPOON,
NAIXT, etc.

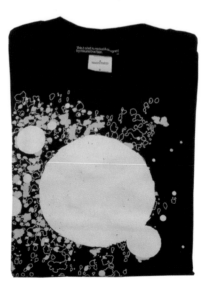

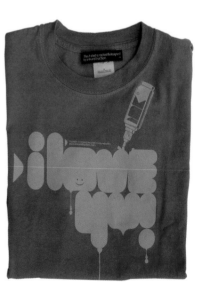

•036 ++ 041

•036 YO. 2004
•037 KLINK. 2005
•038 ...FÜR ALLES. 2005
•039 PSYKÉ. 2005
•040 PATTERN. 2005
•041 I LOVE YO!. 2005

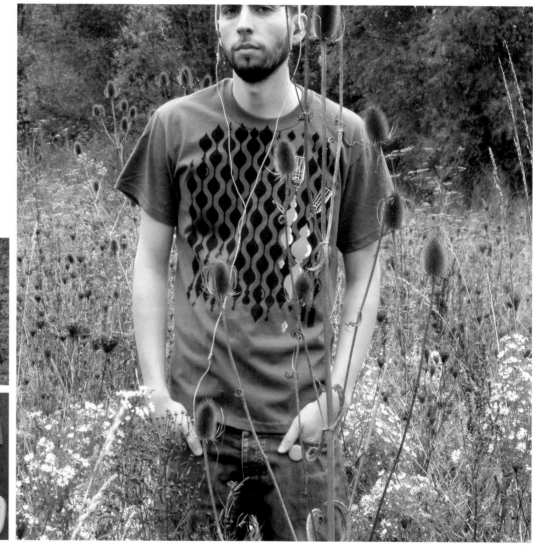

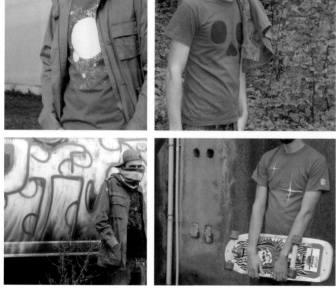

• 042 ++ 045

• 046

• 042 PATTERN. portfolio detail. 2005
• 043 TÊTE DE MORT. portfolio detail. 2005
• 044 PSYKÉ. portfolio detail. 2005
• 045 KLINK. portfolio detail. 2005
• 046 JOCKEY. portfolio detail. 2005

. PROJEKT
WE ARE NOT FROM THE GHETTO

. BESCHREIBUNG
Gangsterposen, Kopftuch vor dem Mund, quer sitzendes Cap, Gürtelschnalle mit Namen, Sturmmaske, farbverschmierte Weste – so haben wir uns in Szene gesetzt, wie in unseren Erinnerungen und Phantasien aus Jugendzeiten, die reichlich genährt von amerikanischen Zeitschriften und seltenen Videos waren, die wir von unseren Wochenenden in der Hauptstadt mitgebracht hatten. Heute bleiben uns diese Erinnerungen und ein paar Alben mit Fotos von Graffiti, die in Lothringen und in der Vendée (französische Provinz) entstanden sind. Das ist unser amerikanischer Traum. „We are not from the ghetto", wir kommen aus einem Schmelztiegel aus 80er Jahre Graffiti, HipHop-Mythen und französischer Ländlichkeit.

Ursprünglich haben wir diese Serie von Zeichnungen für eine Ausstellung angefertigt. Verständlicherweise taucht in unseren Zeichnungen auch unsere eigene T-Shirt-Kollektion auf. Also haben wir sie ebenfalls dazu verwendet, die Textilien bei unseren Händlern zu bewerben.

. PROJECT
WE ARE NOT FROM THE GHETTO

. DESCRIPTION
We paraded ourselves in gangster poses and with faces half-masked by kerchiefs, caps askew, name belt buckles, balaclavas, and paint-smeared jackets. This was reminiscent of the adolescent memories and fantasies of our younger days which had been richly nourished by American magazines and the rare videos we acquired during weekends in the capital. All that remains today are these memories and a few albums with photos of graffiti from Lorraine and the Vendée (French province). This is our American dream. "We are not from the ghetto", we come from the melting-pot of nineteen-eighties graffiti, HipHop myths and French provinciality.

We originally produced this series of drawings for an exhibition. Understandably we showed our own T-shirt collection in the drawings, so that they could be used for advertising the textiles in our dealers' shops.

. 047 + 053 SELF-PORTRAIT SERIES. marker on Canson paper.
size: 110cm x 70cm. 2005

. 047

• 054

• 055

- - - - - - - - - - - - - - - - - - -
•054 POSTER. single colour screenprint on 135g paper.
 100% black. 50 pieces. size: 70cm x 50cm. 2004
•055 POSTER. two colour screenprint on 135g paper.
 100% black and pink/182C. 50 pieces. size: 70cm x 50cm. 2004

. PROJEKT
PHOTOSHOP SUCKS/GRAFIK-SKLAVEN

. BESCHREIBUNG
PHOTOSHOP SUCKS. Unpassend? Respektlos? Nicht
wirklich, denn wir schätzen dieses Instrument und seine
Zwecke. Es geht dabei vielmehr um seine missbräuch-
liche bzw. die exzessive Verwendung und um die Blender
unter den „Grafikkünstlern", was wir in einer direkten
Form, ähnlich eines Skate-Slogans, aufgreifen wollen.
So etwas wie ein freundlich gemeinter Seitenhieb. Diese
Auseinandersetzung hat uns dazu angespornt, uns auf
viele einfache künstlerische Experimente einzulassen.
Im Allgemeinen betrachtet ist es aber leider ein stets
aktuelles Thema.

GRAFIK-SKLAVEN. Eine gesellschaftliche Detailaufnahme!
Wie viele von uns werden von Leuten unterjocht, die
Visualisierungen brauchen und uns nur als eine Hand mit
einem Stift sehen? Letztendlich ist es eine persönliche
Entscheidung. Niemand hat uns je gezwungen, unsere
Dienste anzubieten und nicht nur unseren Schweiß, son-
dern auch unser Herz zu investieren. Warum also?

. PROJECT
PHOTOSHOP SUCKS/GRAPHIC SLAVES

. DESCRIPTION
PHOTOSHOP SUCKS. Unsuitable? Irreverent? Not really,
because we appreciate this instrument and its purpose.
We want to address the problems of its abuse or exces-
sive use and the dazzlers among the "graphic artists"
in a direct form, similar to a skate slogan. It is meant to
be like a friendly sideswipe. As this project urges us to
undertake many simple artistic experiments, it is unfortu-
nately, an ever current topic.

GRAPHIC SLAVES. A close-up of society! How many of us
are enslaved by people who need visualisations and see
in us only a hand holding a pen. It is ultimately a personal
decision. Nobody has ever forced us to offer our services
or to devote our hearts as well as the sweat of our
labour. So why should we?

•057

•056

- - - - - - - - - - - - - - - - - - - -
•056 PHOTOSHOP SUCKS/GRAPHIC SLAVES. T-shirt. 2004
•057 LAURA PECCI GALLERY. Milan. Italy.
acrylics/atomiser/glue. 2003

. PROJEKT
BÄUME VS. MUSTER

. BESCHREIBUNG
Im Rahmen der letzten Ausstellung haben wir B-Boy-
Character, die gewissermaßen uns selbst darstellten
bzw. Selbstportraits waren, gemalt. Deren Basis waren
Baumstämme, bekleidet mit Caps und Turnschuhen.
Gefüllt waren die meisten dieser Bäume mit Tarnmotiven
oder dekorativen Mustern. Aus diesem Grund entstand
das Interesse, die Motive, welche aus der Interpretation
und der Beobachtung der Natur stammen, mit sich selbst
zu konfrontieren: Camouflage auf einer Pappel, ein Papier-
muster auf einer Eiche, usw.

Schließlich haben wir, in einer zweiten Phase, Motive
aus Textildrucken, wie z.B. Streifen oder Punkte in den
Wäldern verwendet – in der Form, wie Camouflage auch
auf der Straße getragen wird.

. PROJECT
TREES VS. PATTERNS

. DESCRIPTION
In the scope of the last exhibition we painted B-boy
characters which were more or less our own self
portraits. The basis of these were tree trunks dressed up
in caps and trainers. Most of these trees were covered
with camouflage motifs or decorative patterns. It was
interesting to confront nature itself with motifs originating
from the interpretation and observation of nature, such as
camouflage on a poplar or a paper pattern on an oak.

Finally, in a second phase we used the patterns of printed
textiles, such as stripes or dots for decorating the trees
in the woods – a parallel to wearing camouflage in the
streets.

•058

•059

•058 ARBRE 1. masking tape on tree. Nancy. France. 2004
•059 ARBRE 2. masking tape on tree. Luxembourg. 2005

Wenn wir heutzutage malen gehen, dann hauptsächlich um eine gute Zeit miteinander zu verbringen. Graffiti ist zum Vorwand geworden uns wieder zu sehen. Wir praktizieren es vorwiegend, wie zu unseren Anfangszeiten, in Form eines schnellen und spontanen Graffitibildes. Dazwischen kommt es gelegentlich vor, dass wir uns vor großen Wandprojekten wiederfinden, um dort mit Aerosolen oder Acrylfarben zu arbeiten – dabei aber die Positionierung der Gestaltung hinterfragen oder unsere Erfahrung nutzen, um andere Arten von Eingriffen in einer natürlichen Umgebung zu tätigen. Immer aber mit dem Bestreben, nicht in das Streetart zu verfallen, in dem man sich damit begnügen würde, fotokopierte Plakate zu kleben. Seit kurzem haben wir die Möglichkeit, die Ergebnisse unserer Forschungen in Galerien oder Orten auszustellen, die den Künsten gewidmet sind, auch wenn der urbane oder ländliche Raum die Orte sind, an denen wir vorzugsweise Dinge beobachten und experimentieren.

Unser Anspruch im beruflichen Bereich hat sich erhöht. Wir sind ständig auf der Suche nach Projekten, die weit von unserem eigentlichen Kosmos entfernt sind um neue Dinge ausprobieren zu können. Dort findet sich die Herausforderung, nicht in eine Routine zu verfallen, in der wir nur noch das täten, was die Leute von uns bereits kennen. Unser Weg hat uns viele Erkenntnisse gebracht – sowohl in der Beherrschung der Typografie als auch in der Kreation von Bildern. Aber so wie wir vom Graffiti zum Grafikdesign gekommen sind, indem wir einige Dinge angenommen und angeglichen haben, so müssen wir heute versuchen ein Grafikdesign zu praktizieren, das viel losgelöster von unserem Erfahrungshorizont ist und unsere Eigenart für viel persönlichere Projekte erhält.

Graffiti oder dessen Einfluss findet sich überall: im Supermarkt, auf CD-Hüllen, usw. Die Lebensdauer eines Bildes wird immer kürzer und noch nie wurden Neuerungen durch die Marketingmaschinerie so schnell verdaut wie heute. Es ist also schwer zu sagen, was wir morgen machen werden.

Nowadays we go out painting mainly to have a good time together. Graffiti has become an excuse for us to meet up again. Basically we still do graffiti just as we did at the beginning, in the form of quick and spontaneous graffiti images. Now and then we occasionally meet up in front of large wall projects to work with aerosols or acrylic paints. When doing this we analyse the positioning of the design or we use our experience to carry out other types of intervention in natural environments. However, we always try to avoid lapsing into the type of street art which is satisfied with sticking up photocopied posters. Recently we have had the opportunity to exhibit the results of our research in galleries or other places dedicated to the arts, although we prefer to make observations and experiments in urban and rural spaces.

Our professional standards have become higher. We are always searching for projects that are very distant from our own cosmos so that we can try out new things. The challenge here is not to lapse into a routine of only doing what people already know we can do. Our way has taught us many things concerning the command of typography and the creation of pictures. However, just as we have graduated from graffiti to graphic design by adopting and adapting certain things, we must now try to execute graphic design that is far more detached from the sphere of our experience and that sustains our inclination for projects that are more personal.

Graffiti or its effects can be found everywhere: in the supermarket, on CD covers, etc. The life-span of a picture becomes increasingly shorter and innovations have never been churned through the marketing machine as quickly as they are today. This means that it is difficult to say what we will be doing tomorrow.

•060

FROM THE SCENE. PT2

. FAKTEN. FACTS
MISTER E. Michel Abraham. *1973

. ARBEITSBEREICHE
. Modedesign
. Grafikdesign
. Illustration

. HISTORY
1987 Beginn mit Writing, richtig aktiv aber erst
Anfang der 90er Jahre mit der TWA Crew
1996 Umzug von Frankreich nach Deutschland, Arbeit
als Verkäufer im Einzelhandel, dann als Grafik-
designer und schließlich als Modedesigner für
verschiedene Untergrundlabels
2002 Umzug nach New York City, Designer in Marc
Eckos Ideenschmiede für Ecko Unltd.
2004 Rückkehr nach "Good Old Europe",
als Freelancer weiterhin für Ecko Unltd. tätig

. FADINGS
Ich habe meinen Abschluss an der besten Kunstschule
gemacht, die es gibt: der „Universal Academy of Graffiti
and HipHop Arts". Ich absolvierte dort über Jahre hinweg
verschiedene Klassen und traf dabei viele interessante,
leidenschaftliche und talentierte Menschen, egal ob
Student oder Lehrer.
Was ich von Graffiti gelernt habe? Spontaneität – meinen
Gefühlen zu folgen, nicht meinem Kopf – Fleiß und
Ausdauer – Risiken einzugehen, wenn nötig auch Regeln
zu brechen – zwei Farben aufeinander abzustimmen, auch
wenn sie nicht zueinander passen – dass „die Tat lauter
als Worte ist" (Zitat: SKKI) – dass du in einem Augenblick
Jäger, im anderen Gejagter bist, jetzt der Mentor und im
nächsten Moment der Toy (Anfänger) – und Respekt.
Wenn ein Sprüher in ein „institutionalisiertes" kreatives
Umfeld übergeht, wird er nicht nur sein Talent und
ästhetisches Empfinden mitbringen, sondern vielmehr
seine Einstellung: Die Art Dinge zu begreifen und sich
intensiv mit ihnen auseinander zu setzen, mit all seinem
Mut. Wie viele Sprüher vorher, die ihre „Straßenskills"
in andere Bereiche eingebracht haben, hatte ich diesen
Ansatz in den Bereich Modedesign einfließen lassen. Auch
heute noch fülle ich Blackbooks mit unzähligen Skizzen
und Ideen – stapelweise gleich neben den Graffitiskizzen.
In der Modewelt muss man jede Saison mit etwas Neuem
aufwarten, immer mit Blick auf die Eigenarten der Marke,
für die man gestaltet. Dies ist vergleichbar mit dem Stil
eines Sprühers, der sich von Bild zu Bild entwickeln,
dabei aber eigenständig bleiben soll. Wie früher schon
muss ich auch heute noch immer den Konkurrenzkampf
für mich entscheiden – und wenn ich jemanden sehe, der
meine Designs trägt, macht mich das genauso zufrieden,
wie mein Tag zu sehen. Wie DONDI schon sagte: „the
battle goes on, overground..."

. KONTAKT. CONTACT
Home. 01
Heidelberg. Germany

Home. 02
michel@pimp-o-tronic.com

. JOB FOCUS
. fashion design
. graphic design
. illustration

. HISTORY
1887 started writing, but became really active in the
early nineties with the TWA Crew
1996 moved from France to Germany and was employed
first as a retail salesman and then as a graphic
designer and finally as a fashion designer for several
urban brands
2002 moved to New York City to join Marc Ecko's
Mindlabs where we made designs for Ecko Unltd.
2004 back to good ol' Europe, still "bombing" for
Ecko Unltd. on a freelance basis

. FADINGS
I graduated from the best of all art schools, the "Universal
Academy of Graffiti and HipHop Arts". For several years
I attended many classes there and met a number of intere-
sting, passionate and talented people, both among
the students and among the teachers.

What did Graffiti teach me? Spontaneity – to follow my
feelings, not just my thoughts – hard work and perseverance
– to take risks and break rules if necessary – that two
colours can be made to match even if they don't – that
"action speaks louder than words" (SKKI) – that first you
are the hunter and then you are the prey, or first the
mentor and then the toy (beginner) – and respect.

I believe that once a writer has "faded" into an "institutiona-
lised" creative field, he brings with him not only his talent
and aesthetics, but above all his attitude and way of just
grasping things and getting into them deeply, which requires
all his courage. Like the many other writers who "faded"
their street skills into other areas, I brought this approach
into the field of fashion design. I still fill up blackbooks with
tons of sketches and ideas and I have a whole pile of them
next to the graffiti ones. In the fashion world, you have
to come up with something fresh every season while always
keeping the touch of the brand you design for. In the same
way a writer's style has to keep evolving from piece to piece
but still be personal. As in my earlier days, I still have
the need to burn the competition and when I walk around,
I am just as satisfied when I see somebody wearing my
designs, as when I see my tag. As DONDI said: "the battle
goes on, overground..."

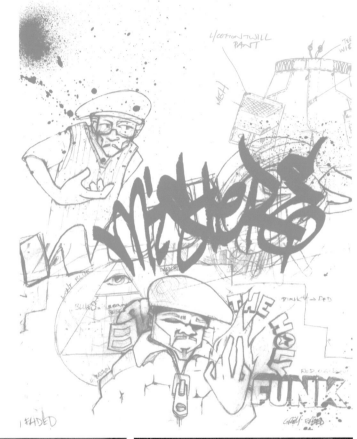

- - - - - - - - - - - - - - - - - - •001 ++ 003
•001 SKETCH. 1999
•002 MURAL. wildstyle & character. 1996
•003 CHARACTER. 2001

• 004 ++ 008 ECKO UNLTD. Fall 2004
• 009 ++ 018 ECKO UNLTD. Summer 2004

• 019 ++ 020

• 021

• 022

SCIENCE

PHYSICAL

• 023 ++ 026

.....................
•019 ++ 020 PHYSICAL SCIENCE. booth. viewed from the outside.
 Inter Jeans Fashion Show. 2000
•021 PHYSICAL SCIENCE. booth sketch. 2000
•022 PHYSICAL SCIENCE. specs for top view. 2000
•023 ++ 026 PHYSICAL SCIENCE. specs for side views. 2000

• 027 ++ 038

• 039 ++ 041

• 042 ++ 043

• 044 ++ 046

. FAKTEN. FACTS
ESHER. Frank Lämmer. *1974

. ARBEITSBEREICHE
. Sachverschönerung durch Farbschmierereien
. alles, was man mit Computern machen kann

. HISTORY
1974 Frankfurt/Main
1980 Berlin
1989 Graffiti
1999 Computer

. FADINGS
Graffiti und Grafikdesign, vor allem die Modeerscheinung
Trendgrafik, haben leider manchmal gemeinsam, eine
schöne Verpackung ohne Inhalt zu sein. Aus vielem,
was mich über diverse Medien erreicht, spricht zu mir
schön ausgearbeitete stylische Langeweile. Sie kommt
daher mit 45 Grad-Winkel-Kästchen, mit drei Pantone-
Schmuckfarben, mit Pseudo-Stencil-Graffiti und natürlich
obligatorischen Sprühspritzern und Drips.

Ein guter Grafikdesigner sollte vielleicht auch keine
eigenen Ideen und Inhalte haben, die kommen ja vom
Kunden. Ich bin nicht so ein guter Grafikdesigner.

. KUNDENLISTE. CLIENTS LIST
. my local homies
. no global player

. KONTAKT. CONTACT
Home. 01
Berlin/Kreuzberg. Germany

Home. 02
http://www.schmuddelrot.de
esher@schmuddelrot.de

. JOB FOCUS
. improving objects by covering them in paint
. everything that can be done with a computer

. HISTORY
1974 Frankfurt/Main, Germany
1980 Berlin, Germany
1989 graffiti
1999 computer

. FADINGS
Unfortunately, graffiti and graphic design, especially
the latest craze for trend graphics, all have one thing in
common: they are lovely wrappings with no contents.
The many things that reach me through various media
convey styles that are beautiful and elaborate, but
tedious. They express themselves with 45 degree
rectangles, three Pantone colours, or with pseudo stencil
graffiti and of course, the obligatory splatters and drips.

A good graphic designer is not supposed to have his own
ideas or concepts, as these come from the client. I am
not such a good graphic designer.

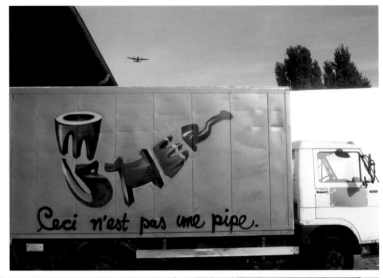

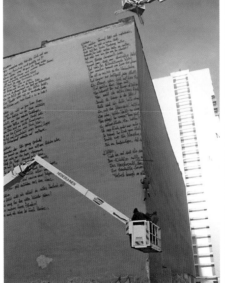

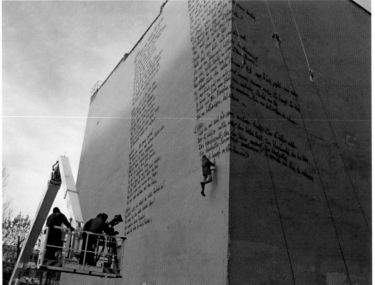

• 001 ++ 003

- - - - - - - - - - - - - - - - - -
• 001 CECI N'EST PAS UNE PIPE. inspired by René Magritte.
Berlin. Germany. 2003
• 002 ++ 003 GOETHES FAUST. ESHER as a stuntman.
production for a commercial. Berlin. Germany. 2004

· 004

· 005 ++ 007

·004 ++ 007 FLAVOUR. graphics, illustration and layout for
Red Bull and the music label !K7. party series communicated
by a small newspaper and various graphical works. 2003-2004

Fischels
Flitze
fischt
flische
Fische

www.sumo.com
Bergmannstrasse 99
10961 Berlin
(030) 69004963

• 008 ++ 009

• 010 ++ 015

• 008 ++ 009 SUMO. menu artwork for Sumo, sushi restaurant
located in Berlin/Kreuzberg. Germany. 2004

•016 ⊹ 018 •019 ⊹ 027

•010 ⊹ 018 MOEBIUS 17. a film by ESHER and Jo Preussler.
60 minutes. 2002. The film tells the story of "Einer" and
"Anderer" who are painting a subway, train no. 17, but
cannot take a photo of it. Later "Einer" is trying to find
the train and is no longer the hunter but the prey and
reaches his limit of imagination. Arno Funke, known as
the German blackmailer "Dagobert", plays the head of the
Transport Services.

•019 ⊹ 027 THE REAL MOEBIUS HARDCORE. parody of their
own film MOEBIUS 17 using dolls made of paperboard.
check http://www.moebius17.de
see the MOEBIUS 17 trailer on FADINGS DIGITAL

. FAKTEN. FACTS
NECK-CNS. Oliver Gelbrich. *1974

. ARBEITSBEREICHE
. Artdirektion für On- und Offline-Medien
. Schriftgestaltung
. Fassaden- und Innenraumgestaltung

. JOB FOCUS
. art direction for online and offline media
. font design
. facade and interior design

. HISTORY
1989 entstehen erste Pieces
1995 Gründungsmitglied der CHECKIN' NEW
SKILLZ Crew (CNSkillz)

. HISTORY
1989 first pieces
1995 founder member of the CHECKIN' NEW
SKILLZ Crew (CNSkillz)

Aus der Auseinandersetzung mit dem Stylegedanken entsteht das Interesse an Gestaltung über Graffiti hinaus. Es folgt ein Designstudium und der Einstieg ins Agenturleben.

A critical analysis of the concept of style awakened an interest in design beyond the world of graffiti. As a result of this, I studied design and entered the world of agencies.

2000 GREY worldwide
2001 die argonauten/argonauten 360°
2004 TWT interactive

2000 GREY worldwide
2001 die argonauten/argonauten 360°
2004 TWT interactive

. FADINGS
Ich versuche permanent Grenzen zu überschreiten und durch die Verschmelzung meiner dominantesten Einflüsse, Graffiti und Design, etwas Neues, nie da Gewesenes, zu entwickeln. Aus dem Spannungsfeld zwischen Emotion und Bewegung in einem klassischen Wildstyle und der reduzierteren und eher klinischen Schönheit des Grafikdesigns lässt sich eine Menge an Inspiration und Entwicklung ziehen.

Aus diesem Spannungsfeld heraus entstehen meine Arbeiten.

. FADINGS
I am forever trying to go beyond the limits and develop something new and unprecedented by integrating graffiti and design, my most dominant influences. It is possible to draw inspiration and advancement from the area of conflict between the emotion and movement of a classical wildstyle and the minimalist and rather clinical beauty of a graphic design.

My work is created from this area of conflict.

. KONTAKT. CONTACT
Home. 01
Düsseldorf. Germany

Home. 02
http://www.neckcns.com
http://www.cnskillz.com
neck@cnskillz.com

• 001 ++ 002

• 001 ARROWS. for BITE magazine's "Wall Invention Project".
Kyoto. Japan. 2003
• 002 STRIPES. for BITE magazine's "Wall Invention Project".
Kyoto. Japan. 2003

djs ateone
till westwood
25.09.2003
disco ★ house triple a köln

djs ateone
till westwood
25.09.2003
disco ★ house triple a köln

djs ateone
till westwood
25.09.2003
disco ★ house triple a köln

neckcns.com

graffiti | design: hybrid art

• 003 ++ 005

• 006 ++ 007

• 003 ++ 005 LOST IN MUSIC. flyer design for Atel. 2003
• 006 ++ 007 DRIPS. design for iBook Click-On Skin. 2003
available at http://www.macskinz.com

• 008 LOVE OF MY LIFE. splashscreen for
http://www.bandits-dresden.de. 2003
• 009 CNSKILLZ.COM. 2004
• 010 HIFIART.COM. 1998
• 011 OFFTHEWALL04.DE. 2004

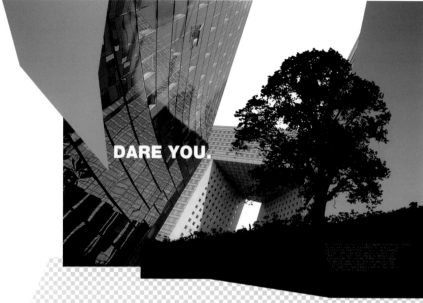

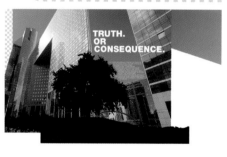

•012 ++ 013

•014 ++ 016

•012 ++ 013 SODASTREAM - REFILL. print on canvas.
 for OFFTHEWALL04 exhibition. 2004
•014 ++ 016 ABOUT: TRUTH. for BATTERIE PDF magazine. 2003

. FAKTEN. FACTS
BESOK. Daniel Nicos Döbner. *1974

. ARBEITSBEREICHE
. Fassaden- und Innenraumgestaltung
. Buch-, Plakat-, Coverillustration
. Characterentwicklung
. Bühnenbild

. HISTORY
1990 erster Kontakt zur Graffitiszene
1996 dreimonatige Reise durch Mittelamerika,
viele Eindrücke für spätere Bilder
2001 Studium Design mit Schwerpunkt Illustration
an der Fachhochschule Münster
2004 Veröffentlichung von zwei Kinderbüchern

. FADINGS
Als ich mit Graffiti anfing, habe ich schnell gemerkt,
dass mir die Auseinandersetzung mit Schrift alleine nicht
ausreicht. Meine Leidenschaft zum Figürlichen hat sich
erst recht verstärkt, da ich als Charactermaler häufiger
in Projekte einbezogen wurde. Somit konnte ich viel mehr
reisen, Leute, Länder, Kulturen kennen lernen und neue
Inspirationen sammeln – ein angenehmer Nebeneffekt.
Durch meinen Wunsch, Kinderbücher u. ä. zu illustrieren
und dem damit verbundenen Zeitaufwand, muss ich mich
zwangsläufig ein wenig aus dem Graffitibereich zurück-
ziehen. Ich sehe das als eine Schwerpunktverlagerung in
Richtung Zukunft. Die Arbeit mit Verlagen ist eine enorme
Herausforderung, zumal es mir aufgrund meiner unver-
kennbaren Wurzeln nicht immer leicht fällt, den richtigen
Geschmack zu treffen. Dennoch sind meine Erfahrungen
im Bereich Bildaufbau und Characterentwicklung von
großem Vorteil.
Der Einfluss von Graffiti, sei es durch Schrift oder Figur,
ist schon tief in den allgemeinen Design- und Wirtschafts-
sektor vorgedrungen. Positiv auf der einen Seite, denn es
ist sicherlich nicht falsch, seine Fähigkeiten kommerziell
einzusetzen. Auf der anderen Seite ist der Markt gesättigt
– speziell in der Modebranche schon lange – und bis auf
wenige Ausnahmen übernimmt Quantität die Vorherr-
schaft. Es ist also höchste Zeit, die Idee der Qualität
wieder zum Sprühen zu bringen: Graffitikultur ist keine
Modeerscheinung.

. KUNDENLISTE. CLIENTS LIST
. Siemens PC
. LTU - Tjaereborg
. Seat
. Deutsche Post AG
. Coppenrath Verlag

. KONTAKT. CONTACT
Home. 01
Münster. Germany

Home. 02
http://www.besok.de
besok@gmx.de

. JOB FOCUS
. facade design, interior design
. book, poster, cover illustration
. character design
. stage design

. HISTORY
1990 first contact with graffiti scene
1996 three-month journey through Central America,
many impressions for later works
2001 study of design with illustration as main subject
at the University of Applied Sciences, Münster,
Germany
2004 publication of two children's books

. FADINGS
When I started off with Graffiti I soon found that concen-
trating on writing was not enough. At the time I often
worked as a character writer in different projects which
made my passion for creating figures grow even stronger.
Consequently I was able to travel a great deal and got to
know other people, countries and cultures. As a pleasant
side effect I gathered new impressions to inspire my
work. Because of my wish to illustrate children's books
and the time needed for this, I was forced to withdraw
a little from the graffiti scene. I regard this as a shift of
emphasis in regard to the future. Working for publishers
is a tremendous challenge, particularly as my unmista-
kable roots do not always make it easy for me to meet
the right taste. However, my experience in the areas of
composition and character creation is a great advantage.
The influence of graffiti, whether through letters or
figures, has already penetrated deeply into the general
sectors of design and commerce. On the one hand this
is positive because there is certainly nothing wrong in
using one's abilities to serve commercial ends. On the
other hand, the market in general is almost saturated and
the fashion trade in particular was saturated long ago.
Although there are a few exceptions, it is quantity that
rules the market. So now it is high time to let the shining
concept of quality come into its own: graffiti culture is not
a temporary fad of fashion.

•001

•001 DIZZY GILLESPIE. spraypaint on canvas. 2000
•002 RACE. BESOK/ROOKIE. mural. Münster. Germany. 2004

•002

16.0

•003 ++ 011

•003 ++ 012 DAS SANDMÄNNCHEN UND DER MANN IM MOND.
storyboard for children's book illustration.
published by Verlag Coppenrath. ISBN 3-8157-3434-7.
2004

Nach einer Weile landete der Papagei auf
einem zugewachsenen Steinhaufen. "Hier
ist es!", sagte Coco. "Siehst du den Spalt
da unten zwischen den Steinen? Da geht
es in die Schatzkammer. Ich halte hier
Wache." Fridolin kroch zaghaft in die
enge, dunkle Öffnung. Ein wenig unheim-
lich war ihm schon zumute.

•013 + 017 VINCENT DER FROSCH. children's book illustrations.
published by Verlag Monsenstein & Vannerdat. ISBN 3-937312-72-2. 2004
see the whole book on FADINGS DIGITAL

•013

Noch vor kurzem saß Fridolin der Frosch am heimischen Teich und langweilte sich. Da fiel ihm sein Cousin Alfons ein, der in den Regenwald ausgewandert war. "Au ja, den werde ich besuchen!" Er machte sich sofort auf den Weg. Nach einer langen Reise saß Fridolin am Rand des Dschungels. "Puh, endlich geschafft! Jetzt kann es ja nicht mehr so schwer sein, Alfons zu finden". Wie anders es hier war, viel wärmer und so angenehm feuchte Luft. Am Besten fand er die vielen kleinen Käfer und Stechmücken. "Toll! Ich brauche nur meine Zunge herauszustrecken und das Essen fliegt mir von alleine drauf."

Die Ameisen versteckten sich und schon brach der Ameisenbär aus dem Unterholz hervor. Er schnüffelte an Fridolin. "Hm, hier war doch kürzlich noch eine Ameisenstraße." - "Die ist verlegt worden. Du musst da hinten suchen!", antwortete der Frosch. "Bist du sicher?" Fridolin nickte und der Ameisenbär wackelte grummelnd in die angegebene Richtung. "Puh, das war knapp." Als er verschwunden war, kamen die Ameisen aus ihren Verstecken und machten sich wieder an die Arbeit. Schnellfuß bedankte sich bei Fridolin für seine Hilfe und zeigte ihm den Weg, den Alfons genommen hatte. Der Frosch hüpfte los.

Nach einer Weile landete Coco, so hieß der Kakadu, auf einem zugewachsenen Steinhaufen. "Hier ist es!", sagte er. "Siehst du den Spalt da zwischen den Steinen? Da geht es in die Schatzkammer. Ich warte hier." Fridolin kroch zaghaft in die enge, dunkle Öffnung. Ein wenig unheimlich war ihm schon zumute.

Nach einer Weile hörte Fridolin jemanden rufen: "Hilfe! Nein, nicht in den Suppentopf!" Diese Stimme kannte er. Das war doch Alfons! Er erspähte Menschen, von denen einer seinen Cousin festhielt. Auf einem Holzfeuer stand ein großer, dampfender Kessel. "Oh nein! Die wollen Alfons doch nicht etwa kochen?!" Fridolin überlegte verzweifelt, was er tun konnte. Da hatte er eine Idee. Er kletterte auf einen Baum und schnappte sich eine Liane. Dann rief er zu seinem Cousin herunter: "He, Alfons, ich bin's, Fridolin! Ich befreie dich! Wenn ich an dir vorbeischwinge, greifst du nach meiner Hand!"

. FAKTEN. FACTS
SUPERBLAST. Manuel Osterholt. *1976

. ARBEITSBEREICHE
. Corporate Identity
. Grafikdesign
. Grafik-Kunst
. Web- und Flashdesign
. Schriftgestaltung

. JOB FOCUS
. Corporate Identity
. graphic design
. graphic art
. web and flash design
. font design

. HISTORY
1990 Start als Writer in Heidelberg
1999 VIVA WordCup: Background Piece – TV-Feature,
Backjumps Magazin: Interview und CD-ROM-
Gestaltung, dreijährige Grafikdesign-Berufsaus-
bildung in Karlsruhe
2003 Einzelausstellung SUPERISM NOW!, Halle02,
Heidelberg
2004 Intensiv-Crashkurs „Fontdesign" bei Lucas de Groot
(http://www.lucasfonts.com)

. HISTORY
1990 start as writer in Heidelberg, Germany
1999 VIVA WordCup: background piece – TV feature,
Backjumps magazine: interview and CD-ROM
design, three year vocational training in graphic
design in Karlsruhe, Germany
2003 solo exhibition SUPERISM NOW!, Halle 02,
Heidelberg, Germany
2004 crash course in "Font design" with Lucas de Groot
(http://www.lucasfonts.com)

. FADINGS
Die Writingkultur war und ist eine sehr wichtige Schule im
Umgang mit Formen und Farben: Die Art der Denk- und
Herangehensweise, die Fähigkeit, unter Zeitdruck und
unter schlechtesten Bedingungen das Beste zu geben,
dabei auf neue Aufgaben zu treffen und neue Lösungs-
wege zu finden, Liebe für die Sache zu haben, sich mit
Stilrichtungen auseinander zu setzen und der Wille zu
burnen – das sind prägende Einflüsse auf mich und mein
Grafikdesign.

Style als eigene Handschrift zu sehen und sich mit seinen
Buchstaben zu optimieren – so werden Ausdrucksstärke
und Persönlichkeit in jedem Piece oder jeder Grafik
sichtbar. Die magische Anziehungskraft von Schrift und
Formen hat mich heute noch nicht verlassen.

Die Vielseitigkeit und Abwechslung beim Sprühen und in
der visuellen Gestaltung sind meine Inspiration und mein
Motor.

. FADINGS
Writing culture always was and is an important discipline
when it comes to teaching the use of shapes and colours.
The way of thinking and approaching, the ability to give
one's best under time pressure and the worst possible
conditions, and in doing so, coming across new challen-
ges that require new solutions, standing up for a cause,
examining different styles, and the will to burn – all
these have had a great influence on me and my graphic
designs.

Through the ability to see style as one's own personal
hand and to improve with the letters, expression and
personality become visible in every piece or graphic.
The magic attraction of letters and shapes still
fascinates me even now.

The many facets and variations in the fields of spraying
and visual design are my inspiration and my driving force.

. KUNDENLISTE. CLIENTS LIST
. Völkl Snowboards
. Universal Music
. HipHopWorldChallenge
. Illmatic Designz
. Montana Cans
. Bladvulling.nl
. Ecko Unltd.
. ASP351

. KONTAKT. CONTACT
Home. 01
Berlin. Germany

Home. 02
http://www.superblast.de
mo@superblast.de

• 001

• 002

• 003

• 004 ++ 005

• 001 SUPERPIECE. vector style. 2004
• 002 RESISTANCE - OUT OF CONTROL. canvas and
T-shirt design 1999. remake. 2003

• 003 ROY HARGROVE - HARD GROOVE. universal music. ad. 2003
• 004 SIR BENNI MILES. T-shirt design. season 2002/03
• 005 HIPHOPWORLDCHALLENGE. 2005

· 006

· 007 ++ 018

· 019

· 006 GOTHICBLAST. font design. support by Luc(as) de Groot. 2004
download GOTHICBLAST font on FADINGS DIGITAL
· 007 ++ 018 LOGOS/GRAPHICS. 2001-2004
· 019 NEO UTOPIA 1976. SUPERBLAST stickers. 2004

• 020

• 021 ++ 022 • 023 ++ 024

- - - - - - - - - - - - - - - - - -
•020 NEO UTOPIA 1976. SUPERBLAST T-shirt. 2004
•021 ++ 022 COAL. Völkl Snowboards. top and base. season 2004/05
•023 ++ 024 PROPOSAL. Völkl Snowboards. top and base. season 2005/06

. FAKTEN. FACTS
FLYING FORTRESS. *1974

. ARBEITSBEREICHE
. Illustration für On- und Offline-Medien
. freie Arbeiten und Wanderkünstler

. HISTORY
1989 Kontaktaufnahme mit Sprühkunst
1991 Start der tatsächlichen aktiven Laufbahn
1996 Studium Kommunikationsdesign
1998 Beginn freiberuflicher Tätigkeiten
2001 progressives Writing

. FADINGS
Neben der An- und Bereicherung des „traditionellen"
Graffiti mit der Sprache des modernen Grafikdesigns ist
für mich die Wandlung des „Codes" die entscheidende
Stufe der Evolution zum aktuellem Stand innerhalb der
Graffitibewegung. Anstelle von Isolation in der eigenen
(Graffiti-) Szene durch Chiffrierung der Messages
(kalligraphische Tags) tritt nun verstärkt ein dekodiertes
Tag in Form von Logos oder figürlichen Elementen auf.
Es wird eine eindeutige Kommunikation gesucht, eine
klare Sprache, die von jedermann zu „lesen" ist und somit
eine weitaus größere Aufmerksamkeit im Bewusstsein
des Betrachters erreicht, wenn es darum geht, einen
Bezug der Arbeiten zu einem Urheber herzustellen. Sicher
handelt sich es bei der Message weiterhin um denselben
altbekannten Inhalt: Ich! Sozusagen Getting-Up mit
bewährten Marketingstrategien.

. JOB FOCUS
. illustration for online and offline media
. freelance work and wandering artist

. HISTORY
1989 first contact with spray art
1991 start of actual active career
1996 study of communications design
1998 start of freelance activities
2001 progressive writing

. FADINGS
Although "traditional" graffiti has enhanced and enriched
the language of modern graphic design, it is the trans-
formation of the "code" that in my opinion is the decisive
evolutionary step to the present state of the graffiti
movement. The isolation inside an innate graffiti scene
that results from ciphering messages (calligraphic tags)
is increasingly giving way to decoded tags in the form
of logos or figurative elements. A distinct form of com-
munication is sought after, an articulate language that
everyone can "read" and that heightens the awareness
of the contemplator for relating a work to its originator.
The message is certainly the same well-known statement:
It's me! To all intents and purposes, this is getting-up with
time-tested marketing strategies.

. KUNDENLISTE. CLIENTS LIST
. HESSENMOB Skateboards. Germany
. WORD magazine. Switzerland
. JUICE magazine. Germany
. BELIO magazine. Spain
. SIXPACK. France
. Montana/MTN Cans. Spain
. BROKE. Italy
. ADDICT Clothing. UK
. Element Skateboards

. KONTAKT. CONTACT
Home. 01
Munich. Germany

Home. 02
http://www.flying-fortress.de
http://www.teddytroops.com
pilot@flying-fortress.de

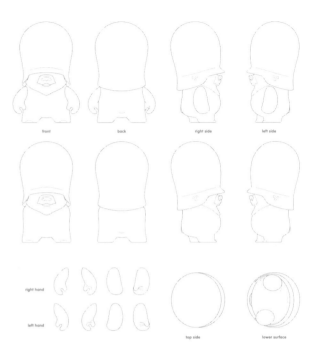

• 002 + 003

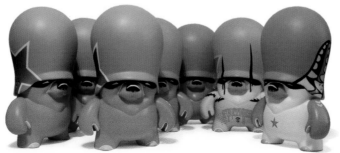

• 001

• 001 TEDDY TROOPS. urban vinyl toys. series 01. 2004
• 002 TEDDY TROOPS. blueprint toy design. 2004
• 003 PIXEL BLOX. SHAWN-THESIGNER/BURNS124/FF. mural. Munich. Germany. 2003

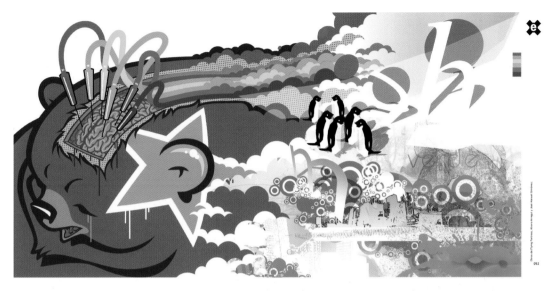

• 004

• 005

• 004 BELIO MAGAZINE. dreams issue.
feat: Alvaro Arregui & José Manuel Giménez. 2002
• 005 LE MESSIE'S CANDY. CD cover design. 2004

•006

•007 + 008

•006 NATAS BITE. Hessenmob Skateboards. T-shirt design. 2004
•007 WORD MAGAZINE. illustration. 2004
•008 WORD MAGAZINE. cover illustrations. 2003

19.0

. FAKTEN. FACTS
SAT ONE. Rafael Gerlach. *1977

. ARBEITSBEREICHE
. Illustration
. Grafikdesign
. Schriftentwicklung
. Animation
. Fotografie

. JOB FOCUS
. illustration
. graphic design
. font design
. animation
. photography

. HISTORY
1992 erste Versuche mit Sprühdose
1996-99 Grafikdesign-Ausbildung, seit
2000 freiberufliche Tätigkeiten

. HISTORY
1992 first attempts with spraycan
1996-99 training in graphic design, since
2000 freelance activities

. FADINGS
Rückblickend auf eine aktivere Zeit als Sprüher, dominiert
doch der Drang, meinen Ideen mit Hilfe neuer Medien
Ausdruck zu verleihen. Mir ist klar, dass das Medium
Sprühdose nur ein Teil eines Schaffensprozesses war,
der sicherlich noch lange kein Ende finden wird. Dennoch
birgt Graffiti nach wie vor ein persönliches Lebensgefühl,
das durch nichts zu ersetzen wäre.

. FADINGS
When I look back on my time as a more active sprayer,
I am dominated by the urge to express my ideas with the
aid of the new media. It is plain to me that the spraycan
as a medium was only part of a creative process that still
has a long way to go. However graffiti still brings with it
a personal attitude to life that is irreplaceable.

. KONTAKT. CONTACT
Home. 01
Munich. Germany

Home. 02
http://www.satone.de
grafx.design@gmx.de

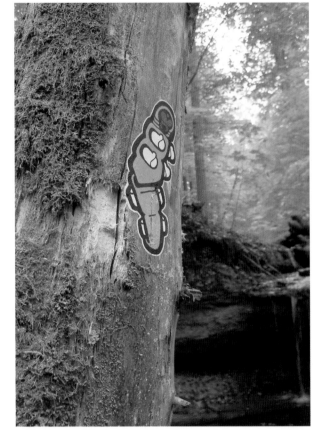

• 002

• 001

•001 THE R-P. illustration. 2004
•002 GRUB. acrylic on wood. 2004
•003 ++ 028 A-Z. letters. found in Italy,
England, Russia and Germany. 2004

• 003 ++ 004

19.0

•029

•030

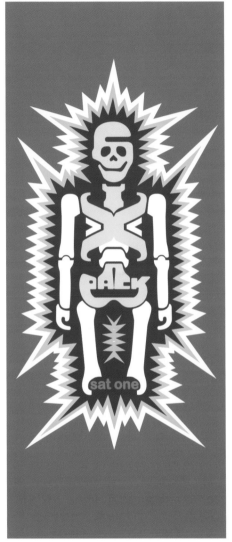

•031

- - - - - - - - - - - - - - - - - -
•029 FREE. cover illustration for COMEUNITY magazine. France. 2004
•030 SKATEDECK. 2003
•031 SIXPACK. T-shirt design for http://www.sixpack.fr. 2004

•032 TELL. hommage to Wilhelm Tell. 2004
•033 TIME. logo. 2004
•034 WOOD. logo. 2004
•035 STREET. logo. 2004

. FAKTEN. FACTS
STUKA. Stefan Manabu Mückner. *1977

. ARBEITSBEREICHE
. Corporate Identity, Corporate Design
. Platten- und CD-Cover-Gestaltung
. Katalog-, Magazin- und Buchgestaltung
. Poster- und Flyergestaltung
. Illustration
. Schriftgestaltung
. Malerei
. Fassaden- und Innenraumgestaltung

. HISTORY
1991 Beginn mit Writing
1996 Schulpraktikum bei Ax Design, Braunschweig
1998 Zivildienst im Kunstatelier der Lebenshilfe
 Braunschweig

Ende der 90er Jahre Schwerpunkt auf Malerei und
Ausstellungen, seit

2000 Studium Kommunikationsdesign an der
 HBK Braunschweig
2000 Gründung des Ateliers TTA
2001 Praktikum in der Werbeagentur
 GINGCO, Braunschweig
2003 Praktikum in der Agentur
 ATALIER, Bern, Schweiz

. FADINGS
Fadings sind dreidimensional, sind Ambition, Basis,
Charakter, Disziplin, Evolution, Freundschaft, Guerilla,
Homogenität, Inspiration, Juvenilität, Kognition, Loyalität,
Metamorphose, Nemesis, Optimismus, Passion, Qualität,
Respekt, Sturzkampf, Temperament, Urbanismus, Vision,
Widerstand, Xenophilie, YinYang und Zyklus.

Mich nicht in meinen Arbeiten wieder zu finden, ohne mich
dabei zu verlieren – das liebe ich. Danach strebe ich.

. KUNDENLISTE. CLIENTS LIST
. Scoop Music
. Beathaviour
. Deck 8
. EMI music

. KONTAKT. CONTACT
Home. 01
Brunswick. Germany

Home. 02
http://www.stukabazooka.com
contact@stukabazooka.com

. JOB FOCUS
. Corporate Identity, Corporate Design
. record and CD cover design
. catalogue, magazine and book design
. poster and flyer design
. illustration
. font design
. painting
. facade and interior design

. HISTORY
1991 started with writing
1996 work experience at Ax Design, Brunswick, Germany
1998 alternative (national) service in the art studio of the
 Lebenshilfe Brunswick, Germany

In the late nineties the accent was on painting and
exhibitions, since

2000 study of communications design at the
 HBK Brunswick, Germany
2000 foundation of the TTA Studio
2001 practical training in the advertising agency
 GINGCO, Brunswick, Germany
2003 practical training in the agency
 ATALIER, Berne, Switzerland

. FADINGS
Fadings are three dimensional, they are ambition, basis,
character, discipline, evolution, friendship, guerrilla,
homogeneity, inspiration, juvenility, knowing, loyalty,
metamorphosis, nemesis, optimism, passion, quality,
respect, surprise-attack, temperament, urbanism, vision,
withstanding, xenophilia, YinYang and zenith.

Not finding myself in my work without getting lost in the
process – this is what I love. This is my aspiration.

- - - - - - - - - - - - - - - - - - -
•001 POISON GAS. illustration. 2004
•002 VIOLET. digital STUKA style. 2004

20.0

•003

•004

•005

• 003 + 005 PHATTSTYLE. various artwork for
Phattstyle fashion store. 2004

no.**01**
Boo milk for love

•006

•007

•006 BUSHMILK. illustration. 2004
•007 KOMPOSITION. 2004
•008 BOB UND FÜHRER. 2004

•008

315.7070.3.16

4 006180 707032

BOSSE.KRAFT

Kraft
Kamikazeherz
Das kleinste Glück
Kraft (Matchboxing Remix)

//03.26
//03.38
//07.06
//04:54

© Scoop Music
© stackman productions

LC 0849

SCOOP 7070-3

Kraft //03:26
Kamikazeherz //03:38
Das kleinste Glück //07:06
Kraft (Matchboxing Remix) //04:54

Musik & Text von BOSSE,
außer Titel 4: Remix von Matchboxing/Kai Voepel
Aufgenommen und gemischt @ one and one-Studios,
außer Titel 1 gemischt @ Topaz
Produziert und aufgenommen von Wolfgang „Stackman" Stach
Titel 1 gemixt von W. Stach & O. Reitmeier & BOSSE
Titel 2 + 3 gemixt von W. Stach & BOSSE

Schlagzeug: Björn Krüger
Bass: Olaf Reitmeier
Gitarren: Thorsten Sala
Gesänge: BOSSE
Programmings + Cello: Sebastian Gramss

Mastering: Ulli Baronowsky,
außer Titel 1 von Michael Schwabe @ Monoposto Mastering

Artwork: Stuka.tta

Alle Titel verlegt bei Scoop Music / BMG UFA

Management:
Scoop Music Entertainment GmbH
info@scoop-music.de

rough trade SCOOP

www.bosse-rockt.de//www.stackman.de//www.scoop-music.de

•009

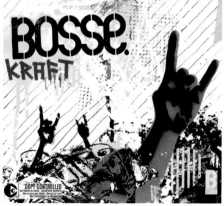

COPY CONTROLLED

•010 + 011

 BOSSE.

•012

•009 BOSSE. Kraft. cover design. 2004
•010 BOSSE. Keine Panik. illustation. 2004
•011 BOSSE. Kraft. rerelease. illustation. 2004
•012 BOSSE. logo design. 2004

. FAKTEN. FACTS
EROSIE. *1976

. ARBEITSBEREICHE
. Graffitimaler
. Stickerkleber
. Radfahrer
. Bereitschaftskünstler
. Editorialillustrator
. Kinderbuchillustrator
. Logoliebhaber
. Gelegenheits-Grafikdesigner

. HISTORY
1978 erste Zeichnung
1993 erstes Graffitibild
1997 erstes alternatives Graffiti
1999 Abschluss Kunstschule
2000 Berufsbeginn als Illustrator

. FADINGS
Als Illustrator finde ich es schwer, nur in einem mit
Deadlines und Kunden abgesteckten Feld zu arbeiten; als
Graffitimaler will ich nicht nur diese Outline-Highlight-
Routine. Ich will, dass sich beide Welten irgendwo dazwi-
schen treffen. Lange hielt ich diese zwei Welten ausein-
ander, indem ich verschiedene Namen für verschiedene
Arbeiten benutzte. Dies änderte sich allmählich. Auf der
Suche nach den Grenzen will ich jetzt meine Fähigkeiten
ineinander übergehen lassen. Ich versuche, mit meinem
Skizzenbuch als Leitfaden, in verschiedenen Bereichen zu
arbeiten, dabei aber immer eine erkennbare Handschrift
beizubehalten, um meine Arbeit näher an mich zu binden.
Ob es eine kommerzielle Arbeit oder ein Silberpiece ist,
ist mir dabei egal.
Ich bin gerne sowohl Illustrator als auch Graffitimaler
und respektiere trotzdem die Traditionen beider Be-
reiche, ohne dass diese durch konservatives Denken
zu Einschränkungen werden. Andererseits versuche ich
die Gefahr zu vermeiden ein weiterer „urban-creative"
Wallpaper-Designer zu werden. Graffitibezogene Arbeiten
werden nach ihrem urbanen Marktwert beurteilt, nicht
nach der eigentlichen Qualität. Das ist ein interessanter,
aber auch riskanter Konflikt.
Ich glaube, dass ein bewanderter Graffitimaler nicht
automatisch auch ein guter Designer ist.

. KUNDENLISTE. CLIENTS LIST
. Red Zone
. Backjumps magazine
. SIXPACK
. FreshCotton
. Avalanche Recordings

. KONTAKT. CONTACT
Home. 01
Eindhoven. Netherlands

Home. 02
http://www.erosie.net
hello@erosie.net

. JOB FOCUS
. graffiti-writer
. sticker-paster
. bike-rider
. stand-by artist
. children's book illustrator
. editorial illustrator
. logotype lover
. occasional graphic designer

. HISTORY
1978 first drawing
1993 first graffiti piece
1997 first alternative graffiti
1999 art school graduation
2000 start as professional illustrator

. FADINGS
As an illustrator I find it difficult to work solely in a field
restricted to deadlines and clients; as a graffiti-writer
I do not only want to carry out the outline-highline routine.
I want both worlds to meet somewhere in between. For
a long time I kept these two worlds separate, using diffe-
rent names for different work. This is gradually changing.
Nowadays I like to "crossfade" skills, searching for that
border. Using my sketchbook as a guide, I try to work in
different contexts while always retaining the same visible
handwriting, keeping my work close to me, whether it is
a commercial job or a silver-piece.
I like being an illustrator as well as a graffiti-writer,
respecting the traditions in both fields without these
traditions becoming limitations (restricting my freedom by
being too conservative). On the other hand I try to avoid
the danger of becoming another "urban-creative" wall-
paper designer whose graffiti-related work is appreciated
by its "urban" market-value and not by the quality of the
work itself. It's an interesting, but risky friction.
I think that a skilled graffiti-writer is not necessarily
a good illustrator or designer.

•001

•001 ODE MAGAZINE. editorial story illustration. acrylics/collage
•002 MURAL. Eindhoven. Netherlands. 2003

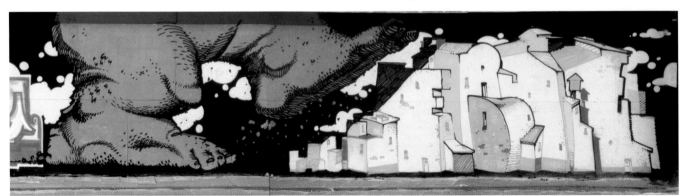

•002

21.0

• 003 ++ 004

• 005 ++ 008

• 003 ++ 004 SKETCHBOOK
• 005 ERODED CITY CYCLES BLING BLING BIKE GANG. illustration
• 006 THROW-UP. Rotterdam. Netherlands. 2003
• 007 ERODED CITY CYCLES. frame sticker
• 008 STICKER. Eindhoven. Netherlands. 2004

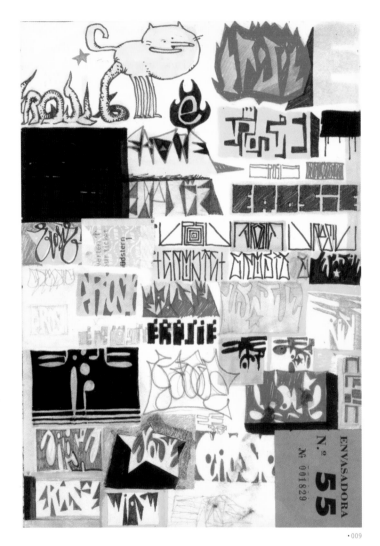

• 009

• 010 + 011

• 012 + 013

• 009 SKETCHBOOK
• 010 MURAL. Rotterdam. Netherlands. 2002
• 011 FLYER LOGOTYPE
• 012 MURAL. Eindhoven. Netherlands. 2004
• 013 FLYER. front and back

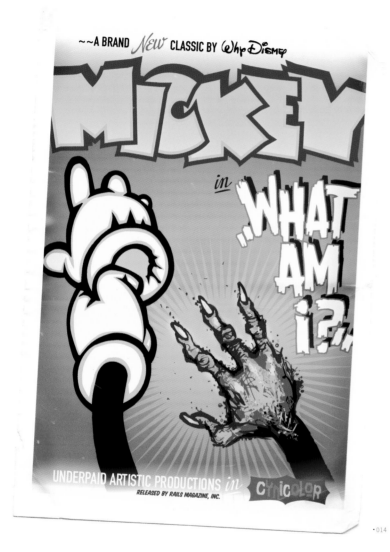

•014

•015 ＋ 017

- - - - - - - - - - - - - - -
•014 RAILS MAGAZINE. digital illustration
•015 SAMSONIC MAGAZINE. illustration. acrylics/collage
•016 TKMST MAGAZINE. illustration. acrylics/collage
•017 KID'S BOOK ILLUSTRATION. acrylics/collage

. FAKTEN. FACTS
FINSTA. *1978

. ARBEITSBEREICHE
Ich könnte mit jedem beliebigen Mittel arbeiten, obwohl
ich gerne möglichst freie Hand haben will. Ich möchte,
dass Menschen zu mir kommen, weil sie wissen, dass
sie mich brauchen. Ich aktualisiere mein Straßen-Portfolio
so häufig wie möglich und mache viele Arbeiten in aller
Öffentlichkeit, so dass die Menschen sehen können, was
ich zu bieten habe.

. HISTORY
1992 Anfang mit Graffiti
1995 erste Illustrationen für eine lokale Zeitschrift,
 Zunahme meiner freiberuflichen Tätigkeit
1999 Studium für Grafikdesign und Illustration in
 Stockholm, Schweden
2004 Studienabschluss mit Diplom,
 Arbeit als Freiberufler

. FADINGS
Mein Leben lang habe mich mit dem Zeichnen beschäf-
tigt; meistens Character und witziger Kram. In sehr
frühen Jahren habe ich mich entschlossen, das Zeichnen
zu meinem Beruf zu machen. Mit siebzehn Jahren fing ich
an, Illustrationen für eine lokale Zeitschrift anzufertigen
und die Straßen mit meinen Graffitiarbeiten zu pflastern.
Ich wurde bald bekannt und bekam immer mehr Aufträge
und Anerkennung. Mein Schwerpunkt ist die Verbreitung
meiner Arbeit – mit Hilfe aller Medien.

. KUNDENLISTE. CLIENTS LIST
. JIV
. Gringo
. Soul Clap
. TV400
. Svt

. KONTAKT. CONTACT
Home. 01
Stockholm. Sweden

Home. 02
http://www.finstafari.com
jah@finstafari.com

. JOB FOCUS
I could work with almost anything but I like to be as free
as possible. I want people to come to me because they
know that they need me. I update my street portfolio as
often as I can by doing a lot of things that can be seen in
public so that people know what I have to offer.

. HISTORY
1992 started with graffiti
1995 started to illustrate for a local magazine
 and to find more and more freelance work
1999 began studying Graphic Design and Illustration in
 Stockholm, Sweden
2004 after a five-year study, I graduated with a Master's
 Degree and started regular freelance work

. FADINGS
I have been involved in drawing all my life. I always
sketched a lot, mostly characters and funny stuff.
I decided at a very early stage that I wanted to make
drawing my profession. I started to make illustrations for
a local magazine when I was seventeen and covered the
streets with graffiti. The word was out and I was given
more and more work and gained recognition. I focus on
getting up using all media.

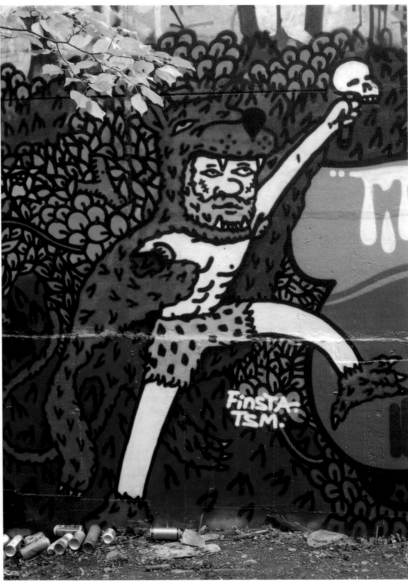

• 001 ++ 002

• 001 B/W. mural. 2004
• 002 KING OF THE JUNGLE. mural. 2004

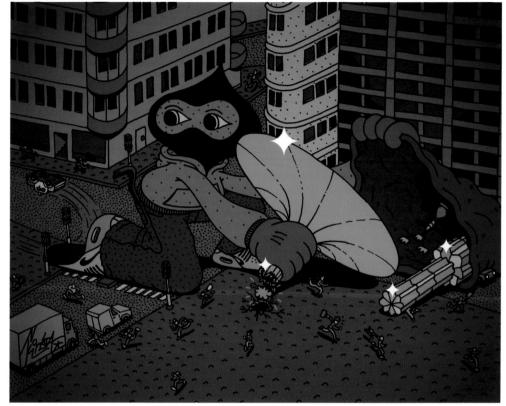

• 003

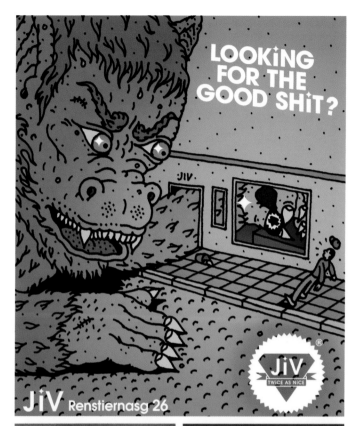

• 003 VARNING FÖR STAN. illustration for Gringo. 2004
• 004 + 005 JIV. artwork for JIV fashion label. 2004
• 006 SPRAYMAN. T-shirt design. 2003

• 004 + 006

•007

•008 ++ 011

•012

•013

•007 HOLY COW. sculpture. 2004
•008 ++ 011 AKESTAM HOLST. business cards. 2003
•012 FUCK Y'ALL. logo. 2002
•013 POP'EM RECORDS. illustration. 2005

•014

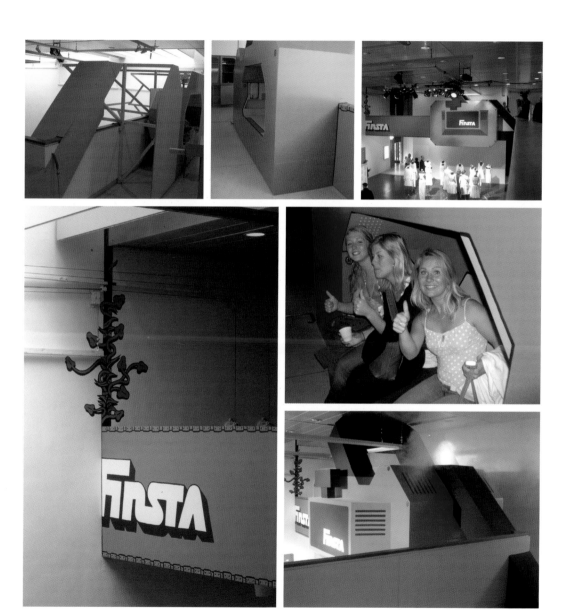

•015 ⊹ 020

- - - - - - - - - - - - - - - - - -
•014 ⊹ 020 FINSTA CHAINSAW. Master's Degree project.
the chainsaw is the FINSTA tool. you could sculpt or
break things down with it. 2004

. **FAKTEN.** FACTS
56K. *1978

. **ARBEITSBEREICHE**
 . Kommunikationsdesign
 . Illustration
 . Stadtmöblierung

. **HISTORY**
 1993 erster Kontakt mit Graffiti
 1998 Konzentration auf Character
 2000 Studium Kommunikationsdesign in Hamburg
 2005 Streetart is no fun

. **FADINGS**
Es ist, wie man eine Stadt wahrnimmt, wie einen die
Geschichten, die zwischen Architektur, Menschen,
Verkehr und Werbung entstehen, beschäftigen und inspi-
rieren, was ich auf meine Zeit mit Graffiti zurückführe.
Städtische Situationen als Gestaltungsmittel in eine Arbeit
mit einbeziehen, unerkannt, ungebeten, unzensiert, quasi
aus dem Off, Botschaften, Ideen und Gefühle mehr oder
weniger verschlüsselt hinter geläufigen visuellen Codes
verbreiten.

Die niemals satten Konsumenten mit Anti-Informationen
versorgen, mit großer Geste absolut nichts aussagen.
Durch minimale Eingriffe in vorgefundene Begebenheiten
und/oder mit gestalterischen Zitaten etwas Altbekanntem
eine neue Bedeutung geben. Und dem niemals abreißen-
den Strom von Einfällen, Emotionen, Input aus Film, Funk,
Fernsehen und Leben irgendwie einen Weg nach draußen
bahnen.

. **KUNDENLISTE.** CLIENTS LIST
 . Polyphon Film- und Fernsehgesellschaft mbH
 . Hong Kong Recordings
 . JUICE magazine
 . MOTORAVER magazine
 . Titus Hamburg

. **KONTAKT.** CONTACT
Home. 01
Hamburg. Germany

Home. 02
http://www.000-56k.de
info@000-56k.de

. JOB FOCUS
 . communications design
 . illustration
 . urban spaces

. HISTORY
 1993 first contact with graffiti
 1998 concentration on characters
 2000 study of communications design in Hamburg.
 Germany
 2005 street art is no fun

. FADINGS
I ascribe to my time with graffiti the perception of a town
and how stories between architecture, people, traffic and
advertising can develop, captivate and inspire.
Unrecognised, unbidden, uncensored, and quasi from
another world, I incorporate urban situations into a work
as a means of composition, and spread messages, ideas
and emotions more or less cryptically behind familiar
visual codes.

I feed the insatiable consumer with anti information and
say absolutely nothing with a grand gesture. I lend a new
meaning to existing situations by minimal interventions
and to the well-known by creative quotations. Doing this
I can somehow blaze a trail for the never-ending stream
of ideas, emotions, and input from film, radio, television
and for life itself.

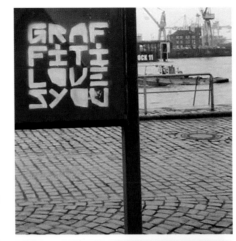

•001 ++ 004

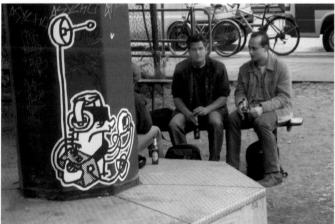

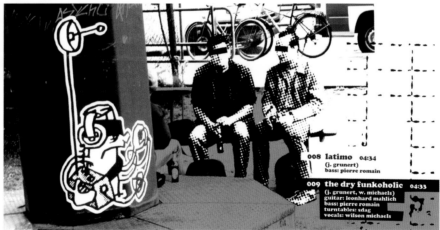

•005 ++ 009

•005 ++ 009 GRUNERT. CD cover, booklet
and promotion sticker. characters in the
streets illustrating the songs. 2004

FUCK UP.

•010 ++ 014

•015 ++ 016

• 017 ++ 023

• 024

• 017 YOU ARE NOT HERE. sticker. 2005
• 018 POINT OF NO RETURN. sticker. 2005
• 019 ++ 023 HOW FUCKING ROMANTIC. doing a fake roadsign. 2004
• 024 HOW FUCKING ROMANTIC. fake roadsign. postcard
for selfpromotion. 2004

PAGE 220.221

. FAKTEN. FACTS
GOMES. Stefan Marx. *1979

| | |
|---|---|
| . ARBEITSBEREICHE | . JOB FOCUS |
| . Artdirektion | . art direction |
| . Modedesign | . fashion design |
| . Zeichnung | . drawing |
| . verschiedene Freelance-Tätigkeiten | . various freelance activities |

. HISTORY
1995 Beginn mit Graffiti
1996 Gründung The Lousy Livincompany
2001 Studium Design an der HAW Hamburg

. HISTORY
1995 started with graffiti
1996 foundation of The Lousy Livincompany
2001 study of design at the HAW Hamburg, Germany

. FADINGS
Die Liebe zur Zeichnung, der Drang des autonomen
Publizierens und das Handeln ohne Befolgen von
Regeln faszinieren mich jeden Tag. Alleine für sich Dinge
zu erschaffen, Gefühle zu zeigen, zu vermitteln und
Aussagen zu treffen, ohne zu sprechen, sind treibende
Kräfte. Reaktionen zu erhalten – mit den eigenen Inter-
pretationen auf zeitgenössische Gegebenheiten der
Stadt zu reagieren. Äußerlichkeiten zu bestimmen und
damit Emotionen zu erzeugen, offene Zusammenarbeit
mit anderen Labels sind interessante Blickwinkel und
Möglichkeiten.

. FADINGS
Every day I am fascinated by my affinity to drawing, the
urge to publish autonomously and to act without following
the rules. Creating objects simply for themselves,
showing and conveying emotions and making statements
without speaking are my driving forces. To obtain respon-
ses and react to the current situation in a town with my
own interpretations are further motivations. Defining
appearance to excite emotions and open cooperation
with other labels offer interesting perspectives and
opportunities.

. KUNDENLISTE. CLIENTS LIST
. The Lousy Livincompany worldwide
. Cleptomanicx
. HESSENMOB Skateboards
. ayume lifeforms
. LANDSCAPE Skateboards. England
. ALIS skateboards. Denmark
. PAPER IT. Paris. France
. John Brown Citrus Publishing. London. UK

. KONTAKT. CONTACT
Home. 01
Hamburg. Germany

Home. 02
http://www.livincompany.com
stefan@livincompany.de

· 001

· 002 + 004

· 001 THE LOUSY LIVINCOMPANY. illustration. 2004
· 002 ISOLÉE. we are monster. album artwork.
 released by Playhouse. 2005
· 003 BOY. illustration. Hamburg. Germany. 2003
· 004 ILLUSTRATION. Brussels. Belgium. 2004

• 005 ++ 007

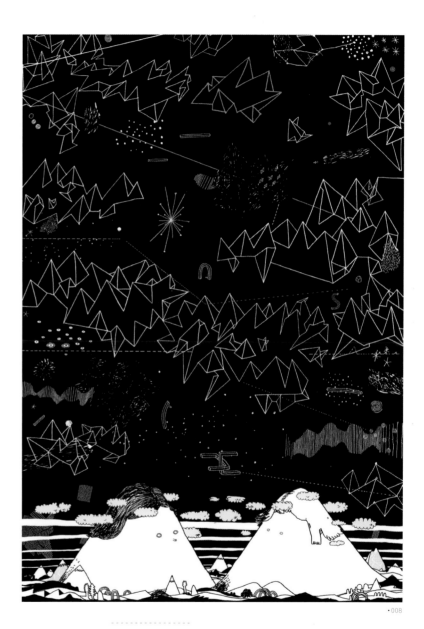

• 008

• 005 TRAININGSLAGER. flyer. 2004
• 006 FRUIT. logo for Cleptomanicx. 2003
• 007 HH HOLIDAY. pattern for Cleptomanicx. 2003
• 008 GOODNIGHT TO THE ROCK'N'ROLL ERA.
 poster for PAPER IT. 2004

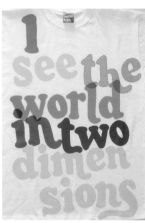

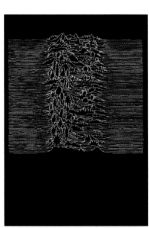

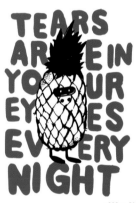

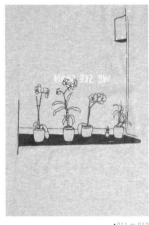

•009 ++ 010 •011 ++ 012 •013 ++ 014 •015 ++ 016 •017 ++ 018 •019 ++ 020

SHE'S A
GALAXY
GIRL

- - - - - - - - - - - - - - - - -
•009 SMILEHORN
•010 TEARS IN YOUR EYES EVERY NIGHT.
 The Lousy Livincompany. 2004
•011 STICKER. The Lousy Livincompany. 2004
•012 WE SEE SOON. The Lousy Livincompany. 2002

- - - - - - - - - - - - - - - - -
•013 SUNDAY. The Lousy Livincompany. 2003
•014 FIRST. The Lousy Livincompany. 2004
•015 SKATECITY. The Lousy Livincompany. 2004
•016 EVERY DAY IS A GOOD DAY FOR TRAVEL.
 The Lousy Livincompany. 2004

- - - - - - - - - - - - - - - - -
•017 I SEE THE WORLD IN TWO DIMENSIONS.
 The Lousy Livincompany. 2003
•018 ENTENTEICH. The Lousy Livincompany. 2004
•019 JOYWOOD. The Lousy Livincompany. 2004
•020 IT'S COLD HERE, YOU LITTLE BIRDS.
 The Lousy Livincompany. 2003

PAGE 224.225

. FAKTEN. FACTS
DIBO. David Paya-Cano. *1980

. ARBEITSBEREICHE
. Illustration
. Design

. HISTORY
1996 erster Kontakt mit Graffiti, bis
2002 Ausbildung und Abschluss als Diplom-Grafik-
designer an der Valencia School of Applied Arts
and Artistic Crafts in Spanien, seit
2002 als freiberuflicher Illustrator tätig

. FADINGS
Seit meiner Kindheit habe ich Comics geliebt und diese
frühen Erfahrungen haben sicherlich meinen Stil nach-
haltig beeinflusst. Graffiti ist mir allerdings erst aufge-
fallen, als ich Teenager war. Ich musste schnell, originell
und einfallsreich sein, obwohl ich ab und zu auch Skizzen
verwendete. Für mich bedeutet Graffiti Farbigkeit und
chaotische Proportionen.

Meine Erfahrung mit Grafikdesign ermöglichte mir einen
tiefen Einblick in die Sprache der Werbung, deren Regeln
ich teilweise auch in meinen eigenen Arbeiten anwende.
Ich mag es, wie sich mein Stil im Laufe der Zeit entwickelt
und entfaltet. Auch unbedeutende Einzelheiten des Alltags
können mich leicht inspirieren und voranbringen. Deshalb
halte ich mit wachen Augen nach kreativen Möglichkeiten
Ausschau, die mir über den Weg laufen.

. KUNDENLISTE. CLIENTS LIST
. Montana. Spain
. Exelweiss. Computer Games
. Costa de Valencia. School of Languages
. Grafital S.L. Web Design and Communication
. Blanchon Imagen y Escena S.L.
. El Fraude. HipHop band
. Odysea. HipHop band
. Toyspain. Urban Vinyl Toys
. Dockers

. KONTAKT. CONTACT
Home. 01
Barcelona. Spain

Home. 02
http://www.dibone.com
dibone@dibone.com for Spain
london@dibone.com for UK

. JOB FOCUS
. illustration
. design

. HISTORY
1996 first contact with graffiti
2002 degree of Higher Graphic Design Technician at
the Valencia School of Applied Arts and Artistic
Crafts in Spain
2002 illustrator on a freelance basis

. FADINGS
I have loved comics ever since I was a child and these
early experiences have had a great influence on my style.
The first time graffiti caught my eye I was already in
my teens. I had to be quick, original and non repetitive,
although I did use sketches on rare occasions. To me,
graffiti means colour and chaotic proportions.

My experience in graphic design has given me great
insight into the language of advertising and I have applied
some of its rules to my personal work. I love seeing how
my style gradually evolves and develops. Minor details of
every day events can easily inspire and move me which
is why I keep my eyes open for any creative possibilities
that may come my way.

- - - - - - - - - - - - - - - - - -

•001 SKETCHING. 2002
•002 MURAL. Urban Art Festival. Sevilla. Spain. 2004
•003 MURAL. Münster. Germany. 2004

•001 ++ 003

25.0

•004 ‖ 006

•004 ‖ 006 MI VIDA Y UN HUEVO. comic. self promotion.
done with Photoshop. 2003
•007 MEETING OF STYLES. logo illustration for the graffiti
event. done with Photoshop. 2003

•007

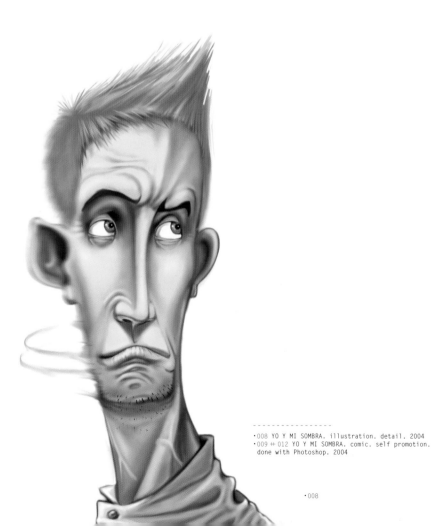

•008 YO Y MI SOMBRA. illustration. detail. 2004
•009 ++ 012 YO Y MI SOMBRA. comic. self promotion.
done with Photoshop. 2004

• 013 + 016

- - - - - - - - - - - - - - - - - - -
•013 + 014 EL ULTIMO TIMO. CD artwork for EL FRAUDE
 HipHop band. 2004
•015 OCEANOGRAFICO. free illustration. 2004
•016 FADINGS. free illustration done for FADINGS. 2004

. FAKTEN. FACTS
HITNES. Niccoló Benedetti. *1982

. ARBEITSBEREICHE
. Wand- und Innenraumgestaltung
. Illustration
. Malerei

. HISTORY
1996 erster Kontakt mit Graffiti
2002 Studiumsbeginn an der Fakultät für Architektur
(Schwerpunkt Grafik und Multimedia) in Rom,
Italien, nach einem Jahr direkter Wechsel in das
zweite Studienjahr des European Institute of Design
(Schwerpunkt Illustration)

Seit 1996 bestimmt die Leidenschaft für Graffiti meinen
Aktionsradius. Während dieser Zeit sind viele Auftrags-
arbeiten auf Wand, im Besonderen aber auf Leinwand,
in vielen europäischen Ländern entstanden.

. FADINGS
Auf Papier, Metall oder auf der Leinwand: Ich habe die
Faszination der Details für mich entdeckt. Auf der Wand
habe ich gelernt, hinzuschauen und diese Details einzu-
fangen. In einem Gemälde entsteht alles unter Zuhilfe-
nahme von Linien, Wasser, Lösungsmitteln oder Farbe.
All diese Elemente gestalten die Form des Bildes,
eines nach dem anderen oder alle gemeinsam. Auf der
Wand kannst du mit magischem Farbnebel Übergänge
erzeugen.

Als kleines Kind wünschte ich mir, meine Bilder wären
lebendig. Und ich wünschte mir, dass meine Dinosaurier
mich vor dem riesigen Tintenfisch, der sich in der dunklen
Ecke versteckte, beschützen würden. Nun musst du nur
einige Meter von der Wand zurücktreten und du wirst den
riesigen Tintenfisch vor dir sehen!

. KONTAKT. CONTACT
Home. 01
Rome. Italy

Home. 02
http://www.hitnes.com

. JOB FOCUS
. wall and interior design
. illustration
. painting

. HISTORY
1996 first contact with graffiti
2002 studied at the Faculty of Architecture (focus on
graphic and multimedia courses) in Rome, Italy,
after first year, change to second year at the
European Institute of Design (focus on illustration)

My passion for graffiti has kept me involved in this activity
since 1996. I have carried out numerous commissioned
works in different European countries. These were mainly
on walls, in interior design and in particular, on canvas.

. FADINGS
Working on paper, metal or canvas I discovered a great
fascination for details. Working on walls I have learned
how to perceive these details and capture them.
In a picture everything is created by using lines, water,
solvents or colour. All these elements, either together or
separately, create the skin of an image. On the wall you
can fade this magic coloured dust and try to capture the
one effect that issues from all the other effects.

As a small child I wanted my drawings to come alive and
hoped that my dinosaurs would protect me from the giant
squid hidden in the dark corner. Now, if you take a few
steps back from the wall, you will see the giant squid
right in front of you!

• 001

• 002

• 003 + 006

• 001 BOLMOST5. illustration. free work. 2004
• 002 HMUGH. illustration. free work. 2004
• 003 GRACHIO. mural. Grosseto. Italy. 2003
• 004 GUFO. HITNES/FRESKOMAGNUS. mural. Rome. Italy. 2004
• 005 MOSTRO. mural. Rome. Italy. 2003
• 006 GATTO. mural. Grosseto. Italy. 2003

26.0

•007 + 009

•010

•007 BOLMOST2. illustration. free work. 2004
•008 CANE. illustration. free work. 2004
•009 UZZELLO. illustration. free work. 2004
•010 CASINO. mural. Bamberg. Germany. 2004

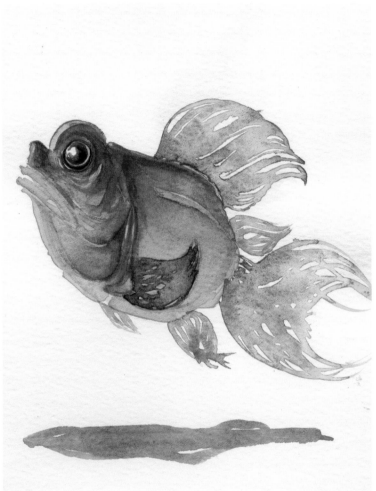

•011 ++ 012

•013

•014

- - - - - - - - - - - - - - - - - -
•011 ETCHING3. etching. 2003
•012 PAPPA. acrylic on canvas. 2004
•013 ACQUE5. water colour on paper. 2003
•014 FISIO. illustration. free work. 2004

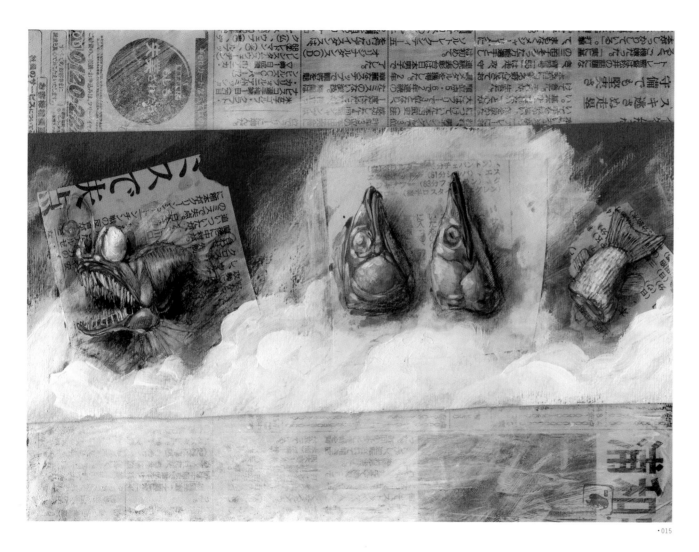

•015

•016

- - - - - - - - - - - - - - - - - -
•015 PESCEFLITTO. painting. 2004
•016 HOMOFISIO. illustration. free work. 2004

. FAKTEN. FACTS
SHAWN-THESIGNER. Florian Flatau. *1982

. ARBEITSBEREICHE
. Malerei
. Fassaden- und Innenraumgestaltung
. Illustration
. Printdesign
. Setgestaltung
. Modedesign
. Screendesign
. Skulptur-, CAD- und Modellbau

. HISTORY
1982 in München geboren
1984 Umzug nach Boston, USA
1988 Einschulung in München
1994 erster Kontakt zu Graffiti durch ZWERG, seit
1997 selbst aktiv
1998 Kontakt zu ersten Münchner Oldschoolern
1998 bis heute stetiger Austausch mit BLASH,
 LOOMIT und Z-ROK
2001 Gründung des Labels SHAWN
2003 erste Ausstellung THESIGNER in der
 Färberei (http://www.diefaerberei.de)
2004 Studium Industrial und Transportation Design
 in Pforzheim

. FADINGS
Die Formensprache und die Stilelemente von Graffiti
werden immer mehr publik. Gerade im grafischen Bereich
ist diese Tatsache deutlich erkennbar.

Schon sehr früh haben mir die Münchner Trueschooler
wie BLASH, SONIC, LOOMIT und schließlich Z-ROK Graffiti
in den unterschiedlichsten Bereichen vermittelt. Jeder von
ihnen hat seinen eigenen Bezug zu Graffiti, wodurch jeder
in einem anderen Bereich tätig ist. Durch diese Beobach-
tung und die sehr wertvolle Vermittlung ihrer Erfahrungen
haben sie meine Entwicklung maßgeblich beeinflusst
und unterstützt. Momentan studiere ich Industrial und
Transportation Design.

Ich sehe es als eine Herausforderung an, zu zeigen, dass
es auch in diesem Bereich möglich ist, die Ästhetik von
Graffiti zu transportieren. Dabei ist und wird Experimen-
tierfreudigkeit gefragt bleiben.

. KUNDENLISTE. CLIENTS LIST
. SHAWN - the label
. SHAWN - the artist
. Pulver Records (http://www.pulver-rec.com)

. KONTAKT. CONTACT
Home. 01
Pforzheim. Germany

Home. 02
http://www.come2shawn.com
thesigner@come2shawn.com

. JOB FOCUS
. painting
. facade and interior design
. illustration
. print design
. set design
. fashion design
. screen design
. sculpture, CAD and model making

. HISTORY
1982 born in Munich, Germany
1984 moved to Boston, USA
1988 started school in Munich, Germany
1994 first contact with graffiti through ZWERG,
 active since
1997 in graffiti
1998 contact to the first Munich Oldschoolers, from
1998 up to present, constant exchange with BLASH,
 LOOMIT and Z-ROK
2001 foundation of the label SHAWN
2003 first exhibition THESIGNER in the
 Färberei (http://www.diefaerberei.de)
2004 study of industrial and transport design
 in Pforzheim, Germany

. FADINGS
The stylistic elements of graffiti and its use of forms are
becoming increasingly public. This is particularly evident
in the field of graphics.

The various aspects of graffiti were imparted to me at an
early stage by the Munich Trueschoolers BLASH, SONIC,
LOOMIT and lastly Z-ROK. Each of them has his own
individual approach to graffiti and operates in a different
area. Through this knowledge and the valuable medium
of their experience they influenced and supported my
progress considerably. I am now studying industrial and
transport design.

I see it as a challenge to show that it is possible to
transfer the aesthetics of graffiti to this sector as well.
At the same time, the willingness to experiment continues
to be in demand, now and in the future.

• 001 ++ 004

• 001 ++ 005 SH. 3DStudio animation. 2001

• 005

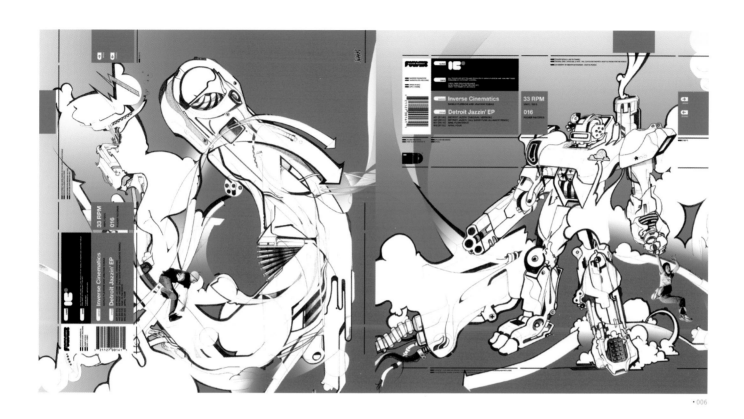

• 006

•011 ++ 020

•021 ++ 023

•011 ++ 020 VS.YOU. making of. 2004
•021 BOMB. 2003
•022 MCC. multi colour can. for colour machine only. 2003
•023 AWAKE. the new can technology. 2003

• 024 ++ 027

• 028

• 024 ++ 028 VS.YOU. 100% handmade vinyl toy. 2004

. **IMPRESSUM.** IMPRINT

FADINGS
GRAFFITI TO DESIGN, ILLUSTRATION AND MORE.
Siggi Schlee

published by Publikat Verlags- und Handels KG,
in cooperation with Gingko Press

ISBN 1-58423-219-6 Gingko Edition/US
ISBN 3-9809909-0-7 Publikat Edition/Europe

© Publikat
Verlags- und Handels KG
Hauptstraße 204
63814 Mainaschaff
Germany

Author: Siggi Schlee
Concept/Design: Siggi Schlee

Quality assurance: Karoline Branke
 Publikat Verlags- und Handels KG
Foreword: Hgb Fideljus/Büro Destruct
Translation/French: Patrick Jungfleisch
Editorial Support: Kristina Schäfer
Proof-reading: Karoline Branke
 Publikat Verlags- und Handels KG
FADINGS Digital: Tobias Lamp
 http://www.signers.de

FADINGS Home: http://www.fadings.de
 siggischlee@fadings.de

FADINGS Soundtrack: Daniel Stenger
 http://www.creamsound.de

For your local distributor get in touch with
Publikat Verlags- und Handels KG, info@publikat.de, or
Gingko Press Inc., 5768 Paradise Drive, Suite J, Corte
Madera, CA 94925, books@gingkopress.com

•001 ++ 004

28.0

. THANKS

Heike, for everything!

Markus Christl, Karoline Branke, Tobias Lamp, Mrs. and
Mr. Hauptmann, Patrick Jungfleisch, Kristina Schäfer,
Ekkehart and Jörn Stiller, Roland Eisert, Daniel Stenger,
Lars Reuther, Hendrik Beikirch, Sigi von Koeding, Ata
Bozaci, Leo Volland, José Luis, Aurélien, Samz, Rafael
Gerlach, Cheesy, Manuel Osterholt, Jürgen Feuerstein,
Marco Gleixner, Barbara and Olaf Auser, Andi Demko,
Quang La Dinh and every single artist for being part of
FADINGS. GRAFFITI TO DESIGN, ILLUSTRATION
AND MORE.

publikat
Verlags- und Handels KG

THE ART OF REBELLION
street art from all over the world
05.2005
ISBN 3-980-9909-1-5
C. Hundertmark
paperback. 16cm x 23cm. 144 pages

BEST OF STYLEFILE
the finest trains, walls, styles and interviews of
Stylefile's first ten issues
07.2005
ISBN 3-980-9909-2-3
paperback. 23cm x 17cm. 256 pages

HAMBURGCITYGRAFFITI
all about graffiti in Hamburg. Germany
10.2003
ISBN 3-980-7478-6-7
TYPEHOLICS
hardcover. 21cm x 27cm. 176 pages

STYLEFILE.BLACKBOOK.SESSIONS.#01
graffiti on paper. scribbles, outlines and full-colour-stuff
08.2002
ISBN 3-980-7478-2-4
M. Christl
paperback. 23cm x 16cm. 160 pages

STYLEFILE.BLACKBOOK.SESSIONS.#02
graffiti on paper. scribbles, outlines and full-colour-stuff
04.2004
ISBN 3-980-7478-8-3
M. Christl
paperback. 23cm x 16cm. 160 pages

STRAIGHT LINES
ECB RESO | a ten year graffiti-art dialog
04.2004
ISBN 3-980-7478-5-9
P. Jungfleisch, H. Beikirch
hardcover. 22cm x 15cm. 128 pages

STYLEFILE
graffiti magazine
out every March, July and November
documenting in high quality the graffiti and street art
movement all over the planet

for details and further information check
http://www.stylefile.de